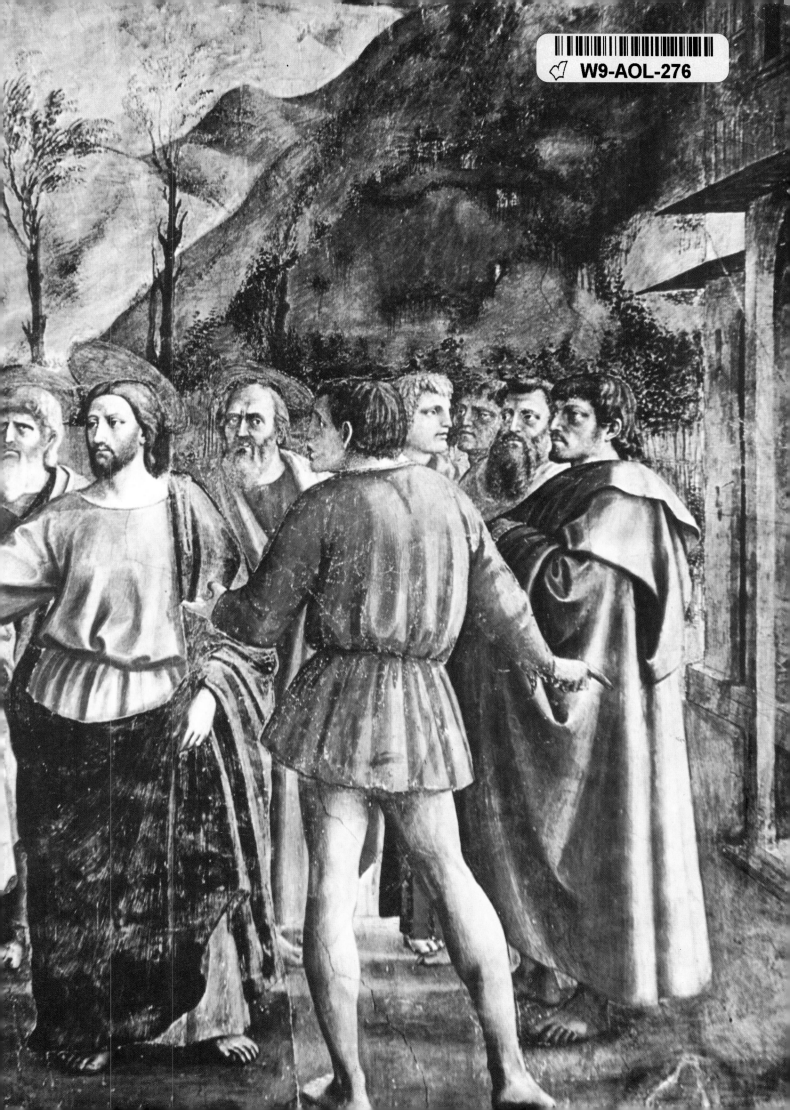

The Face of
Christ

Aug 23, 1982

To Bob,

With Love,

The Face of
Christ

Denis Thomas

Doubleday & Company Inc.
Garden City, New York

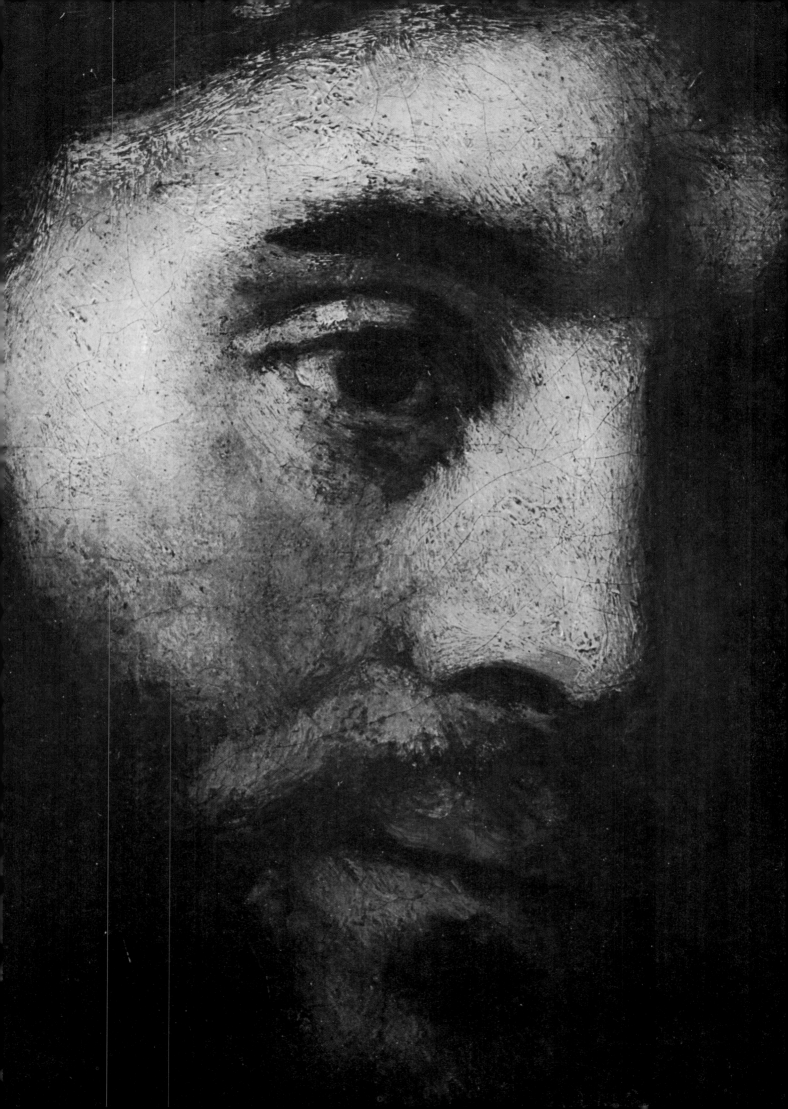

To David, Stephen, James and Paul

Published by Doubleday & Co., Inc., Garden City,
New York, U.S.A.

Copyright © The Hamlyn Publishing Group Limited
London · New York · Sydney · Toronto
Astronaut House, Feltham, Middlesex, England
1979

ISBN 0–385–15306–6
Library of Congress Catalog Number 78–20744

Phototypeset by Keyspools Limited, Golborne, Lancs.
Colour separations by Vidicolour Limited, Hemel Hempstead, Herts.
Printed in Spain by Grafiacromo, S.A. – Córdoba.

Contents

Foreword

To read the pages of this book and to ponder the pictures which it contains is to realise afresh the depth of the Christian faith and the range of its impact through the centuries. Faith expresses itself in words and in pictures, and words will always evoke pictures in the mind before the painter or the sculptor ever depicts what is seen. As Christians believe with St. Paul that the glory of God is revealed in the face of Jesus, at once the question arises: How do we picture him?

This book suggests the answer, for it is not a random collection of lovely pictures but an attempt to trace the ways in which Jesus has been portrayed as God and Man throughout the centuries. How wide is the range of themes here presented? There is Jesus in divine glory, Jesus as Man portrayed like the people known to the artist in his own setting, Jesus as Man in his own historical setting of Palestine, Jesus as the ideal of manhood, Jesus suffering in agony, Jesus suffering in serenity and triumph, and Jesus as the destroyer of death. The blending of realism and symbolism is not surprising when there is depicted a faith which is both down-to-earth and full of heavenly meaning. Studying the themes in this book we ask what is the underlying secret, and the words of St. John are likely to come to mind: The Word was made flesh and dwelt among us.

I feel sure that this book will achieve much for the enjoyment of beauty, the understanding of history and the pondering of the Christian faith.

Lord Ramsey of Canterbury

Author's Note

The ways in which men have depicted the face of Christ over the past eighteen hundred years may have something to say about the nature of the Christian faith, and also about the nature of man. An art critic, approaching the subject in a spirit of inquiry, enters a world of metaphor and allusion, of visual puns and cryptic signals, of abstract ideas expressed in forms whose meaning lies beyond words. The artist himself is faced with similar demands, especially if he is not versed in the beliefs and observances which make up the complex structure of orthodox Christian belief.

Comparative judgements of religious works of art can have little meaning to people who respond to them in private or emotional ways. The best we can do is to measure the achievements of a Giotto or a Dürer or an El Greco against those of artists who seem merely to be going through the motions of pious imitation. It is not surprising if, in the end, we find that the most moving, memorable or – in our own individual terms – truthful images of Christ are those which have been produced by the great masters, or by anonymous craftsmen for whom performing such a task was an act of worship.

Thanks and acknowledgements are due to the many individuals, galleries and authorities who have offered suggestions or granted permissions, and to Angela Murphy for her contribution as picture researcher.

Out of the dark

No likeness exists of the most famous man who ever lived. We do not know what he looked like, whether he was short or tall, dark or fair skinned, noble or commonplace in appearance. No physical description of him is to be found in accounts of his life, written a full half-century after he died. 'We do not know his external appearance, nor that of his mother,' pronounced St. Augustine. The earliest references to his physical form occur in writings, three or four generations removed from his time, by propagandists of the church that was founded in his name. By then, the supremacy of the new moral religion over its man-worshipping predecessors – the ascendancy of the soul over the body – was a matter

Had he not had something heavenly in his face and his eyes, the apostles never would have followed him at once, nor would those who came to arrest him have fallen to the ground.
St. Jerome

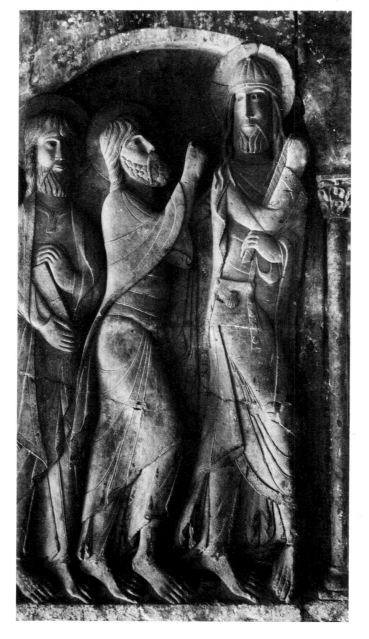

The Road to Emmaus (detail). Early 12th century. Relief. Cloister of S. Domingo de Silos, Burgos, Spain.

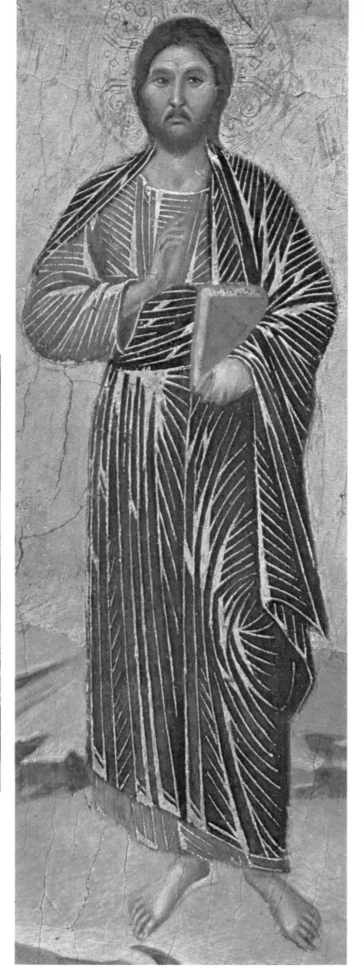

Duccio: *The Transfiguration* (detail). *c.* 1311. National Gallery, London.

The Devil Tempting Christ (detail). *c.* 1130. From nave capital, Autun Cathedral, France.

Gentile da Fabriano: *The Coronation of the Virgin* (detail). 15th century. From a polyptych. Brera, Milan.

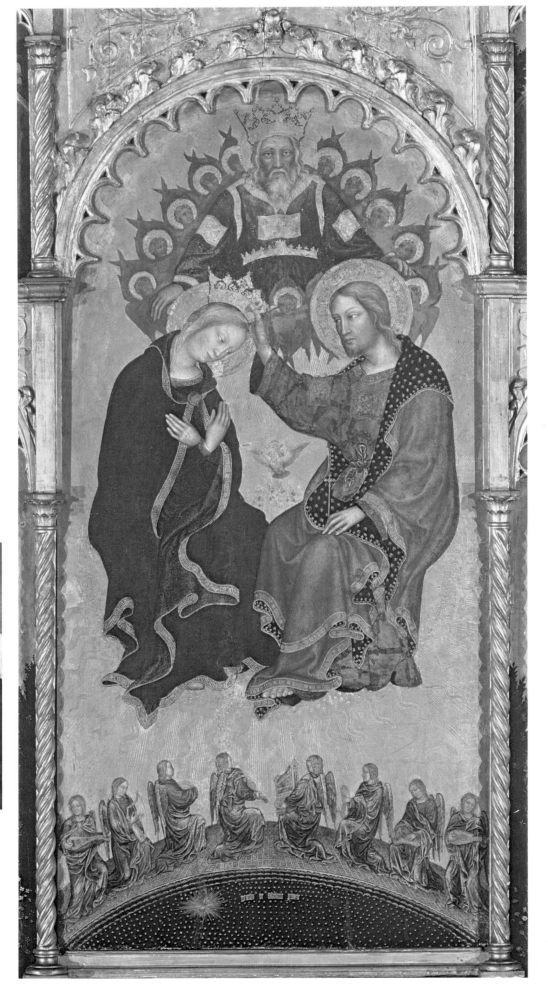

Raphael: *The Coronation of the Virgin* (detail). 1503. Vatican Museum, Rome.

Filippino Lippi: *Christ and the Magdalene* (detail). 15th century. Pierpont Morgan Library, New York.

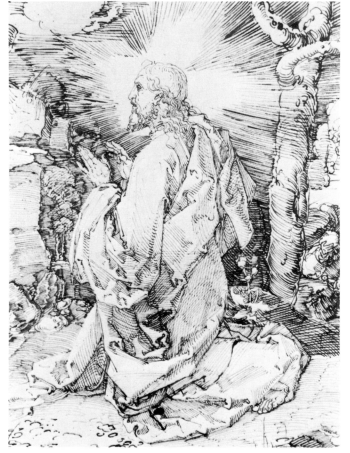

Albrecht Dürer: *Christ on the Mount of Olives* (detail). 1515. Albertina, Vienna.

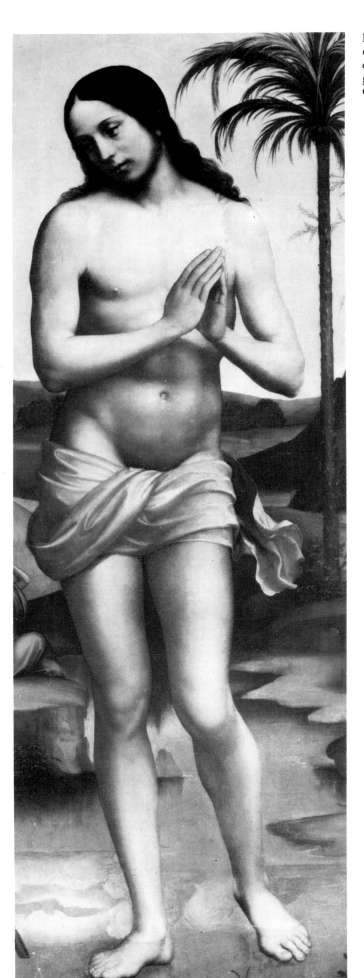

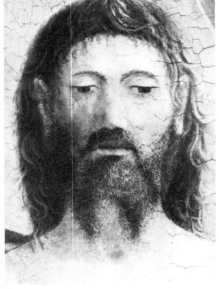

Francesco Francia: *Baptism of Christ* (detail). Early 15th century. Reproduced by gracious permission of H.M. Queen Elizabeth II.

Piero della Francesca: *The Baptism of Christ* (detail). Early 15th century. National Gallery, London.

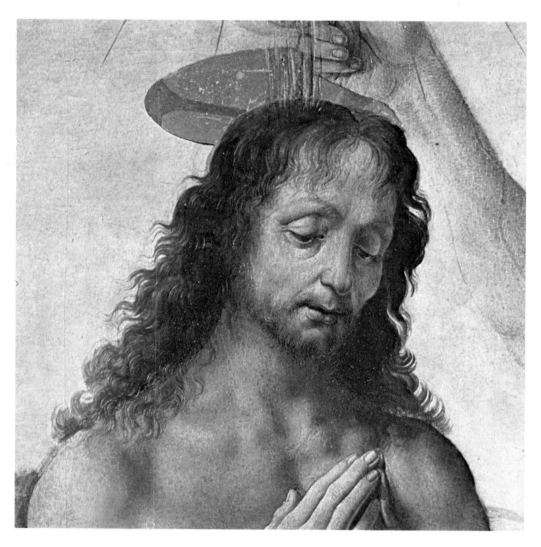

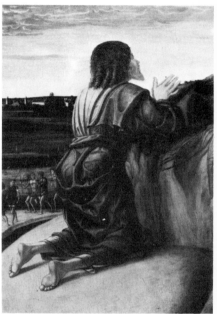

Andrea del Verrocchio: *The Baptism of Christ* (detail). *c.* 1470. Uffizi, Florence.

Giovanni Bellini: *Agony in the Garden* (detail). *c.* 1465. National Gallery, London.

of dogma. Its God on earth must therefore be at the opposite extreme from the muscular athletes of Olympus, 'undistinguished' and 'inglorious' in the flesh.

Jerome, however, pondering on Christ's human shape, concluded that some element of godliness must have shone through. 'Had he not had something heavenly in his face and his eyes,' wrote the saintly scholar, 'the apostles never would have followed him at once, nor would those who came to arrest him have fallen to the ground.' This is a view which the subsequent history of Christian art endorses. It is not important that the face of Christ, as presented to believers in him, should be an authentic likeness. What is important, Christians eventually decided, is that such images should be compatible with the beauty of the word. There were also prophecies to be taken account of, which had raised men's expectations above mere corporeal forms. The later chapters of the Book of Isaiah, written five centuries before the birth of Jesus, had made it clear that Yahweh, when he came, would look like no ordinary being: 'To whom could you liken God? What image could you contrive of him? ... He lives above the circle of the earth, its inhabitants look like grasshoppers ... He is like a shepherd, feeding his flock, gathering lambs in his arms, hiding them against his breast'.

From the beginning of the Christian era, artists have been faced with the problem of whether Christ should be shown as human or divine. The belief that he lived as

Tintoretto: *Christ Washing the Disciples' Feet* (detail). *c.* 1535. Wilton House, Wiltshire.

Fra Bartolommeo: *Head of the Dead Christ*. Late 15th century. Ashmolean Museum, Oxford.

Titian: *The Baptism of Christ* (detail). 16th century. Pinacoteca Capitolina, Rome.

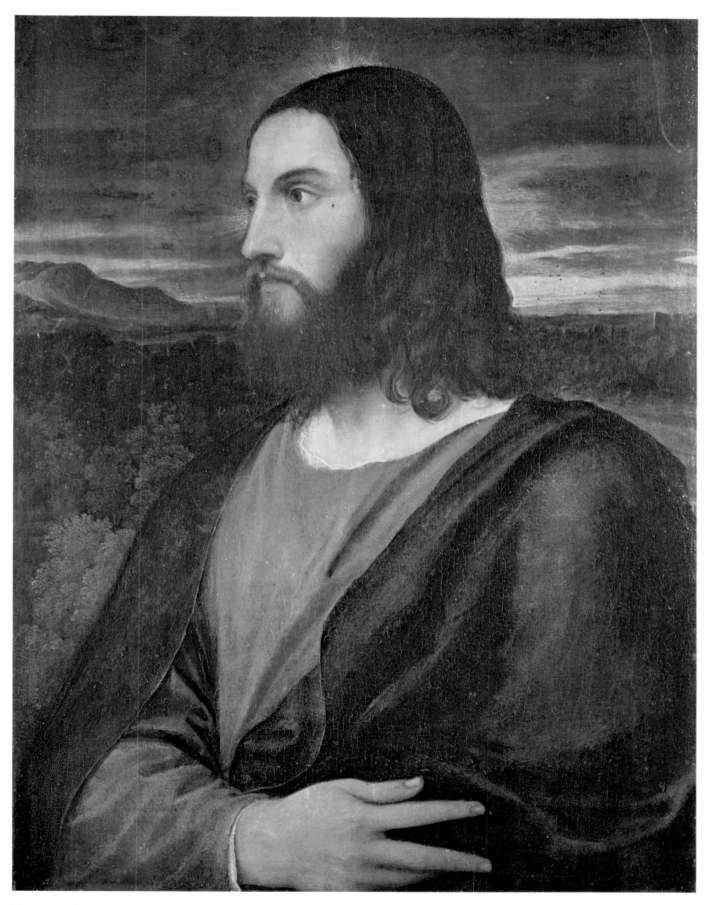

Titian: *Head of Christ*.
Galleria Palatina, Palazzo
Pitti, Florence.

other men, and felt the same worldly emotions, is essential to the Christian message. At the same time, it was necessary to the faith that Christ should also be shown as superhuman. No one has seen God, however; nor is it easy to envisage a form which encompasses both creator and created. Some early Christians attempted a solution, declaring that Jesus only appeared in phantom form for a brief spell before reverting to his godly existence: the doctrine of Docetism. Others have taught that Jesus was a mortal chosen by God, rather like an adopted son, for his pure and virtuous ways. Only those of strict faith have been able to contain, in intellectual terms, the concept that the son of God became human without ceasing to be the son of God: that the Word was made flesh, as St. John says, and dwelt among men, 'full of grace and truth'.

However, according to the gospel, man was created in God's own image. This has eased the artist's task somewhat, by making possible an otherwise inconceivable reflection. The fusion – perhaps the contradiction – between man and god in the Christian context calls for a supreme leap of the artist's

imagination. To a degree, painters and sculptors of each age have come to an accommodation with these difficulties, from the early, semi-paganised idea of Christ's face and form, through the ethereal stereotypes of the Carolingian and Byzantine epochs to the Man of Sorrows and the humanised realisations of the Renaissance. In France, Spain and northern Europe the face and the body were to become symbols and instruments of pain, as if artists had rediscovered the terrible force of suffering. In the last two centuries, when widely held faith gradually relapsed into mere forms of worship, Christ was represented in an aura of increasingly comfortable piety. It took another hundred

Gerrit van Honthorst: *The Incredulity of St. Thomas.* *c.* 1617. Prado, Madrid.

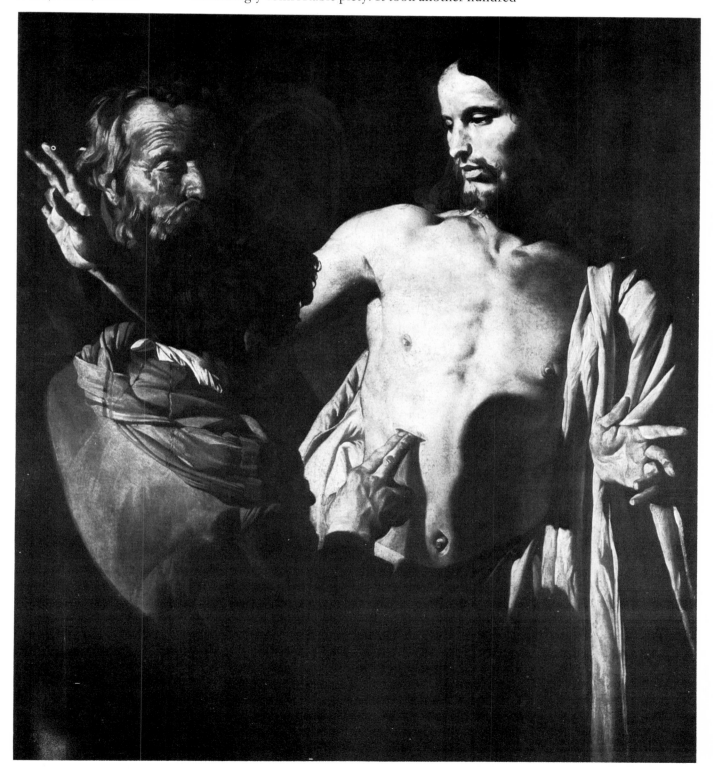

years to turn him into the superstar of our own time. The
new faith had its roots in the lives of common people:
workmen in the back streets, labourers in the fields and
vineyards, fishermen along the sea and lake shores;
Syrians, Levantines, Anatolians, freedmen and slaves – in
gospel terms, the humble and meek. The Bible stories
made a strong appeal to such people, expressing in
homely terms the teaching of the Testaments. The
witness of Jesus's life gave Christianity an unrivalled
veracity, making the miraculous seem credible, clothing
the abstractions of faith in familiar flesh.

These stories found their way into the art of the
catacombs, those cramped recesses where Christian
families descended to lay out their dead, complete, in
expectation of the Last Trump. These solemn places,
originally built by Romans, consisted of narrow,
connecting galleries, between ten and fourteen feet high,
into which an occasional slit allowed air and a faint light
to enter. Opening off the galleries were the tombs, carved
out of the soil or rock, in which the dead were laid,

Above
John Constable: *Christ
Blessing the Children* (detail).
Altarpiece. *c.* 1805. St.
Michael's Church, Brantham,
Essex.

Right
Fra Angelico: *Noli Me
Tangere* (detail). Early 15th
century. S. Marco, Venice.

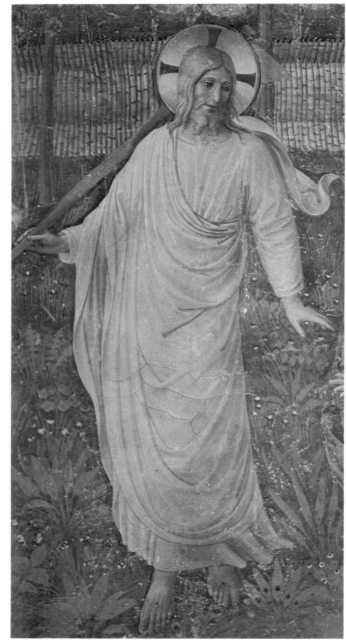

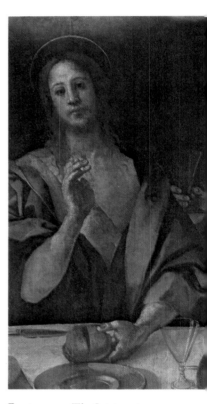

Pontormo: *The Supper at
Emmaus* (detail). 1525. Uffizi,
Florence.

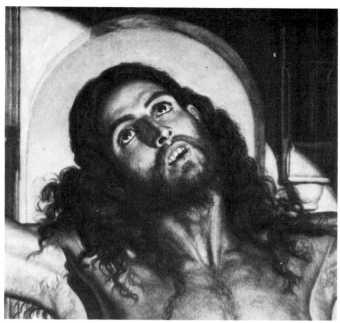

William Holman Hunt: *The Shadow of Death* (detail). 19th century. City Art Gallery, Manchester.

Christ Carrying the Cross (detail). After Bellini. 15th century. Isabella Stewart Gardner Museum, Boston.

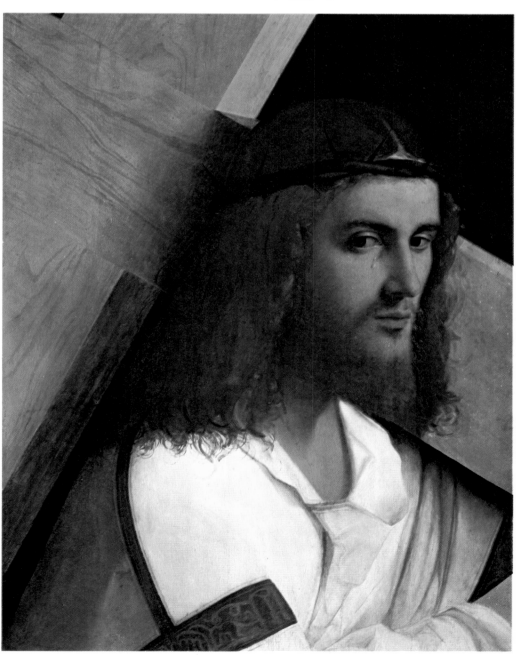

In the catacombs of ancient Rome, where the early Christians laid their dead to rest, images of Jesus appear for the first time. He is shown in the likeness of a curly-headed young man, akin to the boy-hero David, or long-haired and bearded, after the orthodox Jewish fashion. In other representations, Jesus appears in the popular guise of the Good Shepherd.

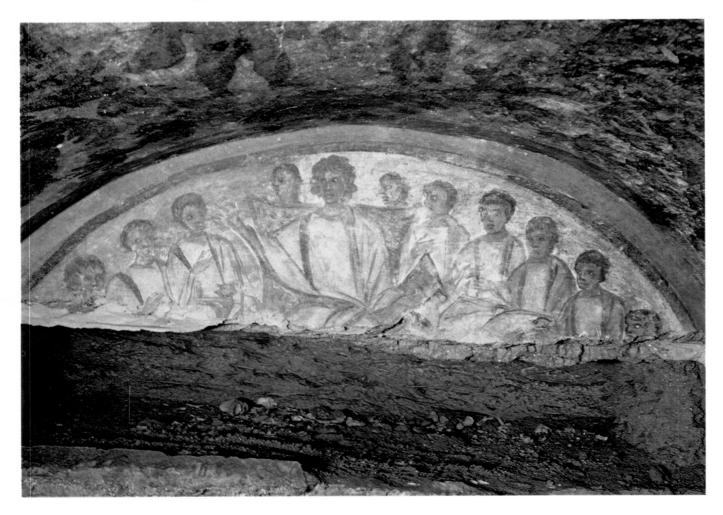

Figure of Christ. 4th century. Catacomb of Domitilla, Rome.

perhaps with a meal set out for them as a last act of charity. Most tombs were modest enough; a few, marking the resting place of a bishop or martyr, would include a small chamber, sometimes with an arch. Roman law gave protection to the dead, and these obscure places seem not to have been disturbed. Many were subsequently built over, when chapels and baptistries were permitted by the Christianised regime.

The pictures with which some of the tombs were decorated are mainly of biblical stories and parables. People who still adhered to the old faiths, or to none, imagined the world as a place swarming with devilish creatures, agents of mischief and disorder. In the dank

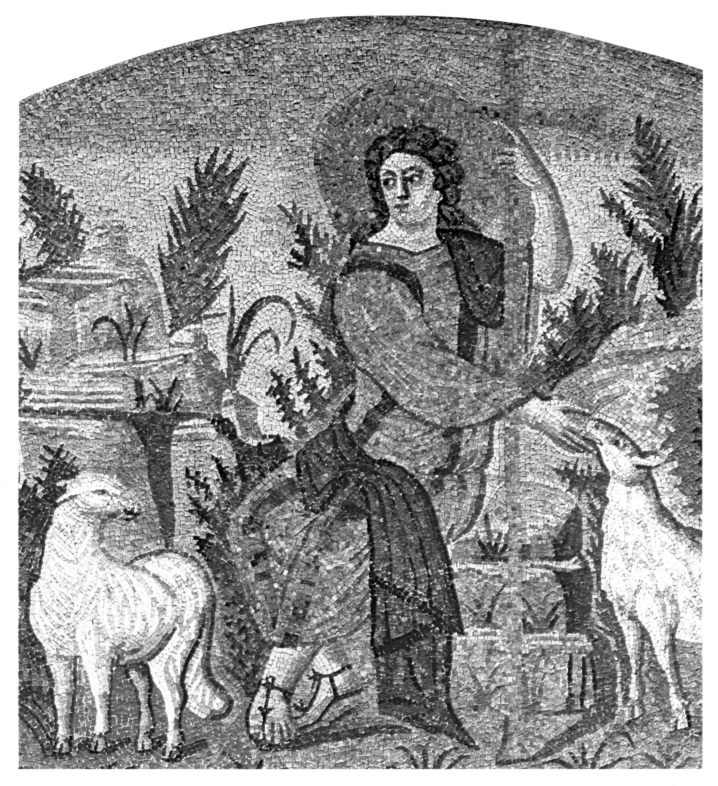

The Good Shepherd (detail).
Mosaic. 5th century. Galla
Placidia, Ravenna.

silence of the catacombs, the Christian dead were laid to
rest among pictures of Noah and the Ark, or Jonah and
the Whale, or the miraculous draft of fishes. From time
to time Jesus appears, usually in the likeness of a young
man. Sometimes he is bearded and long-haired, in the
orthodox Jewish style; more often he is shown as a curly-
headed youth, kin to the young David. Some early wall-
paintings show him in the popular role of Good
Shepherd, holding a lamb across his shoulders: an image
revived in modern times by Picasso, whose statue of a
man and a sheep, made in Paris during the Occupation,
shows the animal, traditional symbol of meekness,
struggling to leap out of his embrace. With no religious

The Raising of Lazarus and
Christ as the Good Shepherd. 3rd
century. The Catacomb of
San Giordani, Rome.

Right
The Suicide of Judas Iscariot;
The Crucifixion and the
Resurrection of Christ; and The
Doubt and Conviction of St.
Thomas. From an ivory
casket. 5th century. Maskell
Collection, British Library,
London.

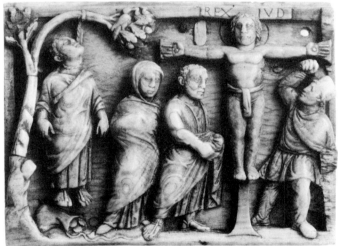

Pilate Washing His Hands, and
Christ Carrying His Cross.
From an ivory casket. Early
5th century. Maskell
Collection, British Museum,
London.

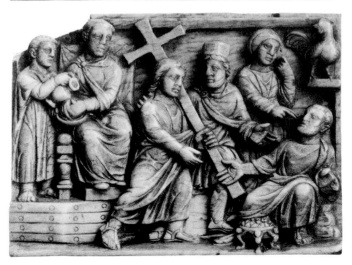

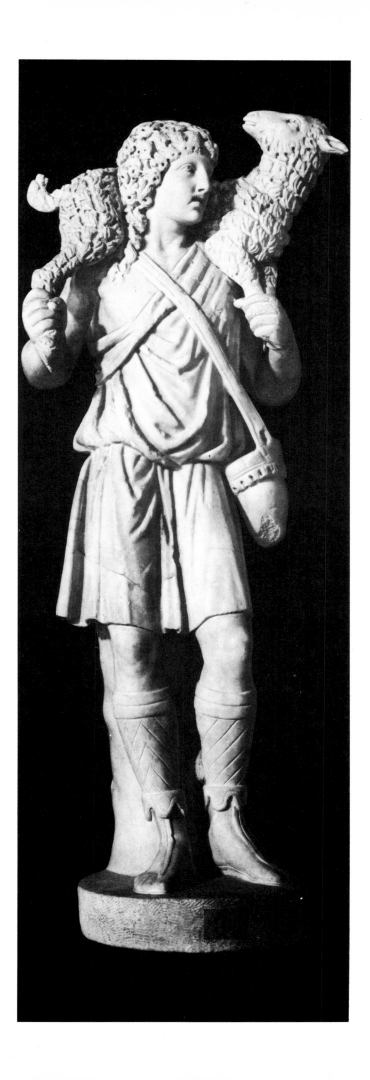

The Good Shepherd. 6th century. Museo Cristian Lateranese, Rome.

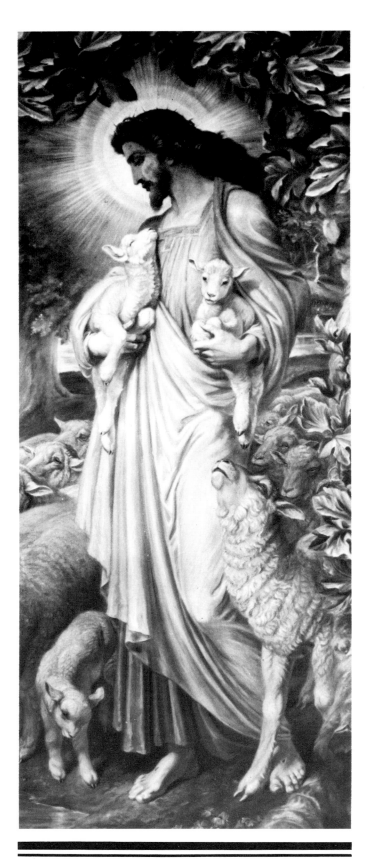

He shall feed his flock like a shepherd: he shall gather the lambs with his arms and carry them in his bosom, and shall gently lead those that are with young.
Isaiah

faith to inspire him, Picasso nevertheless achieved in this image a kinship with anonymous Christian artists of the third century, and also with the pre-Christian era, since the image has its roots in pagan sepulchral art. One early Christian tombstone bears a message from the deceased, describing himself as 'a disciple of the pure Shepherd who feeds his flocks of sheep on mountains and plains, who has great all-seeing eyes'.

It would be surprising if the imagined likeness of Jesus did not sometimes coincide with the ideas of Jupiter, Zeus or Apollo which were familiar throughout the Roman world. The idea of a physically beautiful and noble-looking Christ does not come from scriptural sources, however. Masculine beauty, as recorded in Hebraic texts, is expressed only in generalised terms. Saul is described as tall and handsome, David as ruddy, with a fair complexion. A fair skin seems to have been taken as an attribute of kingliness. In *The Song of Songs*, the comely Shulamite excuses herself for being swarthy, 'because the sun hath scorched me'. Solomon, on the other hand, is 'white and ruddy', his head as 'of the most fine gold'. It seems unlikely that the offspring of a village girl in Palestine would grow up to look like any such hero-figure as these. A more relevant consideration, of course, dispels such hopeless conjectures: the nature of the message as embodied in the man.

In the form in which it eventually prevailed over rival cults it was a mutation of Judaism, which in its purest expression held so exalted a view of the nature of God that the idea of incarnation amounted to blasphemy. Yet the concept of gods who walk among men, and who suffer earthly pains, was familiar throughout the Hellenic world, enshrined in legend and in the mythic history of mankind's not-too-distant past. The Christian belief that the Creator made Man after his own image, offering salvation by himself entering the world as flesh and blood, was offensive to orthodox Jewish doctrine, a contradiction of all Judaism's efforts to sublimate the deity. The fate of Jesus has no parallels in Hellenic myth; but the old belief in gods capable of living among men, enduring fleshly adventures and then departing whence they came, was revived within the Christian gospel. Moreover, these Hellenistic remnants enabled people to put their own pictures to the new faith. Man-worship, which lay at the heart of Hellenism, had proved illusory; now, by infiltrating a heresy into the orthodox Jewish faith, the Christians were able to give man-worship an unprecedented dimension.

From the *historiae*, scenes and events from the gospels with which the first Christian churches were decorated, descended an anthology of biblical subjects which artists, sculptors and decorators were to draw upon in the Middle Ages. The Christian faith was supported by a whole literature of evidence, the Old Testament as well as the Gospels, reaching all the way back to the Creation. This was a provenance worth publicising. As has been pointed out by a modern scholar, F. van der Meer, when artists depicted the Nativity they did not forget to show the very grotto where the birth occurred; and in the Easter morning scene they took care to include the grave, which anyone who went to Jerusalem could see for

himself. Other sights from what was to become known as the Holy Land, and which make appearances in church *historiae*, include Abraham's Oak, the Pillar of Salt, The Twelve Stones in Jordan, the House of Rahab in Jericho, and the cave where Lazarus was buried. The story of how Jesus raised Lazarus from the dead was especially popular. Paintings of it are found in the catacombs and cemeteries, as well as in the early Christian churches. They illustrated in a homely way that Jesus meant what he said when he promised victory over death.

There were political reasons for the imperial government to dislike the new faith. The Christians' talk of converting the rest of the world, and establishing a new kingdom, put them in a special category. Their faith was out of keeping with the collectivist attitudes of a superstate. Though it would have cost them little to go through the motions of respect for the values of the

Opposite
Christ in Majesty. Miniature. From a psalter written for Westminster Abbey. *c.* 1200. British Museum, London.

In the earliest Christian communities tolerated under Roman law, images of Christ show him as miracle-worker and teacher – the main roles in which he is described in the gospels – and as guardian of the divine law. He also assumes his position of heavenly kingship, gloriously crowned.

Christ Enthroned (detail). From an ivory diptych. 6th century. Byzantine. Bibliothèque Nationale, Paris.

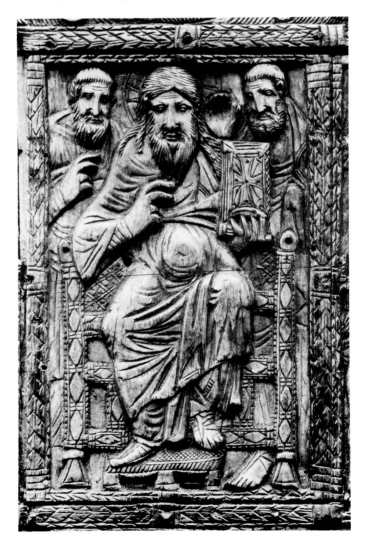

30

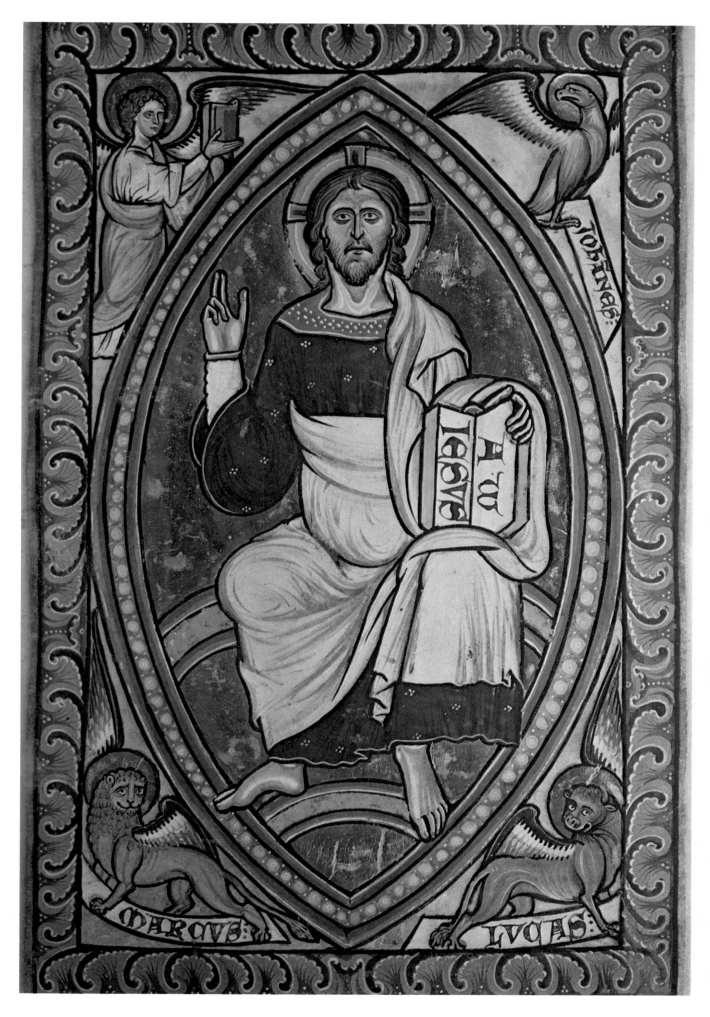

Above
Christ and Disciples (detail).
From the Bury Bible.
1121–1148. Corpus Christi
College, Cambridge.

Right
Christ in Majesty. Miniature.
From *The Gero Codex*. 10th
century. Hessische Landes-
und-Hochschulbibliothek,
Darmstadt.

regime, many preferred to face death, in wilful defiance of the law. This made them even more conspicuous. 'Do you not see the Christians flung to wild beasts to make them deny their Lord?' wrote a second-century scribe. 'Do you not see that the more of them that are punished, the more their numbers increase? These things do not look like the achievements of man. They are the power of God, the proofs of his presence.' There are accounts of Roman magistrates inviting accused Christians, for their own sakes, to make the minimum gesture of obeisance which would enable the law to be merciful – without result.

The early Christians also faced the displeasure of the orthodox Jewish authorities. Having, as it seemed, broken the First Commandment by recognising a man as divine, on equal terms with the Almighty, they now set about flaunting the Second Commandment as well, by propagating their faith through visual images. The Hebraic objection that image-making encouraged idolatry, was blatantly disregarded.

Figure of the Redeemer. c. 1015. Musée de Cluny, France.

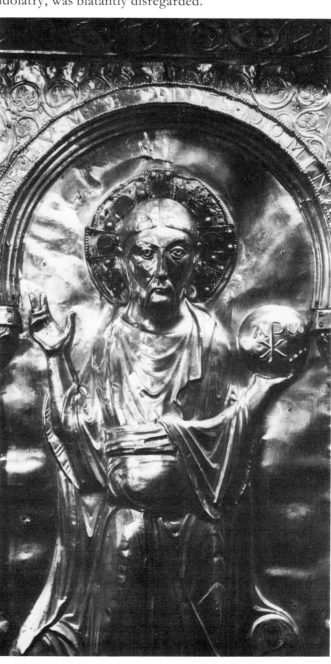

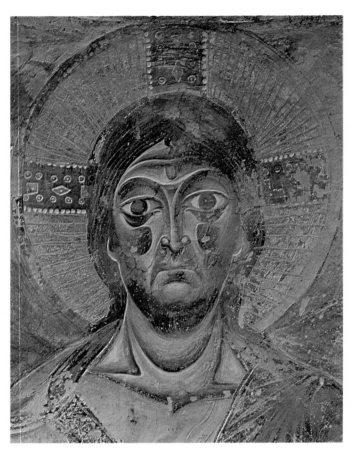

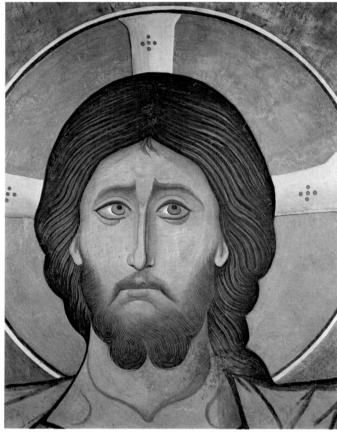

Christ in Majesty (detail).
Fresco. Second half 11th
century. S. Angelo in Formis,
Capua.

In this, the Christians had their Bible to support them.
The Book of Genesis tells of God's pleasure in fashioning
so beautiful a world; and in Exodus we are told that the
Creator imbued artists and craftsmen with wisdom,
understanding and knowledge and with 'all manner of
workmanship', to devise 'cunning works, to work in
gold, and in silver, and in brass, and in cutting of stones
for setting, and in carving of wood'.

The means used were those of their pagan
predecessors. As the historian Arnold Toynbee has
expressed it, the Christian Church adopted hellenic visual
art, the Greek and Latin languages, Hellenic philosophy
and Roman political institutions, as a means of putting
itself in rapport with prospective converts. It succeeded
not only in providing itself with effective instruments of
communication, but it also revived them by breathing life
into dry Hellenic bones. The Christians, with their
missionary zeal, became a cultural force in the declining
Empire. Their art, though at first clandestine and private,
was the creation of people sure of their own salvation. It
carried the same message as their worship and daily
behaviour, that the meek would inherit the earth – a
preposterous, but also vaguely threatening, idea which

Christ Pantocrator. Mosaic.
11th century. The Monastery
at Daphni, Greece.

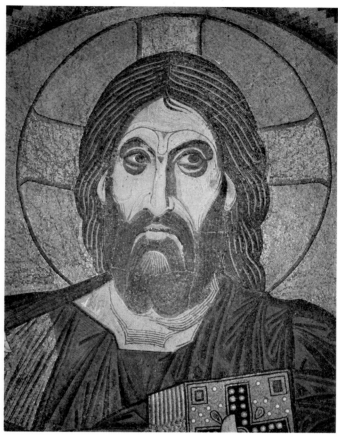

Church Window. 11th century. Originally in the Abbey Church of Wissembourg, Alsace. Strasbourg Museum.

set the Byzantine empire state on its guard.

Dissidents must always expect a hard time under zealous regimes. Though Roman rule in its declining years was not always merciless, the laws relating to unauthorised worship remained on the statute book, ready to be invoked if at any time the established authority should appear to be in danger from religious subversion. By the beginning of the fourth century this danger seemed to be passing. Or perhaps the Romans' own faith in mere terrestrial divinity was by now exhausted: one after another their rulers had been made gods, and one after another they had come to ungodly ends. When the emperor Constantine embraced the Christian faith he gave up his own claim to divinity, calling himself merely 'a bishop, ordained by God to oversee whatever is external to the Church' as opposed to one who was qualified to administer the sacraments. The Christians' burden was lifted, as it might have seemed, miraculously. In 313 they found themselves granted full civil rights and freedom of worship. In 381 Theodosius I formally established the Christian State; and a culture which had spent so long in dark corners could at last emerge into the light.

Christ Pantocrator. Mural. 12th century. Church of Panagia Tou Arakou, Lagoudera Monastery, Cyprus.

From shepherd to king

Roman art was stamped with the imprint of the state, Christian art with the authority of the Word. It was to be found in the first churches, usually houses of well-to-do converts adapted for purposes of worship, often in company with existing Hellenic or Roman wall decorations. Baptism might take place in such places, of adults drawn to the faith. A third-century Syrian township, Dura-Europos, on the Euphrates, has been found to contain evidence of a Christian community, with a baptistry decorated with paintings showing Christ as the Good Shepherd, and walking on the water. These are executed in much the same spirit as similar remnants which have been found in the catacombs and in early Christian cemeteries. The art of the Christian sarcophagi of southern Europe, for all its clumsiness, is also rich in expression, the planes often divided up by columns or by the figure of Christ endlessly repeated. He is usually shown as taller than the other figures, to convey a larger-than-life presence and authority.

The certainties of Christianity begin to find expression in these confident images of the 'overseer and shepherd of our souls'. But it is a symbolic presence that has come down to us, not an attempt at imagining the real man. At Dura-Europos, in a wall painting dating from about A.D. 232, Christ appears in his formalised role as a teacher, clad in classical robes, sandals on his feet, a scroll in his left hand, the right hand raised with the first two fingers extended, the two outer ones bent into the palm: the attitude and garb which were to prevail over all others in which Christ has been depicted since those early times. The natural world also begins to make an appearance, as if in response to the belief that enjoying the beauty of things around us is itself a tribute to God.

Later, when Christianity became the state religion, and Constantinople, the old Byzantium, the capital of the world, there was a flowering of Christian imagery. Biblical scenes, including the figure of Christ, were widespread by the fifth century. A letter survives, written about the year 400, urging the Eparch Olympiodorus in Constantinople to be sure and represent the Cross in the apse of the church, and to include scenes from the Old and New Testaments in the nave instead of the hunting and fishing scenes which the Eparch had evidently proposed. Christ sometimes appears in these surroundings, only one remove from the peasants and rustic maidens favoured by the church decorators. A mosaic pavement from Jerusalem, now in the Archaeological Museum at Istanbul, shows a fresh-faced Christ in the guise of Orpheus, sitting amid a semi-pagan menagerie, attended by a centaur and a satyr. In classical mythology, Orpheus, the charmer of wild beasts and one of the more endearing gods, also stands among those who have descended into the domain of the dead and come up alive. A particularly fine mosaic of the Good Shepherd at Ravenna, in the Mausoleum of Galla Placidia, shows Christ as a young pastor in a rocky landscape, a sheep nuzzling his hand, his crook the symbolic Cross. He appears again, still as a beardless youth, in the Oratory of Christ Latomas, Salonica, where he is epitomised as Emmanuel, the spring of living water, and in the church of San Vitale, Ravenna, where there is

The mosaic masterpieces at Ravenna, standing between the Roman and Eastern cultures, depict Christ once again as youthful and unbearded, in a toga of royal purple. In other mosaics he is shown in scenes from the gospel stories, which accustomed worshippers to the grave, bearded face and flowing white robes which were to become the universally accepted form.

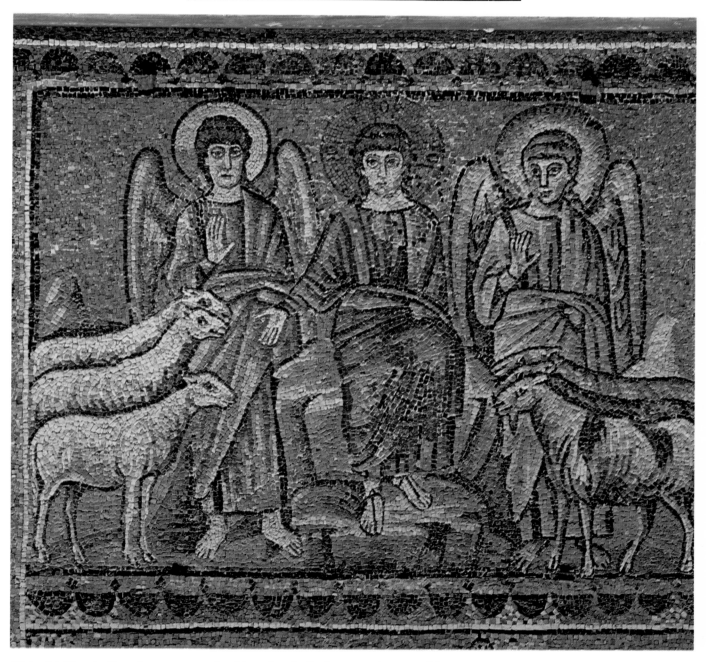

Christ Dividing the Sheep from the Goats. Mosaic. Early 6th century. S. Apollinare Nuovo, Ravenna.

no mistaking the similarity to such an earthly potentate as the Emperor Justinian, in the choir mosaic.

Christian art now takes on a new grandeur. It evokes a higher world, a heavenly kingdom on earth in which Christ receives the obeisance of a hierarchy of prophets, apostles, saints and martyrs: everything that was promised has come true, and everything that is promised for the future will come to pass. There is no indication in

Christ in Limbo (detail).
Mosaic. 12th century.
S. Marco, Venice.

Below
The Entry into Jerusalem
(detail). Mosaic. 12th century.
S. Marco, Venice.

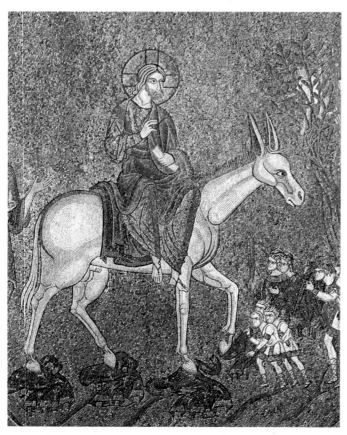

the paintings and mosaics of the pain and degradation of the Saviour's end – aspects of his life which were not among those on which the earliest Christian artists chose to dwell: 'He who has been hanged', the Book of Deuteronomy says, 'is accursed of God.' The face looks out from the glowing walls, neither terrible nor pitiable, but with an air of spiritual command. It says much for the fusion of the Eastern and Western traditions in Christian art, that it should have found the quiet centre of Christian belief, innocent of agony or strain. The Eastern style, in which a background of striking colour overwhelms any suggestion of space, is found making room for the ease and freedom of the Hellenistic tradition, with its light and shade, movement and airy grace.

Under Justinian, the Church of Holy Wisdom in Constantinople was reconsecrated in still more glorious form: the emperor was able to boast that he had surpassed Solomon. The Hagia Sophia remains a masterpiece, a demonstration of earthly riches dedicated to heavenly glory. Constantine and Justinian both figure in the mosaics, offering church and state to the Mother of God. These images, and others scarcely less splendid, were to suffer at the hands of the iconoclasts. But the basilica still conveys the 'marvellous grace' described by the contemporary historian Procopius, of a building that seems 'to float in the air on no firm base'. This idealisation of inherited classic forms has well been called the first true Christian art in the grand manner. The first Christian period may be said to have come to an end during the seventh century. By then, the achievements of the preceding three hundred years, including the growth of an intellectual and spiritual quality far surpassing that of pagan art, had merged with the early Byzantine style.

Ravenna had become the capital of a province representing the Byzantine state in the West, so enabling the two main cultures, Roman and Eastern, to run together. The church of Sant' Apollinare Nuovo, consecrated by Maximillian in AD 549, is a gallery of mosaic masterpieces. A procession of martyrs, forming a mosaic frieze, makes its way down one side of the nave, leading to the enthroned Christ at the east end. Above, figures of saints stand in niches, simulating statues. Above each of the windows is a scene from the Passion, also in mosaic. On the north wall Christ is shown in the equivalent position, performing various miracles. His face is youthful and unbearded, and he wears a toga of Roman purple. One picture shows him enthroned between two angels, separating the sheep from the goats. Again, the face, expressionless, is that of a young patrician. In contrast, a mosaic of the same date showing the Transfiguration, in the apse of the Church of the Virgin in the monastery of St. Catherine, Mount Sinai, untouched since the days of Justinian, shows Christ in white robes, gazing down with an intent bearded face.

Also at Ravenna is the earliest pictorial version of The Agony in the Garden. It is a scene totally innocent of drama. The figure of Christ, hands stretched out in prayer, betrays none of the tragic awareness which gives the story its full meaning. It is typical of the mood of Christian art of the period that this should be so. The artist story-tellers draw back from the painful climax, the

violent or cruel action, the sight of grief or terror. These beautiful images, many of them as bright as when medieval worshippers flocked to see them, are like tableaux, the action frozen at a point before the blood began to flow, the tears to fall, and the hearts to break.

This is not to say that they are lacking in emotional impact. Even to a modern visitor, attracted more as a tourist than as a worshipper, the great mosaics of Ravenna evoke a world of intense spirituality, far removed from bodily ills and grievances, suspended in a universe of blue sky and golden sun. To the faithful, the illustrations to familiar stories have an added, symbolic value. The baptism of Christ becomes an epiphany, with the apostles as witnesses. Paradise is a metaphorical garden for the rest and recreation of Christian soldiers. There, too, in fulfilment of Isaiah's prophecy, the wolf can be seen living with the lamb and the leopard lying down with the kid. Christ himself sits on top of the world.

The course of Christian art was disrupted by doctrinal clashes, culminating in what in our own times might be called a backlash against figurative art. In 726, Leo III, the Isaurian, ordered the image of Christ to be removed from his palace gate and replaced by a cross. It was the signal for a severe tightening of the Church's authority over religious imagery, brought about partly by a resurgence of orthodox Jewish objections to idolatry and partly by the example of Islam, with its dogmatic views

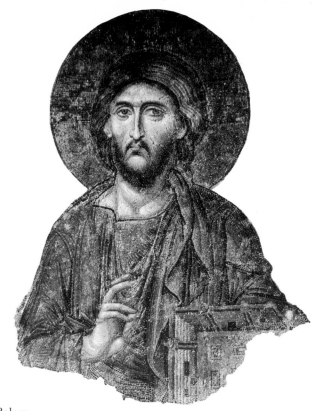

Below
The Procession of Martyrs (detail). Mosaic. 5th to 6th century. S. Apollinare Nuovo, Ravenna.

Above
Christ Enthroned (detail). Mosaic. *c.* 1300. Hagia Sophia, Istanbul.

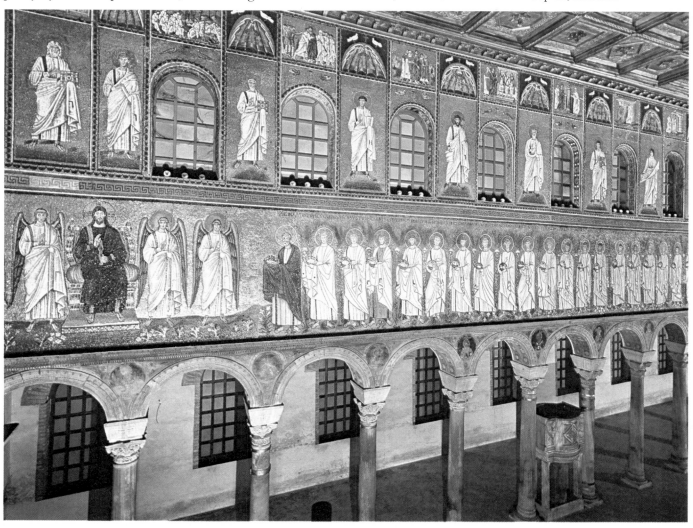

on figurative imagery. The emperor had all icons done away with, frescoes and mosaics scraped off or whitewashed. There was widespread passive resistance – these pictures, after all, were a testament to the birth, growth and survival of the Church itself. At last John Damascene, a Father of the Church who was also a Greek, devised a formula which would allow the worship of religious images, on the grounds that they stimulate and evoke the image of God. The removal or destruction of works in Christian churches in the Eastern world leaves some gaps in the story; but in due course the image of Christ was restored to the gate of the imperial palace, the decorations of Hagia Sophia were restored, and people returned to pray in churches once more ablaze with the images of their faith.

The Eastern church seems to have exerted a stricter discipline over forms of worship, including religious art. In the high-minded Orthodox view, the Word was not to be translated fancifully. Christ, henceforth, was to be shown only in human form. Rules were laid down for painters, telling them how they were expected to show scenes from the Old Testament, and from the life of Christ, the parables, the miracles, the calendar of martyrs, and much else besides. Roman law, codified under Justinian to accommodate Christian worship, laid down penalties for heresy. Any convert who lapsed into paganism faced execution. Jews were forbidden to convert Christians, and were not allowed to own Christian slaves. The emperor invoked the authority of the Pope as his licence to impose these powers as head of the church-state. After the upheavals of the iconoclastic interlude, rulers laid heavy stress on their relations with Christ and with the heavenly company of saints and martyrs.

Wall-painting (detail). 13th century. St. Sepulchre Chapel. Winchester Cathedral, England.

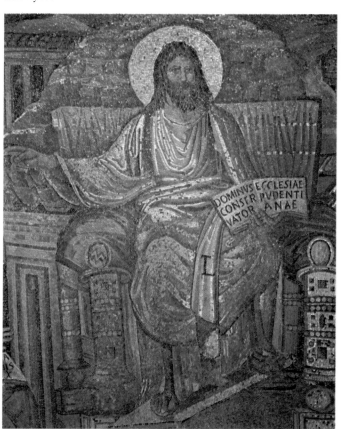

Christ Teaching the Apostles. Mosaic. *c.* 400 S. Pudenziana, Rome.

Right
Master of the Virgo inter
Virgines: *The Road to Calvary*
(detail). *c.* 1495. From a
triptych. Bowes Museum,
Yorkshire.

*I am poured out like water
And all my bones are out of
joint :
My heart is like wax,
It is melted in the midst of my
bowels.
My strength is dried up like
a potsherd,
and my tongue cleaveth to my jaws.
They pierced my hands and
my feet,
I may tell all my bones.
Psalm 22*

Hieronymus Bosch: *Christ
Carrying the cross. c.* 1510.
Museum Voor Schone
Kunsten, Ghent.

The calm, magisterial face now becomes one of the
most persistent images in Christian iconography. With
some notable exceptions, it is as if attempts at realistic

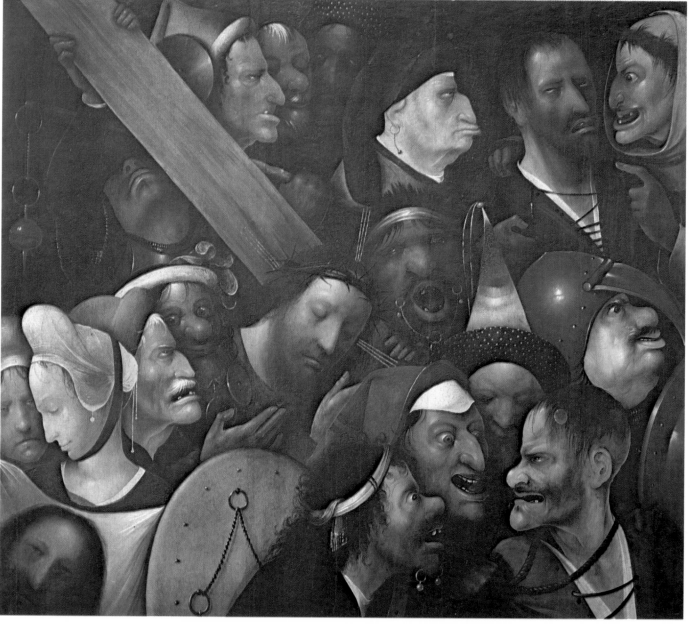

Antonio Francesco Lisboa: *Christ Carrying the Cross* (detail). Polychromed wood carving. *c.* 1796. Congonhas do Campo, Brazil.

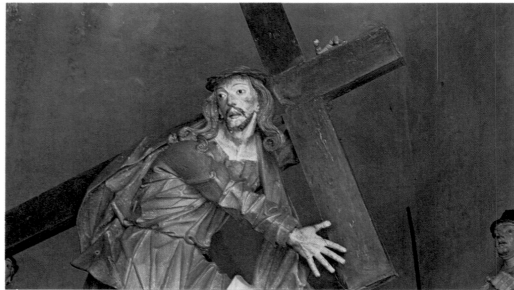

El Greco: *Christ Carrying the Cross*. Late 16th century. Prado, Madrid.

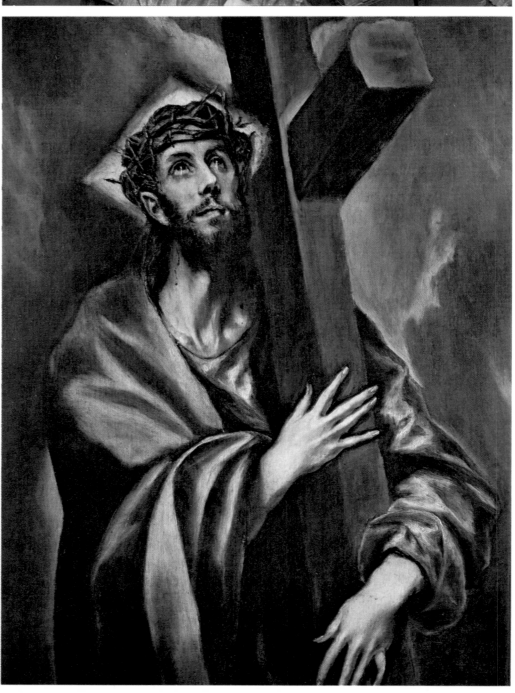

portraiture – an art developed in Roman times with much success – were regarded as unseemly where God's son was concerned. However, artists felt no such inhibitions when depicting other characters in the gospel story. From the beginning, they were given faces illustrative of what the gospels say of their natures and personalities: weatherbeaten Peter, his open countenance framed by a sailor's curly beard; the intense, deeply etched face of Paul; the boyish apostle John, with the lustrous eyes; and above all the Baptist, tragically handsome under the thick black locks and energetic beard. Art scholars have remarked on the eloquent treatment of eyes in early Christian painting – gleams of an inner life, tokens of the spirit. In an *Enthroned Christ* from the San Vitale, Ravenna, dating from the middle of the sixth century, the glancing, wide-open eyes in the young face express a mysterious humanity; godliness is conveyed in the cruciferous nimbus behind the head.

This is one of the earliest appearances of the nimbus,

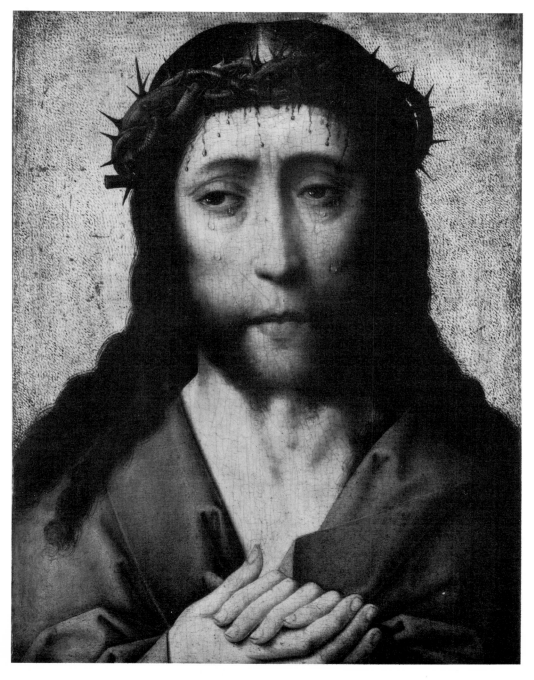

Studio of Dirck Bouts: *Christ Crowned with Thorns. c.* 1475. National Gallery, London.

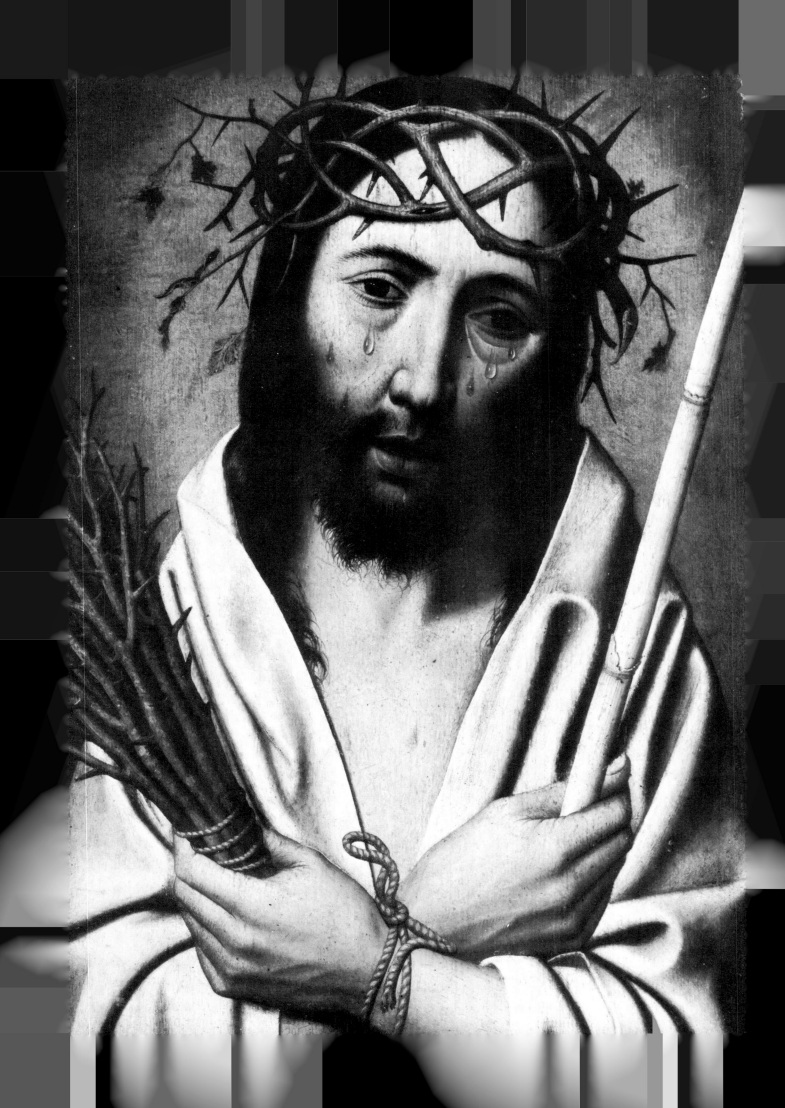

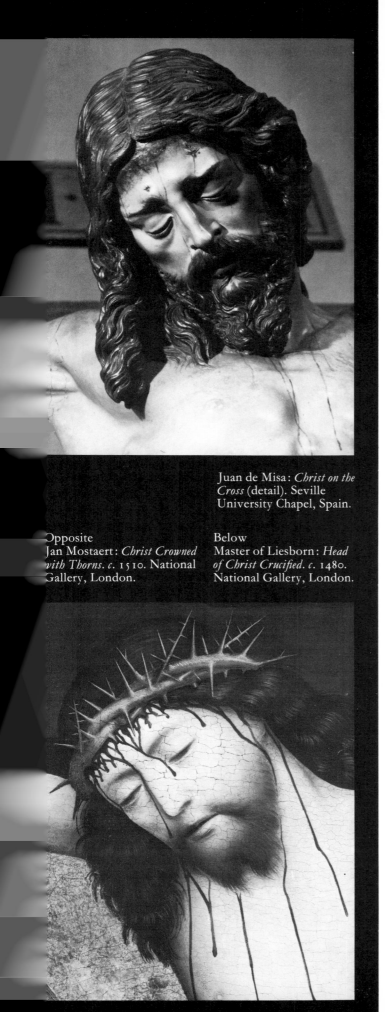

Juan de Misa: *Christ on the Cross* (detail). Seville University Chapel, Spain.

Opposite
Jan Mostaert: *Christ Crowned with Thorns. c.* 1510. National Gallery, London.

Below
Master of Liesborn: *Head of Christ Crucified. c.* 1480. National Gallery, London.

or disc of heavenly light, which from the sixth century onwards becomes an essential addition to images of Christ, as to other figures whose divinity seems to require emphasis or glorification. Its origins are pagan, and are lost in antiquity. The rays of light around the head may derive from the sun image, which is common in all ages; or it may be that a blaze of light has always been considered a sign of godly power. Medals struck in memory of Constantine after his death show him with a nimbus, though he made no claim to divinity, unlike so many of his predecessors. Mosaics in the church of S. Vitale, Ravenna, show not only the emperor Justinian with the nimbus, but the empress Theodora as well. These, and other examples of non-divine personages invested with the same insignia, suggest that Christian artists were following a tradition. The nimbus does, however, now rise to heights of superb ornamentation. In some crowded scenes including saints and martyrs, each with his gilded disc, the effect is dazzling. In purely decorative terms, the device is at its most effective in early Christian imagery. Later, when it is simplified into the halo, first as a flat ring and eventually in perspective, like a spinning plate, it serves more as a pious reminder than as a symbol of glory.

Images of Christ sometimes show him as the vine, which in the Old Testament is a symbol of the chosen people ('Thou did cast out the nations, and planted it') or as the hardy, proliferating faith. Jesus's own words, 'I am the Vine', have lent additional force to the image. It is sometimes to be found in the same design as The Shepherd, which has proved the most durable of all Christ's personifications. It fits the Christian belief well; certainly it is a change of form which no classical god would have found appropriate. The presence of sheep in a church decoration can denote the Christian flock. On its own, as a stylised figure bearing a cross, its head ringed with a halo, the lamb became a widely recognised synonym in the Western Church. Its origins lie in biblical texts, notably St. John's reference to the sacrificial Lamb of God who 'taketh away the sins of the world', and in St. Luke's parable of the one lost sheep in a flock of a hundred: 'Does he not leave the ninety-nine and go after the missing one until he has found it ... I tell you, there will be greater joy in heaven over one sinner who repents than over ninety-nine righteous people who do not need to repent.'

There is equal significance in the symbolic Christ, the Christ concealed in aniconic forms and cryptograms. One of these, the fish, appears to have been a kind of secret sign for the benefit of the faithful. The Greek word for fish, *Ichthus*, can be made up from the first letters of the Greek words for Jesus, Son of God, Saviour. This ready-made acrostic served the early Christians well; though it is worth noting that the fish had been a symbol in religious cults, and in Judaism, in times past. The Christians added further significance to the fish sign by equating it with the springs of living water in the world to come. A third-century theologian, Tertullian, wrote of mankind as 'small fishes', named after the great Ichthus, or Jesus – creatures who could live only in the watery element they were born in. Fish also figure symbolically,

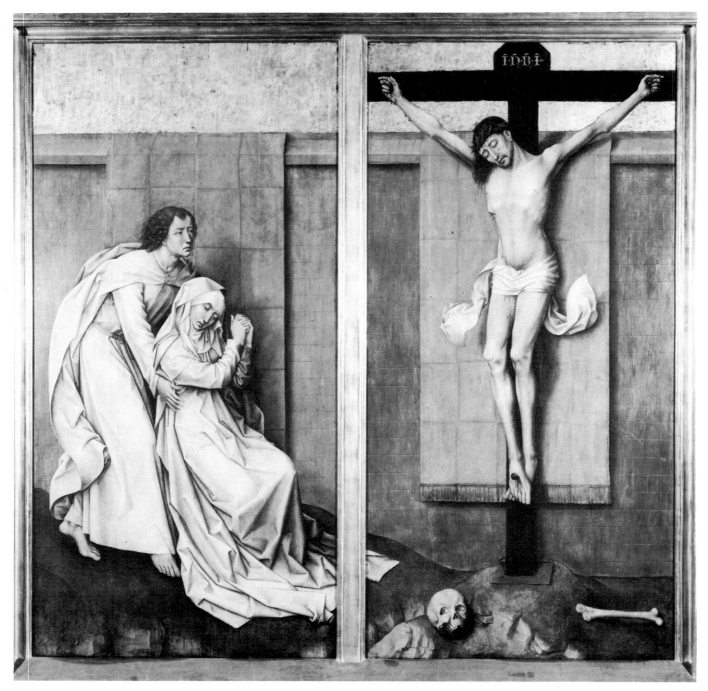

Rogier van der Weyden: *The Virgin and St. John and Christ Crucified*. 15th century. John G. Johnson Collection, Philadelphia Museum of Art, Philadelphia.

as well as literally, in such gospel stories as the feeding of the five thousand, with its allegorical reference to the Kingdom of Heaven. A wall-painting in the Roman catacomb of St. Callistus shows a basket of loaves balanced on a fish's back, a cryptic evocation of the communion.

The Christians also devised their own monogram from the Greek *XP*, Chi-Rho, the first two characters of the word 'Christos'. It makes a striking colophon, incorporating the suggestion of crucifixion and, in some interpretations, of the shepherd's crook. Often it is surrounded by a laurel wreath, inherited from Roman art. The Passion was not, at first, overtly referred to: crucifixion was still an ignoble as well as an intensely cruel death, reserved for base criminals. Not until the sixth century does the Cross begin to assume the potent symbolism of the triumphant Christ.

Under the disciple of the Eastern church, the figure of

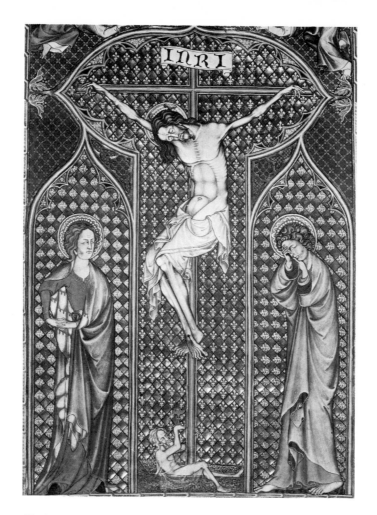

The Crucifixion. From *The Arundel Manuscript.* 12th century. British Library, London.

Christ emerges in a form charged with austere spirituality. This is the image made familiar throughout Christendom by the icon. Gone, now, are the boyish pastor and the sacrificial lamb. All over the empire, barbarians were at the gate. Instead of a shepherd, people felt the need for a holy emperor, a commander and defender. He emerges, a figure of awesome authority, as the Pantocrator, the heavenly potentate who presides over the cathedral of Cefalu, in Sicily.

Christ now becomes the icon incarnate. He sits on a sumptuous throne, confronting us, the multitude, with bearded gravity, the gospels in his left hand, making the sign of the benediction with his right. In that figuration he has survived into modern times, even outliving the images of Renaissance painters, whose humanising touch often seems to come closest of all to miraculous reality.

In the icon we have a sacramental image, part of the apparatus of worship and a portable embodiment of divine authority; perhaps to be carried on missionary campaigns against the heathen, or even into battle, as the emperor Heraclius used it against the Persians. By degrees, the icon became itself a holy object, one that put people directly in touch with divinity. It was justified, by an ecumenical council held in 787, on the grounds that 'the honour paid to the image passes to the original, and he that adores an image adores it in the person depicted therein'. The acceptability of the icon as a holy object, so dangerously close to the image-worship forbidden in the gospels, turned on the doctrine of the incarnation. Christ himself, by appearing in material form as the image of the

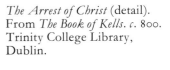

The Harbaville Triptych
(detail). Ivory. 10th century.
Louvre, Paris.

Father, had set the precedent. A man-made image of the Son was, by extension, nothing less than an image of God himself, just as the Bible was a direct revelation of the Word.

In the West these influences are apparent in religious art of the Dark Ages, carried by strange paths and comprehended only as stylised forms. Irish monks working on *The Book of Kells* interpreted the iconic decoration in their own way, in symmetrical Celtic patterns. Design takes over from true conviction. At the court school of Charlemagne, the early Roman style persisted into the last years of the eighth century. A figure of Christ blessing, of about A.D. 781, from an evangelistary commissioned from the scribe Godescale, shows patternwork in the Irish style. The wide-eyed, chubby-faced Christ, long-haired but beardless, is a long way from the Byzantine model. Bibles, as objects of reverence, were given gem-encrusted covers, on which craftsmen monks lavished devoted skills. Precious metals were used for reliquaries, indispensable for the safe keeping of holy remains such as pieces of shroud, splinters from the Cross, and saintly bones. Groups of saints, and figures from gospel stories, were carved in ivory in Charlemagne's court workshops, their small scale released by the free, expressive attitudes of the figures. A new style of writing, Carolingian minuscule, was devised for transcribing sacred texts. In England, book illuminators of genius exported their skills to the Continental monasteries, leading to the formation of important centres at Echternach and Trier.

In everything they touched, from parchment or fabric to ivory and gold, monastic craftsmen celebrated the communion of man and his Saviour. The embellishments of altarpieces, miniatures, chalices, copes, caskets, beakers, brooches, books, were acts of worship sublimated in what we recognise as art.

The face on the cloth

Time and again the will to believe proves strong enough to heal the body or mind, challenging – sometimes changing – the physical and material world. The miracles of the gospel story may be metaphors, but they exist in documented historical context, which remains relevant to daily life today. It was inevitable that Christians, rather than relying on imagination to conjure up the face of Christ, should yearn for tangible evidence of how he looked in the flesh.

The legend of the Veronica Cloth probably springs from this desire. The story goes that Veronica, a young maiden, was at home in her house near the road to Calvary when she heard the approach of a jeering crowd. She hurried to the window, looked out, and saw Christ staggering under the weight of the Cross, surrounded by soldiers and a mob of her own people. In a sudden fervour, she snatched off her veil and burst into the street as the procession was passing her door. She forced her way to the stumbling Christ, and wiped his sweating face with her veil. In gratitude, he told her that his portrait would for ever be imprinted on the cloth.

This anecdote, though nowhere mentioned in the scriptures, has found its way into the Stations of the Cross; and in the Old City of Jerusalem tourists are shown the very spot where the incident took place. References to the cloth, though frequent, are unspecific.

Holy relics, supposedly bearing the imprint of the face of Christ, have been accepted as genuine manifestations since the time of King Abgar of Edessa, in the 1st century A.D. These include The Mandilion, an impression of Christ's human form, and The Veronica Cloth, on which he was reputed to have wiped his face on the procession to Calvary. The Shroud of Turin, which at one time in its history was admitted to be a forgery, has lately been subjected to scientific tests, in an effort to unravel the mystery of its disturbing image.

A Veronica Cloth was once preserved in St. Peter's, Rome. Perhaps there was more than one version; or copies might have been made, to be carried in procession on holy days. There are no reliable reproductions of what were, in any case, inventions or copies based on verbal descriptions of some legendary original. Earlier suggestions of a holy cloth are on record, sometimes overlapping that of the Veronica legend. The earliest is that Christ gave his shroud to a priest's servant shortly after reappearing in the flesh. Another is that the cloth in which the body was laid became the property of Pilate's wife, from whom it passed to St. Luke, who hid it in a safe place. A length of cloth, known as The Holy Shroud of Compiègne, attracted pilgrims to the abbey there for centuries. Yet another was found by Crusaders in Antioch, and brought back to Europe as a holy relic.

None of these has contributed to the search for a

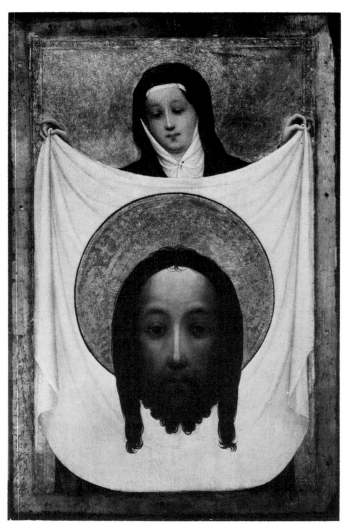

The Master of St. Veronica:
St. Veronica with the Sudarium.
Early 15th century. National
Gallery, London.

likeness of Christ. But some credence is attached to an image on cloth, reaching back to the Eastern beginnings of Christendom, owned by King Abgar of Edessa some time during the first century A.D. – 'the impression of God's assumed human form', as an official account written in 945 describes it, 'depicted without being drawn by the marvellous will of its creator'. From the time of its reappearance in the sixth century it was known as The Mandilion – a word, now obsolete, describing a loose coat or sleeveless cassock. The likeness which, according to tradition, could be seen on the cloth (like the Veronica Cloth, it was said to have been used to dry Christ's face) has a strikingly Byzantine cast: a symmetrical composition showing a grave, bearded visage framed in long hair.

The most celebrated of these hallowed pieces of cloth, The Turin Shroud, has lately re-emerged as the most mysterious of all the supposed relics of the Passion. It is a fourteen-foot length of linen, preserved in the Cathedral of St. John the Baptist in Turin, bearing the ghostly image of a naked man, evidently a victim of crucifixion. The head and body appear to have marked the cloth from both front and back, the shroud having enwrapped the corpse lengthwise in a double fold. The attitude of the body, and the veiled dignity of the face have persuaded generations of the faithful that this is, indeed, a true image of Christ, miraculously imprinted on the shroud at the moment of the Resurrection.

Despite its history as a declared forgery, The Holy Shroud of Turin, as it is known in Italy, has been an object of veneration for six hundred years. It could go back much further, if we are to believe the recent proposition that it is one and the same as The Mandilion, the holy cloth of the Byzantine world, with its provenance reaching back to the first century. But the full impact of the Turin Shroud has been apparent only since 1898, when permission was given for it to be photographed where it hung, above the altar in Turin cathedral. The photograph was taken with great difficulty. But the negative, a glass plate, was a revelation. The pale, shadowy outlines, which had filled earlier generations with awe, now emerged in the likeness of a recognisable man, his body lacerated and bloody, his face swollen with blows. The eyes, which in the shroud seem to be open, were now seen to be closed.

A professor of anatomy at the Sorbonne, who examined the marks on the body, declared them to be medically compatible with Christ's recorded sufferings. He dismissed the possibility that the shroud might be fake, on the grounds that no faker of earlier times would, or could, have produced an image in negative. More recently, tests and analysis have indicated that the flow and seepage of the blood, as revealed in photographic details, are anatomically beyond any layman's capacity to reconstruct. Anatomically, too, the wound in the side is found to be in the place, and delivered with the kind of spear, likely to be known to a Roman soldier trained in the grisly duties of a crucifixion.

Similarly, the victim appears to have been nailed not by the hands, as in representations of the Crucifixion, but through the wrists – a far more probable method. A

study of the small, dumb-bell-like marks on both sides of the body indicates flagellation by a long whip with two pellets tied at the end of each lash: the Roman *flagra*. The victim appears to have been lashed from behind by two such whips, one from each side. One medical view is that the ferocity of this scourging, and signs of severe damage to the victim's knees, as if from heavy falls, could have hastened death in the crucifixion position. Contrary to the Roman custom, the legs were not broken.

In 1903, long before modern science and technology set about unravelling the mystery, the 'verdict of history' had been anticipated by one Herbert Thirston. In a magazine, *The Month*, he wrote: 'As to the identity of the body whose image is seen on the Shroud, no question is possible. The five wounds, the cruel flagellation, the punctures encircling the head, can still be clearly distinguished . . . If this is not the impression of the Christ, it was designed as the counterfeit of that impression. In no other person since the world began could the details be verified.'

To many, the opinions of specialists and scholars are irrelevant. When the Shroud was shown by Italian television in 1973, Pope Paul, in a personal reminiscence of his first sight of it as a young man, spoke of it as something 'so true, so human, so deep, and so divine as we have been unable to admire and revere in any other image'. The force and humanity are recognised by most people; the divinity, perhaps, by less. In such a matter the rational mind is at odds with a deeply-felt wish to believe in the unbelievable. But the 'truth' of the face presented to us by the Turin Shroud raises another aspect: the question of recognition. The face is acceptable because people can believe in it. It is a face which seems to belong to the collective idea of what Jesus looked like; or more particularly, what a man of such transcendent nobility and goodness *ought* to look like.

One of the arguments for taking the Turin Shroud seriously is that the face bears resemblances to certain early representations of Christ. Ian Wilson, whose book on the Shroud summarises recent research in this area, finds a likeness in the *Rex Regum* of Jan van Eyck, after a source datable to the fifth century. The original has not survived, but is known from contemporary copies. It shows the same front-facing aspect as the face on the Shroud, the long hair parted in the middle and falling to the shoulders, a forked beard, a prominent nose, a moustache drooping to join the beard, a hairless gap beneath the lower lip. The Byzantine source would itself have been based on continuous copying of a standardised original. Examples cited include a study of Christ Pantocrator from the catacomb of St. Pontianus, Rome, of the eighth century and, as far back as the sixth century, a mosaic of Christ enthroned, in the Sant' Apollinare Nuovo church, Ravenna. The hypothesis is that, some time in the sixth century, a consistent or authorised version of Christ's features was established, showing him full-face with long hair parted in the middle, a forked beard, a Semitic nose, and deep eyes with large pupils. Believers in the Holy Shroud may be encouraged to feel that it is there, in that inexplicable image, that the 'official' likeness was carried into the world.

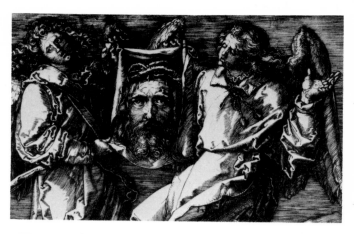

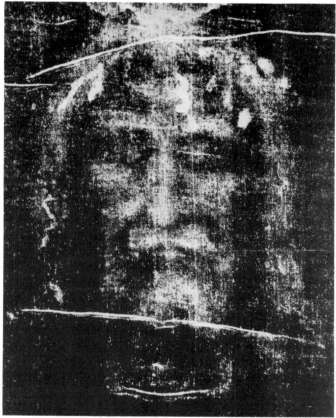

Top
Albrecht Dürer: *Sudarium Displayed by Two Angels* (detail). Engraving. 1513. British Museum, London.

The Turin Shroud (detail). Turin Cathedral, Italy.

The word and the book

As early as the second century, the written word was carrying the Christian message, both in the traditional scroll and in the codex form which is the basis of the modern book. The codex, with its flat sheet, enabled artists to copy the work of mosaic and fresco painters, as well as illustrating favourite stories and dramas from antiquity. The Bible joined Homer as a work of popular literature, with illustrations which anticipated the illuminators' art of the Middle Ages. Ornate gospel books, for use on lecterns in places of worship, depicted episodes from the best-known stories, in styles which combined classical, Syrian and Egyptian conventions with literal illustration. The draughtsmanship, though sometimes clumsy, can also be expressive. In the Gospel Book of Rossano, the scene at the raising of Lazarus shows Christ's companions reacting with appropriate awe and animation as the shrouded figure emerges spookily from the tomb. Christ is seen in the long-haired, bearded version, the head framed in a golden nimbus. He

The spread of illustrated manuscripts, and the illuminated works of monkish scribes, encouraged literate and sometimes highly unconventional images from as far afield as Ireland and Spain.

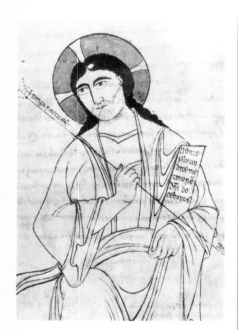

Christ and St. Dunstan (detail). From a medieval drawing. *c*. 950. Bodleian Library, Oxford.

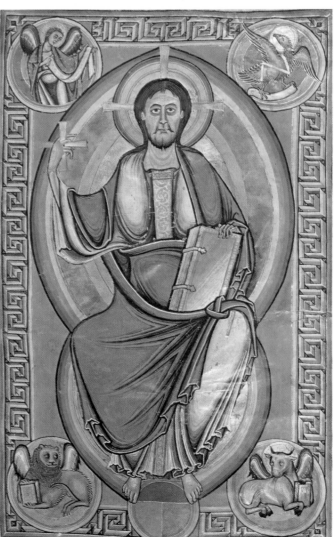

The Majesty of Christ (detail). From *The Stavelot Bible*. British Library, London.

The Raising of Lazarus (detail).
From *The Rossano Gospels*.
Duomo di Rossano, Calabria.

appears again in this form in the trial before Pilate, and as
the personification of the Good Samaritan of Luke's
gospel. An *Ascension* in the Rubbula Gospel Book shows
him, half-smiling and dark-bearded, soaring
heavenwards on the wings of attendant angels. In each of
these gospel book images, Christ, in terms of the
religious drama, is the dominant actor, the Two in One
of canonical law.

Culture and learning flourished anew in the ensuing
centuries, and Christian art with them. Under
Charlemagne's influence scholarship became an
important accomplishment in both church and state. The
courts became centres of literacy, based on a new script,
the Carolingian minuscule, which gradually spread
through the emperor's dominions. Calligraphy grew into
an advanced art form, with illustration in its wake. *The
Godescale Evangelistary* was commissioned by
Charlemagne and executed between A.D. 781 and 783 by a
court scribe. Containing some remarkable figures, it
ranks as a masterpiece of eighth-century art. Perhaps its
best-known sheet is the *Christ Enthroned and Blessing*,
showing a youthful, fresh-faced Saviour whose eyes,
exaggerated in size after the manner of the Ravenna
mosaics, convey a disturbing intensity. The surrounding
space, managed with unusual sophistication, includes
suggestions of a schematised landscape at the figure's feet
and above the head.

The Vivian Bible (otherwise known as the First Bible
of Charles the Bald), some sixty years later in date,
includes a *Christ in Majesty* which carries this mastery a
further step forward by bringing earth, sky and heaven
together in one harmonious composition. The face of
Christ is touched with an expression of worldly concern.

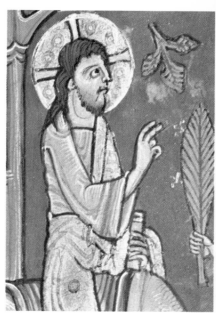

The Entry into Jerusalem
(detail). From *The St. Albans
Psalter* 12th century.
Hildesheim Domschatz.

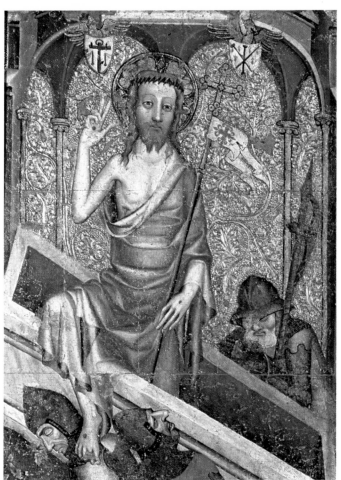

Detail from a retable in
Norwich Cathedral, England.
c. 1380–90.

The Garden of Gethsemane
(detail). From *The Ingeborg
Psalter*. Musée Condé,
Chantilly.

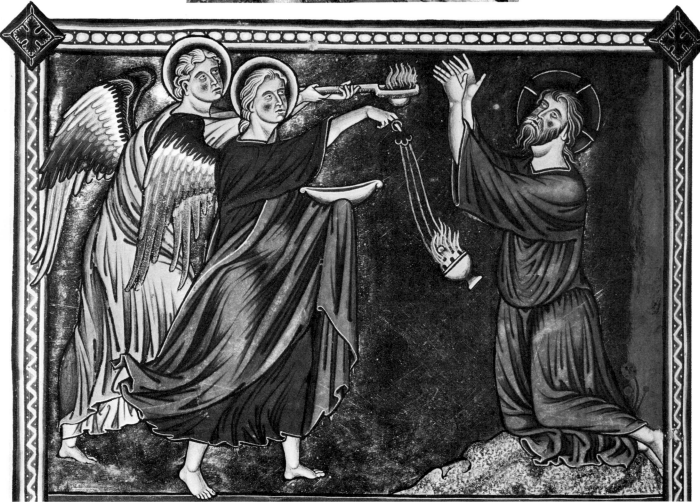

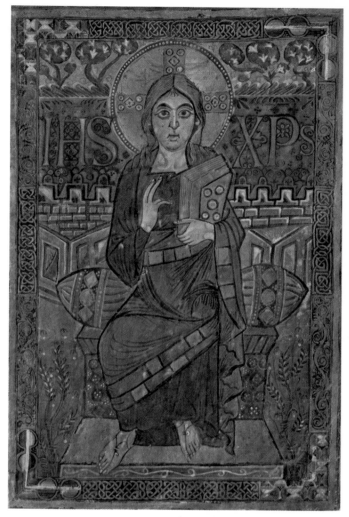

The same expression, though in a very different face, is to
be seen in the *Christ in Majesty* in the Sacramentary
Fragment from Metz. Christ is painted with no obvious
attempt at divinity; the strong, unbearded face is that of a
mortal hero, alive with youthful intelligence. A
Crucifixion on a neighbouring sheet in the same document
makes an equally arresting impact. The cross is
developed into an elaborate design in which the hanging
figure, with its air of triumphant composure, stands for
Christ's victory over death.

The first Christians in northern Europe who can be
accounted artists were the Irish monks. Noted for their
scholarship, they were also skilful copyists of texts and
books. In the late eighth century they began to introduce
decoration into their transcriptions of gospel stories,
using styles which achieve complex decorative effects by
means of abstract and geometric ornamentation. With no
native tradition of drawing the human form, they resorted
to a stylised manner far removed from the post-Hellenic
imagery of the south. The figure of Christ was treated in
this fashion, the deliberately patterned features barely
distinguishable from those of the accompanying saints
and martyrs. That masterpiece of manuscript illumination,
The Book of Kells, includes a monogram of Christ which,
in its densely patterned components, uses tiny heads and
figures with the same decorative ingenuity as the clusters
of flowers and swirling tendrils which help to make up
the design. In a sense, this is an image of Christ: abstract,
exuberant, bursting with imagination. Art of this

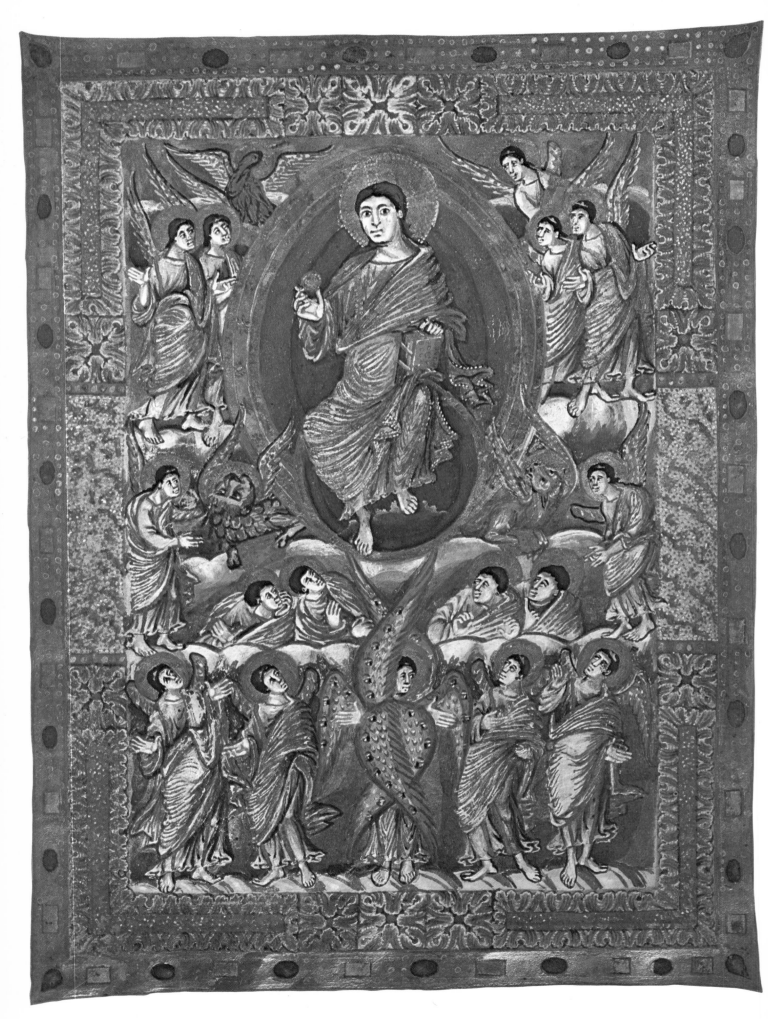

56

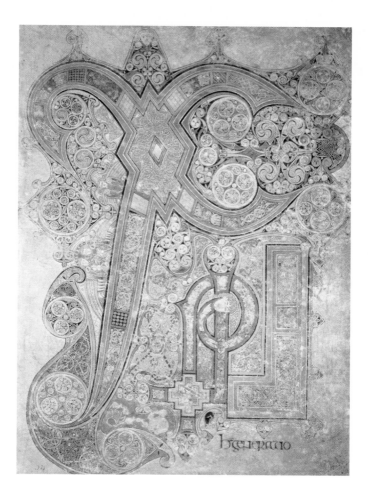

character pointed in a new direction. It was unrelated to
the Mediterranean tradition, independent of the forces
that gave early Christian art its form and direction; and it
marks the beginning of that wristy, linear style which has
remained a characteristic of British art ever since.

The skills of English illustrators of manuscripts became
highly valued from the tenth century into the twelfth,
introducing into a decadent Latin tradition a vivacity that
influenced religious art all over Western Europe. The
'illumination' of manuscripts, so called because of the
colours and golds used to light up the text, was achieved
by the use of flat washes, often overlaid with whites or
with deeper tones to give the effect of modelling. Scenes
from the life of Christ were depicted in narrative rather
than didactic form, with groups and single figures often
breaking out of the decorative convention with startling
effect. A *Christ, Creator of the Stars* from a late twelfth
century bestiary in the Bodleian Library, Oxford, has an
elegant, ascetic quality in the face and figure which is
heightened by vertical strips of pink on the gold
background. Compared with a page from a psalter of the
same date, showing *The Last Supper* and *Christ Washing
St. Peter's feet*, also in the Bodleian, it has an almost
Mannerist sense of style.

At the same time as this burst of English creativity,
German art was moving towards a distinctive style. It
was the age which saw the foundation of cathedrals on a
monumental scale, such as Speyer, Mainz and Bamberg,
along with well-funded monasteries which became centres
of Christian art – bronze sculpture, fresco painting,
craftsmanlike work in gold. There already existed in

Germany a tradition of Carolingian culture, typified by the Mainz ivories, which was inclined to heaviness and severity. An ivory panel, believed to be from Reichenau, Lake Constance, and now in the British Museum, showing Christ at the raising of the widow's son, has about it the strong, stylised gravity associated with German Ottonian art. The Christ is unfamiliar: an elderly presence, more weighty than divine.

This is the obverse, or perhaps the complement, to the more expressionist side of the German genius, as found in the illuminated manuscripts of the Reichenau school. They tell the familiar biblical tales with a fresh verve and attention to narrative detail: tales of Christ's boyhood, the miracles and the Passion, in which a wealth of supplementary action supports the main event. The gestures and attitudes of the figures, active to the point of dislocation, are closer to Asiatic sources than to any nearer home.

More striking still is the early Christian art of Spain, which remained untouched by Carolingian and Byzantine influences alike. Its origins were classical, but it still strikes the eye as startlingly 'modern'. The forces that worked on it were anti-classical, such as those of Coptic art, which gradually travelled through north Africa to Spain in the sixth century, followed by more barbarous fashions making their way south from France. In the eighth century came the great Islamic expansion, which was to have a lasting impact on Spain and its culture; and it is this Arab element that gives early Spanish art such novelty and force. Typically, it is executed in flat, plain colours, one-dimensional in form, heavily patterned and ornamented, the shapes and colours colliding with dizzying effect.

In France, the Carolingian culture began to break up under the stress of barbarian influences. From the wide variety of local and regional energies that were now released there emerged the style subsequently dubbed Romanesque. Masons and carvers drew freely on pagan, Gallic, Islamic, classical and oriental models to create entire bestiaries and fantastic groups of animated figures, as decorations in abbeys and churches. The style took root in such centres as Cluny, Moissac and Provence, to an extent that led some churchmen to fear that its hectic exuberance might be endangering the Church's proper function. 'What are they for, those filthy apes, ferocious lions, monstrous centaurs, half-men, tigers, fighting knights, those multi-headed bodies and multi-bodied heads, animals with serpents' tails and animal-headed fish?' demanded St. Bernard of Clairvaux in a letter to the abbot of Thierry, complaining about the sculptures in the cloister: a man could spend the whole day marvelling at these objects, he said, rather than putting his mind to the law of God.

Such a reaction to what had become, in effect, an art form of the time, was the abbot's protest against changing manners. By then, examples of the kind he objected to existed all over Europe. They stand midway between ancient and modern art, in the same way that feudalism stands midway between ancient and modern society. Decoration for its own sake, imaginative illustration, escape for the mind's eye, was finding its way

Christ Creator of the Stars.
From a 12th century
manuscript. Bodleian Library,
Oxford.

Christ Washing St. Peter's Feet
and *The Last Supper*. From a
12th century manuscript.
Bodleian Library, Oxford.

into churches pierced by brilliant windows, glimmering
with light. Inside, these places were increasingly
resplendent in ornaments, finery, vestments and pictures.
The Church was aspiring towards an earthly Jerusalem,
for ordinary people to enter and enjoy. Meanwhile, all
hell broke loose in the cloister.

Today's visitors do not see the great religious
monuments in this way, but as stripped treasure-houses.
What we have gained in objectivity has been at the cost
of aesthetic response. We come nearer to the view of
Thomas Aquinas, that the beautiful in art is more to do
with completeness, proportion and colour than with
considerations of the ideal. But a modern pilgrim to
Moissac or Souillac may still admire the energy of an art
which strove for the ideal, while inevitably falling short.
On the tympanum at Moissac, Christ presides over his
court like some Eastern mogul, attended by the twenty-
four Elders, all craning their heads to gaze at him, and
supported by Jeremiah and St. Paul in lithe, balletic
attitudes. The very stones are made to dance and swirl,
defying gravity. At Souillac, in the neighbouring
département of Lot, the prophet Isaiah seems to be
twisting out of the stone that encloses him, his crossed
legs and swinging robe expressing the energy and
excitement of a man possessed.

Christ is not often present among these interesting
groups of figures. The sculptors have reserved for him
the premier positions, elevated in the celebration of
heavenly power. He sits enthroned on the tympanum at

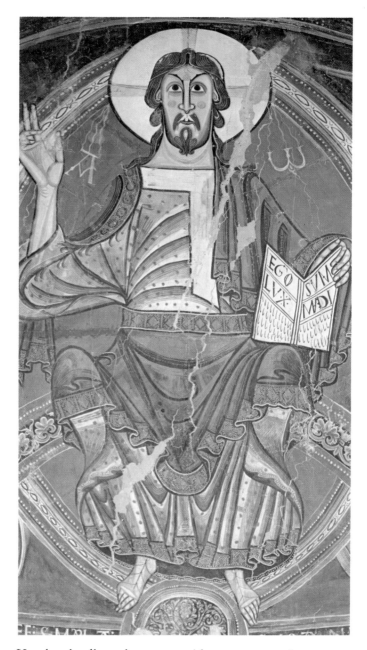

Vezelay, lordly and severe, amid a concourse of worshippers; and as supervisor of the Last Judgement above the door at Autun. A masterly *Deposition* in Parma Cathedral shows him being lifted from a cross which has the shape and form of a tree trunk – as fine a panel as any to be found further north, sculpted by a Lombard craftsman and architect, Benedetto Antelami. At Angoulême he ascends from the west front into a bank of sculpted clouds, eyes lowered, arms outstretched in blessing.

There is no one point at which the Romanesque becomes Gothic. But whereas in the Romanesque it is possible to detach individual examples of artists' work from their surroundings, and to admire them in isolation, the Gothic makes more comprehensive demands. As well as being ornamental it is organic and intellectual. In the Gothic masterpieces of northern France, architecture is faith in action, employing the crafts and skills of men who believed in their work, and who were inspired by the confident grandeur of a Church which felt itself to be in touch with the infinite.

A body 'like unto heaven'

Gothic cathedrals glowed with reds and golds, blues and yellows, the statues resplendent in coloured robes. Sculptured figures were seen rather as characters in a drama, invested with extra-terrestrial power. Herimann of Tournay, writing of the shrine of St. Piat, tells of the figures of the wise and foolish virgins, who seemed to 'weep and be alive', some shedding tears like water, others like blood. Dante has a description of the Virgin with an adoring angel, sculptured 'in a gracious attitude'. The angel 'did not seem to be a silent image: one would have sworn that he was saying *Ave*'. The poet defines the

In the age of the Gothic cathedrals, glowing with many rich colours, Christ took his place in the company of mortal men and women infused with heavenly grace. Sculptured figures were seen as characters in a drama, invested with extraterrestrial power. The face of Christ shows a grave pleasure at being in such company.

The Raising of Lazarus (detail). Relief. Anglo-Saxon *c.* 1000, or Norman *c.* 1130. South aisle of the choir, Chichester Cathedral, England.

Le Beau Dieu. Stone carving. *c.* 1225. Portal of the Saviour, Amiens Cathedral, France.

purpose of sculpture, familiar to any visitor to a medieval place of worship in his time, as 'visible speech'.

At Chartres there are over seven hundred figures among the sculptures on the triple portal. Christ is in the middle tympanum, with symbols of the Evangelists around him, the Apostles below. Around the arch there are the twenty-four Elders. The tympanum of the right-hand door shows the glorification of the Virgin. The arch sculptures represent the seven liberal arts. The Ascension is taking place over the north door, and against the pillars stand twenty-four figures representing, we are told, the ancestors of the Virgin. Traces of colour can still be seen on some of them – faint indications of their splendid past. A visitor to Paris in the time of Charles VIII noted that the west front of Notre-Dame was ornamented with gold and painted in many colours, and that all the sculptures were decorated. The sight can only be imagined. Today, as the visitor looks up at the gauntly beautiful flanks, nothing is left to dazzle the eye, however deeply the magnificent stone imprints itself on the mind.

Architecturally, the Gothic cathedral builders achieved hitherto unimagined effects of space. Piers and columns rise like elegant trees, their branches forming a canopy in the upper air. Solid weights dissolve in tracery, and distances in coloured shade. All this presupposes a Creator with a mathematical brain; so it is natural to come across God in Gothic manuscripts with compasses or dividers in his hand. At Chartres, effigies of saints and other heavenly persons are joined by Aristotle and Pythagoras. The face of Christ, one likes to think, shows a grave pleasure at being in such company. Kenneth Clark, standing below the arch of the central doorway, described these figures as revealing a new stage in the ascent of Western man. 'The refinement, the look of selfless detachment and the spirituality of these heads is something entirely new in art. Beside them the gods and heroes of ancient Greece look arrogant, soulless and even slightly brutal.'

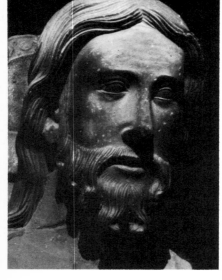

Christ Teaching. Stone carving. *c.* 1200. Centre door, south portal, Chartres Cathedral, France.

Christ Receives His Mother's Soul (detail). 1250–60. South portal, Strasbourg Cathedral, France.

This, after all, was the age in which scholasticism thrived, in which universities were springing up all over Europe, and in which the Christian sensibility nurtured the idea of human love. It was also responsible for a heightened sense of guilt, in response to which artists brought a greater intensity to their images of Christ's sacrifice. Philosophers discoursed on the nature of reality, including the reality of mankind and the reality of the Church. Did God exist? The question was raised even while the cathedral spires were climbing, stone by stone, to the heavens. Here were the great minds of ancient Greece, newly available in translated texts, to challenge men's faith with science and metaphysics. These notions were not necessarily dismissed as heresies, but absorbed into the traditional, though by now intellectualised, canons of the faith. Some aspects of holy writ, which had been difficult to reconcile with orthodox teaching of the Word, were re-examined. Bernard of Clairvaux, the Richelieu of his time, preached a sermon on *The Song of Songs*, in which he accounted for the poem's voluptuous eroticism by likening the king and his beloved to God and the soul. The line, 'Let him kiss me with the kiss of his mouth' became, in this interpretation, analogous with the Holy Spirit: Christ as 'the true lover', as Abélard called him in a letter to Héloïse.

Such an image was not one which could be translated into paint or stone. But if the figure of Christ excited passionate emotions, then a degree of chaste sensuality was permissible in the way an artist depicted it. From medieval times into the Renaissance, the body of Christ becomes an object of worship, its nakedness crying out for love and pity. As the incarnation of the Christian message, poignant and adorable, it is received into the arms of anguished women as a lover as well as a corpse. In Giotto's fresco showing *The Lamentation*, in the Arena Chapel at Padua, the head, unmarked by pain, is cradled by the grieving Mary, who looks into the face with desolate longing.

Worship of Christ's body reached a climax of intensity in the medieval age. The combination of pain and bodily beauty inspired stone-carvers, woodworkers, scribes, and churchmen to transports of love and pity. Francis of Assisi, according to legend, received the stigmata on his own body as he lay on his death-bed, and died with a psalm on his lips.

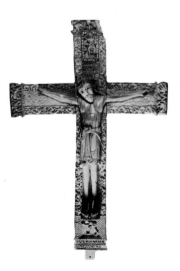

Ivory crucifix. 1063. Spanish. Museo Arqueológico, Madrid.

Perhaps, within the monastic straitness of the Christian faith, with its austere notions of chastity, love of Christ's body also helped to sublimate sexual guilt. Recent writers have seen in the tormented body a sado-masochistic icon which deeply affected the treatment of the nude male figure in Western art. It is true that some artists have dwelt on the humiliation and outrage of the victim's flesh, with a relish that can be disconcerting. Equally, the martyrdom of saints has offered opportunities to show extreme cruelty in proximity with male nudity. But there

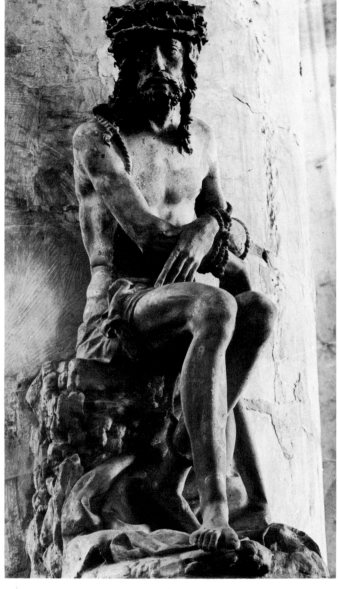

Christ at the Column (detail).
Stone carving. 15th century.
Church of St. Nizier, Troyes.

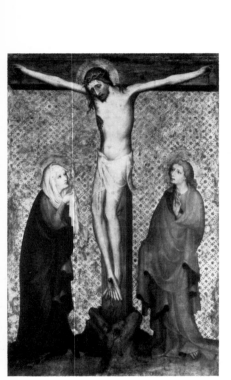

The Pähl Altarpiece. c. 1400.
Bayerisches
Staatsgmaldesammlungen,
Munich.

is another side to the medieval attitude to Christ's suffering. Contemplation of the broken body could induce, in the pure of heart and mind, a condition of lyrical exaltation. This is how an English hermit of the fourteenth century, Richard Rolle, writes of the scourged and bleeding Christ:

'Then was thy body like unto heaven; for as heaven is full of stars, so was thy body full of wounds. But, Lord, thy wounds be better than stars, for stars shine only by night, and thy wounds be full of virtue day and night. All stars by night shine but little, and a single cloud may hide them all; but one of thy wounds, sweet Jesus, was and is enough to do away with the clouds of all sinful men . . . I beseech thee that these wounds be my meditation night and day; for in thy wounds is medicine for each desire of my soul . . . Sweet Jesus, thy body is like a book written all with red ink; so is thy body all written with red wounds.'

Worship of the body of Christ became part of the Christian liturgy when Thomas Aquinas instituted the feast of Corpus Christi. The hymns which he composed for the occasion, and others by Bernard of Clairvaux, are

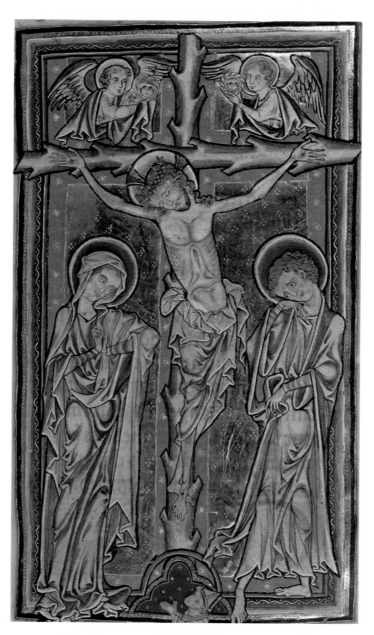

Crucifixion. From *The Evesham Psalter*. Mid 13th century. British Library, London.

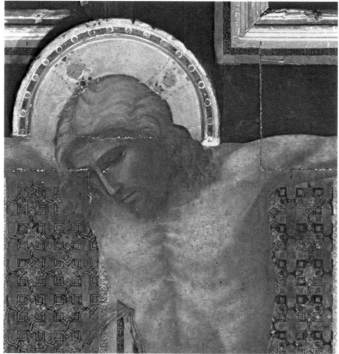

Giotto: *Crucifix* (detail). *c.* 1300. Sta. Maria Novella, Florence.

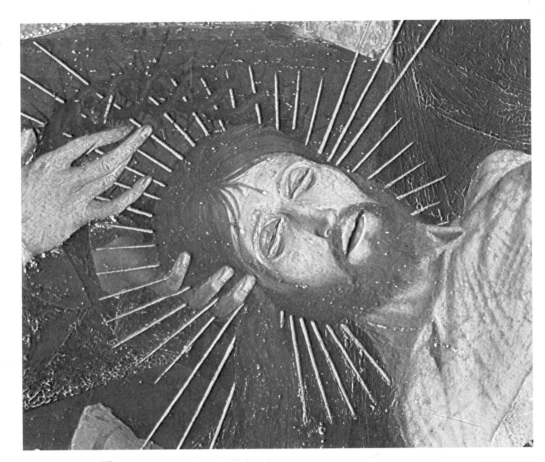

Avignon School: *Pietà*
(detail). From an altar screen.
c. 1460. Louvre, Paris.

Avignon School: *Pietà of
Villeneuve-les-Avignon*. From
an altar screen. *c.* 1460.
Louvre, Paris.

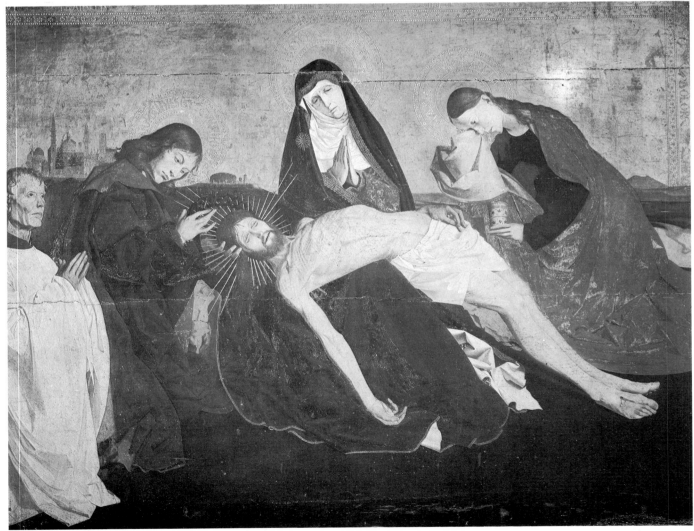

Pontormo: *Descent from the Cross* (detail). Early 16th century. S. Felicita, Florence.

Luis de Morales: *Mater Dolorosa* (detail). Late 16th century. Real Accademia de San Fernando, Madrid.

Donatello: *The Dead Christ
Attended by Angels* (detail).
Marble. *c.* 1430–40. Victoria
and Albert Museum, London.

Rueland Frueauf the Elder:
The Man of Sorrows (detail).
Alte Pinakothek, Munich.

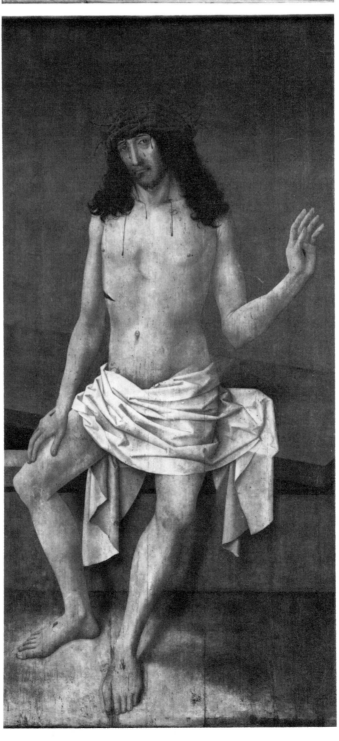

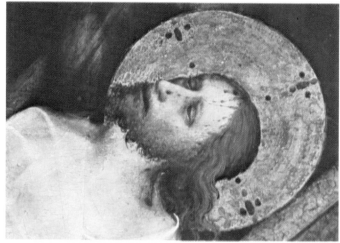

Rogier van der Weyden: *The Entombment* (detail). *c.* 1435. Prado, Madrid.

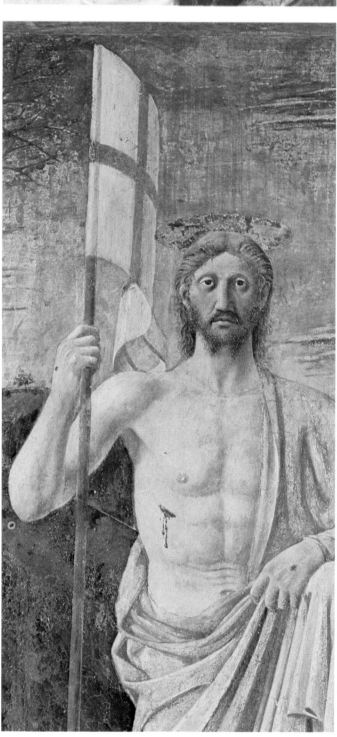

Piero della Francesca: *The Resurrection* (detail). 15th century. San Sepolcro, Italy.

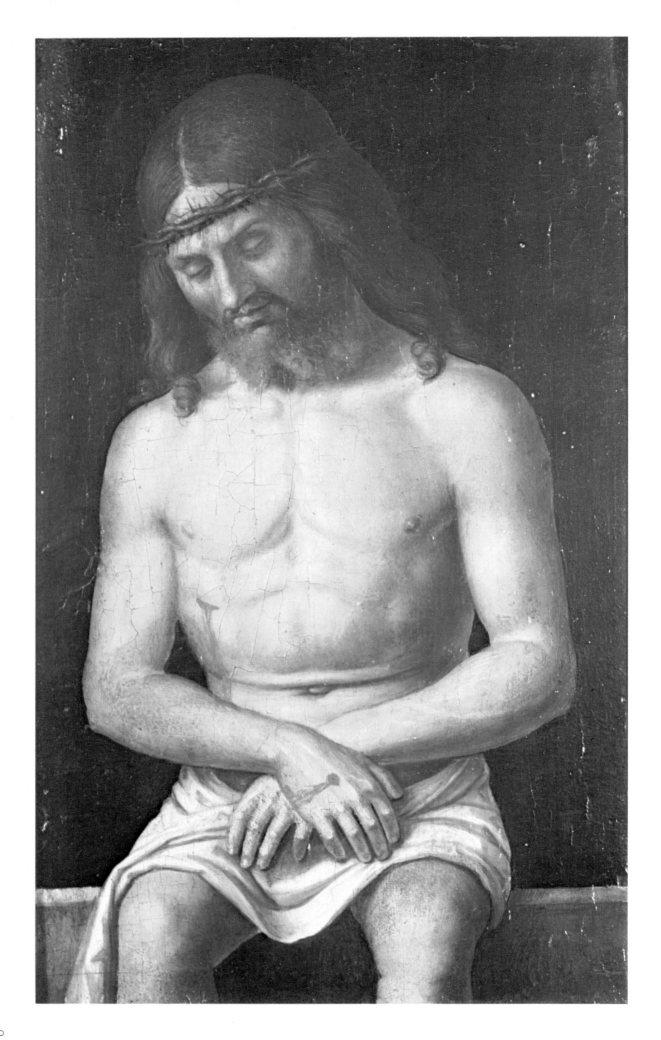

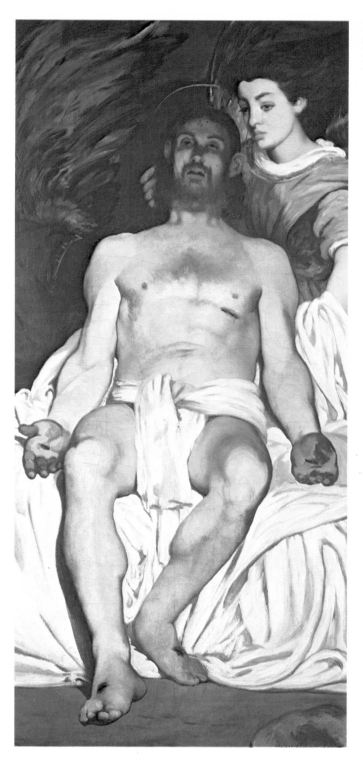

paeans of love, as eloquent as any in the romantic literature of the period. Francis of Assisi wrote the first recorded poem in the Italian language, *The Canticle of the Sun*, expressing 'the thrust and counterthrust of joy in salvation and pain at the thought of Christ's passion', as one commentator describes it. In *The Mirror of Perfection*, an early account of his life, there is a description of how, 'inebriated with the love and compassion of Christ', the saint would begin singing, simulating the motions of a bow across a viol. 'But all this pantomime ended in tears, and his exuberance was dissolved in passion for Christ.' On his death-bed, according to legend, he received the stigmata, the wounds of Christ, on his own body, and died with a psalm on his lips.

Portraits of pain

The image of Christ as a victim is central to medieval art, as it is to medieval religious belief; it extends even to versions of the Nativity depicted in thirteenth century stained glass windows. We are shown none of the picturesque scenes of stable and crib, the animals and worshipping kings. Instead of a cradle there is a dais or

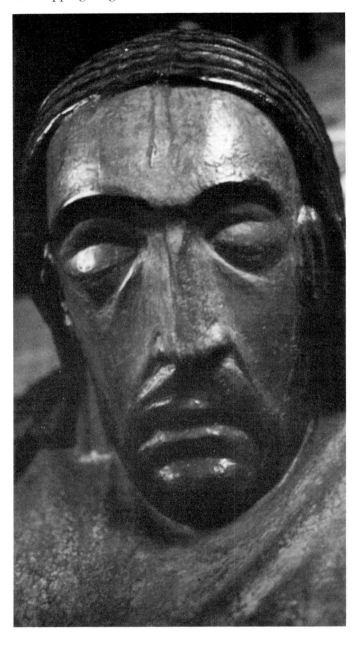

The Gero Crucifix. Wood carving (detail). 10th century. Cologne Cathedral, Germany.

altar, with the baby lying on it as if for sacrifice. According to the scholar Emile Mâle, one French manuscript of the thirteenth century shows us, directly above the baby stretched out on the altar, Christ crucified. The upright of the cross rises out of the altar. 'Human feelings are stilled in the presence of such a mystery, even the feeling of maternal love. Mary, the commentaries tell us, ponders in religious silence the words of the prophets and those of the angel, which have just been accomplished. St. Joseph shares her silence; and husband and wife, eyes fixed before them, seem withdrawn into their own souls . . .' Their private vision is of the end of the story. In the cathedral of Cologne there hangs the life-size wooden figure known as *The*

Gero Crucifix, after the archbishop in whose time it was carved. It shows a man of pitifully human from, destroyed with pain. That pain is felt, as it was meant to be felt, by those for whom the victim died; and by his mother and father, haunted by the future, on the day that he was born.

The face of Christ as shown in medieval images is the bearded, mature likeness made familiar through Byzantine art, a type which was to become the accepted 'portrait'. The attention which the Church had given to Christ's sufferings and sacrifice made him, by a process of identification, more comprehensible to ordinary men and women, who accepted his humanity as readily as earlier generations had assumed his divinity. At a time when an interest in portraiture was spreading across Europe, it was natural that Christ, the most familiar figure in both religion and art, should assume a likeness which enabled him to take his place among the heroes of civilisation.

At this time, too, the first great figure in the history of painting emerges from the anonymity which surrounds nearly all his predecessors. This was Giotto, reputedly a pupil of Cimabue and the earliest master to conceive of the human form as the means of expressing non-corporeal ideas. In him the humane mysticism which made possible the life of St. Francis and the poetry of Dante, found its outlet in painting. Compared with the Byzantine idea of Christ as an iconic figure, a holy

Christ Pantocrator (detail). Miniature mosaic icon. Second half 12th century. Museo Nazionale del Bargello, Florence.

Christ in Glory. Romanesque fresco. 12th century. Berzé la Ville, France.

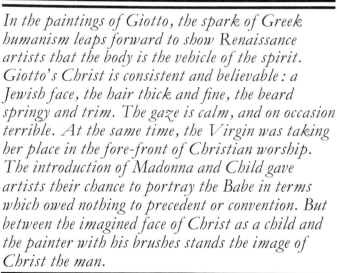

In the paintings of Giotto, the spark of Greek humanism leaps forward to show Renaissance artists that the body is the vehicle of the spirit. Giotto's Christ is consistent and believable: a Jewish face, the hair thick and fine, the beard springy and trim. The gaze is calm, and on occasion terrible. At the same time, the Virgin was taking her place in the fore-front of Christian worship. The introduction of Madonna and Child gave artists their chance to portray the Babe in terms which owed nothing to precedent or convention. But between the imagined face of Christ as a child and the painter with his brushes stands the image of Christ the man.

symbol, Giotto's representations are daringly humanistic, inhabiting the space we live in and breathing the air we breathe. He achieves these effects by simple means: a straightforward choice from alternative conjunctions of light and shade, tone and line, introducing a largeness and breadth which appeal (in a phrase coined by Bernhard Berenson) to the tactile imagination. With no knowledge of anatomy (the study of the nude was unthinkable in medieval times) he nevertheless manages to create human figures in the round, their movements described by a swift, unerring line which animates even his most solemn compositions.

A modern mind, not fuelled with a faith as intense and comprehending as Giotto's, may fail to reach the limits of

Quentin Massys. *Christ : the Virgin*. Left-hand side of the diptych. *c.* 1510. National Gallery, London.

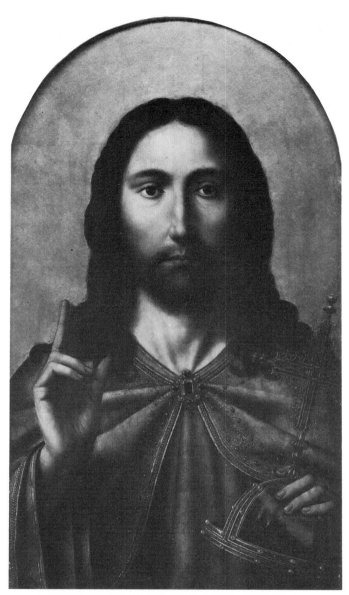

School of Cologne: *Christ as Saviour of the World*. *c.* 1451. Dulwich College Picture Gallery, England.

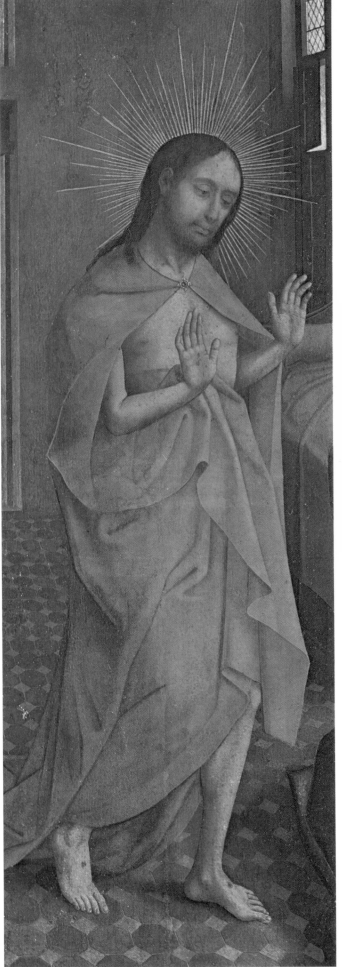

Rogier van der Weyden:
Christ Appearing to the Virgin
(detail). *c.* 1460. National
Gallery, London.

Giotto: *The Kiss of Judas*
(detail). 13th century.
Scrovegni Chapel, Padua.

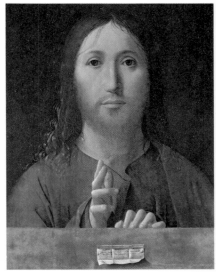

Antonello da Messina:
Salvator Mundi. 1465. National
Gallery, London.

the same experience; but it is from Giotto that the spark of Greek humanism, fired by a more elevating faith, leaps forward to show Renaissance artists that the body is a vehicle of the spirit. His concern is not with the beauty of the body, but with the spirit living and acting through it. This gives his paintings a gravity that has nothing to do with earthly values, except where these have been handed on by Christ: compassionate love, concern for the poor and victimised, the nobility of common life. These are the qualities which made Giotto a supreme story-teller in paint, relating not merely a sequence of actions but spiritual meanings as well. His image of Christ, most commonly in profile to the right, is consistent and believable: a Jewish face, the hair thick and fine, the beard trim and springy, as of a young man. Even when driving the money changers out of the temple in the Padua fresco, the face is not marred by un-Christian emotion. But who would withstand the calm and terrible gaze with which the doomed man stares into the eyes of Judas? It is the same face, in the same profile, as Giotto shows us in his portrayal of the Ascension. Now, though, the eyes are inclined upward, and the lips are parted in the beginnings of a smile.

In some of Giotto's paintings we are given glimpses of the countryside, seen with a child-like directness and simplicity. Christ may sit enthroned beneath the conventional vine; but St. Joachim is shown among an endearingly odd flock of sheep and goats, and St. Francis preaches to the birds under a tree bursting with blossom. His way of looking at the world made an immediate appeal to those around him. 'Giotto alone,' wrote Vasari, first biographer of the early Italian artists, 'in a rude and inept age, when all good methods of art had long been lost, dead and buried in the ruins of war, set out on the path that may be called the true one.' In thirteenth-century terms, the natural world, the creation of the same God as made man, is a symbol of the Word. God's mysteries are revealed all around us, was the message of the divines, if only we have the clues to uncover them. Honorius, of the abbey church of Autun, preached that every creature is the spirit of truth and life, and that the image of Jesus is engraved in all men. To Adam of Saint-Victor, a nut held in the hand represented an image of Christ, its flesh standing for his human form, its shell for the cross, and its kernel for his hidden divinity. 'Artists of the thirteenth century', writes Emile Mâle, 'looked upon the bursting buds and leaves with the tender curiosity which we know only as children and which true artists retain all their lives. The powerful lines of young plants, stretching out, aspiring towards being, impressed them by their concentrated energy. A bursting bud became the fleuron surmounting a pinnacle. Young shoots springing out of the ground became the base of a capital. The capitals of Notre-Dame in Paris are modelled upon young leaves bursting with sap, which seem by the mere force of their vitality to thrust up vaultings and abaci.' Sculptors, too, shared in this celebration of the gift of life, conjuring flowers and herbs, blossoms and bouquets, out of solid stone. 'Thus the Middle Ages, falsely accused of indifference to nature, contemplated with love and wonder the least blade of grass.'

Mother and child

It was also the age in which the Virgin became a prominent figure in the liturgy, a Christian goddess in her own right. There may be more than one reason why this should have occurred at an identifiable time in the history of the Church. The awakening of more tender sexual feelings between men and women, allegorised in poems and stories of courtly love, would seem to be conducive (even the rediscovered Aristotle admitted that conjugal love may sometimes rank with the virtuous friendship felt by one man for another). Equally, a creed which abhorred the sex act might be expected to drive women, no less than men, into a psychotic relationship with the beautiful and ever-virginal Mary. To worship a personification of love, even if one were not encouraged by the Church to love one's own wife or husband in the carnal sense, was surely permissible.

On another plane, the cult of saintly miracle-workers was as strong in the Middle Ages as it had ever been. Intercession by a heavenly mother who, in the way of earthly mothers, did not set herself up as a judge of common frailties, might be forthcoming if the suppliant approached her in the right way. God was an Old Testament avenger, not noted for leniency. The Son had left behind him an enormous weight of guilt and

The St. Vitus Madonna (detail). National Gallery, Prague.

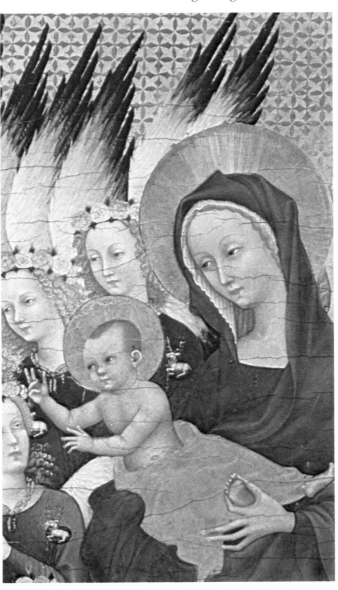

'*The Wilton Diptych*' (detail). French. *c.* 1395. National Gallery, London.

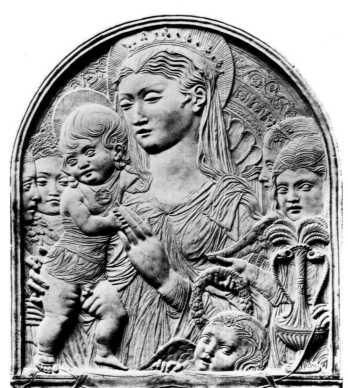

Duccio: *Virgin and Child with Angels* (detail). 1460. Marble. Victoria and Albert Museum, London.

Raphael: *The Alba Madonna* (detail). 1510. Andrew Mellon Collection, National Gallery of Art, Washington.

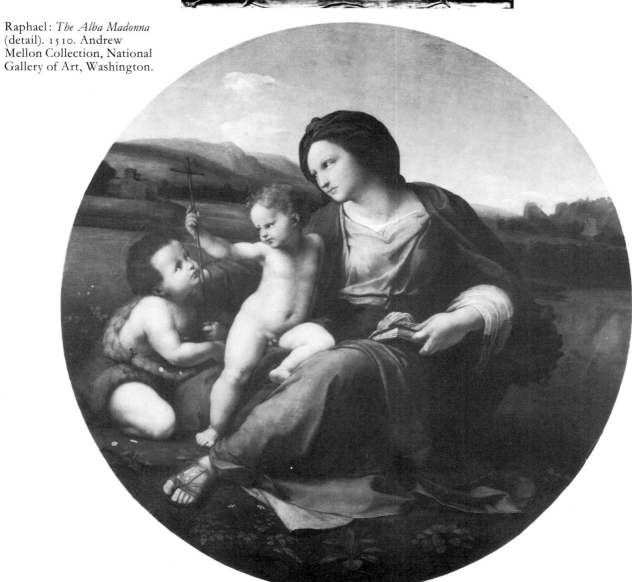

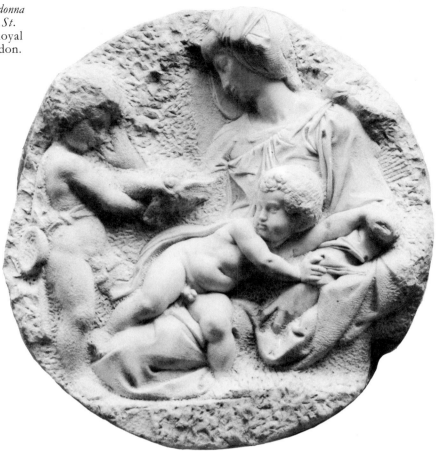

Michelangelo: *The Madonna and Child with the Infant St. John.* Tondo. *c.* 1505. Royal Academy of Arts, London.

Albrecht Dürer: *The Christ Child.* Kunsthalle, Hamburg.

Opposite
Giovanni Bellini: *Madonna and Child. c.* 1488. Burrell Collection, Glasgow Art Gallery.

conscience for mankind to expiate. But Mary, the mother of mankind, lived on in an aura of womanly compassion: she would understand.

Never having been far from the centre of worship, Mary became in the latter years of the Middle Ages a pivotal symbol of the Christian faith. Relics ascribed to her drew pilgrims from all over the Western world. Prayers were written for her, in chastely ornamented Latin. Her image, painted in loving colours, adorned altars and humble walls. Her name was given to some of the finest of Gothic churches, in Paris, Amiens, Laon, Rouen and Rheims. The cathedral of Chartres is in large part a shrine to the Virgin: the most celebrated of her relics, the tunic which, it is said, she wore at the Annunciation, has been enshrined there for eleven hundred years. When the original building was burnt down early in the twelfth century, it seemed that the

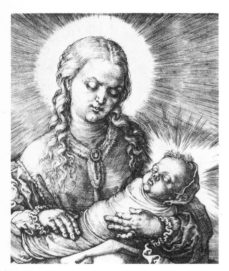

Albrecht Dürer: *Madonna with Swaddled Child* (detail). Etching. 1520. British Museum, London.

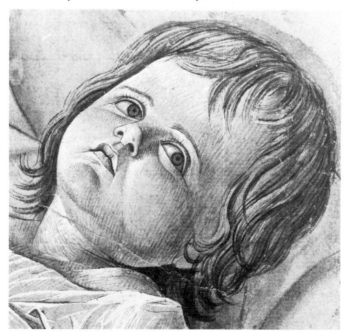

Giovanni Bellini: *The Infant Christ* (detail). 15th century. Ashmolean Museum, Oxford.

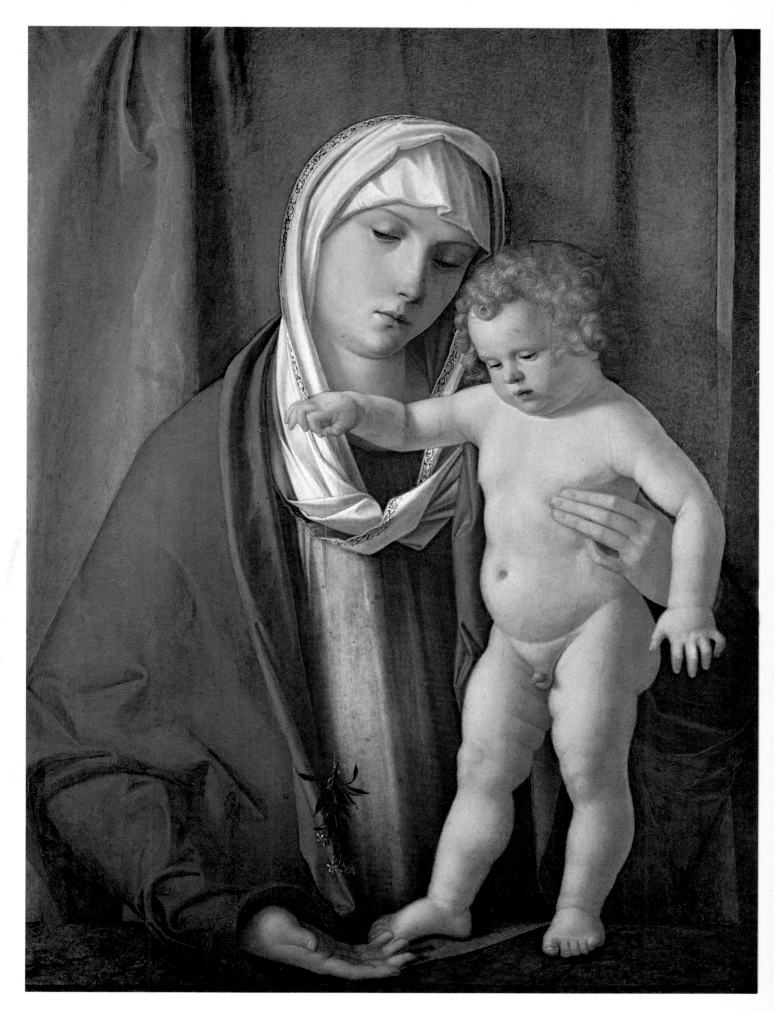

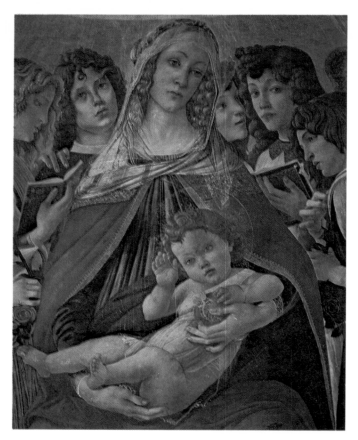

precious object must be lost. Miraculously it was found intact – which was the signal to build an even greater church in her honour on the same site.

When Duccio, in the early years of the fourteenth century, finished his altarpiece for the cathedral at Siena, showing *The Virgin as the Queen of Heaven*, crowds flocked to see it. She is painted on a monumental scale, dwarfing the haloed worshippers grouped around her. To the people of Siena this painting became known as the *Maestà*, or *Majesty*. When the day came for its installation at the cathedral, in June 1311, the whole city turned out to honour it. An account written at the time tells how 'one by one all the most worthy persons approached the painting with lighted candles in their hands. Behind them came the women and children in attitudes of devotion. The crowds accompanied the painting to the cathedral, while the bells rang out the *Floria* in homage to so noble a work.' It remains one of the great monuments to the Virgin, whose power over the medieval mind could equal that of Christ himself.

As to her appearance, painters and carvers have felt free to use their imagination. With no authoritative 'likeness' to follow, they made their own choice from among the work of predecessors, discreetly adding or embellishing as the spirit moved them. The graceful young mother whose baby reaches up to touch her cheek, bringing a smile to her lips, is one of the most widely known of these images. In Giotto's versions Mary has a rather more matronly aspect than one recognises in *The Virgin Enthroned* of his mentor, the great Cimabue. Duccio gives the Virgin a sweeter presence than either, partly by means of a simple change in the position of the hands. Simone Martini, who succeeded Duccio as the most masterly of the Sienese painters, shows the Virgin,

in his *Annunciation* in the Chapel of S. Ansana at Siena, as a lissom Eastern princess in a fabulous Damascene palace. Of these late medieval examples of the Madonna it is Giotto's, perhaps, which makes the most convincing impression: a woman beyond myth and legend, painted with the certainty of truth.

Such glances at the Madonna afford an opportunity to compare ways in which the Child, too, was invested with a spiritual reality. Generally, the infant exhibits adult intelligence rather than juvenile divinity; but the face is painted, in medieval times, with such innocent disregard for anachronism as to banish disbelief. Between the imagined face of Christ as a child and the painter with his brushes stands the image of Christ the man, a creation of other minds. Artists have mastered this difficulty

Carlo Crivelli: *The Virgin and Child* (detail). 15th century. Victoria and Albert Museum, London.

Edward Burne-Jones: *The Star of Bethlehem* (detail). 1888–91. City Museums and Art Gallery, Birmingham.

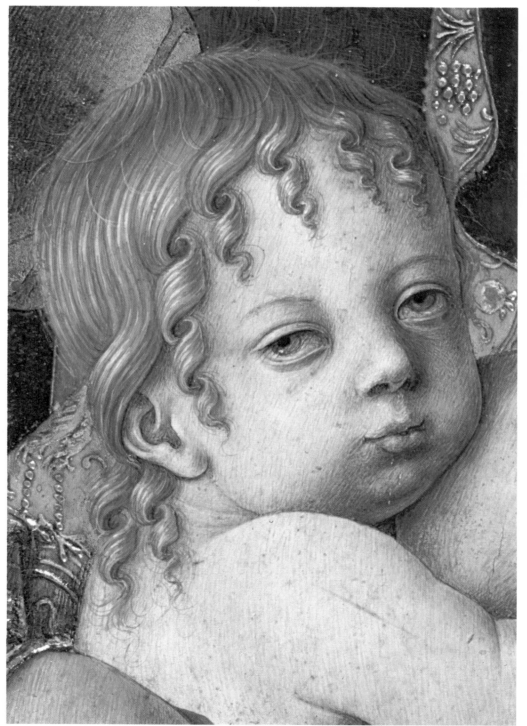

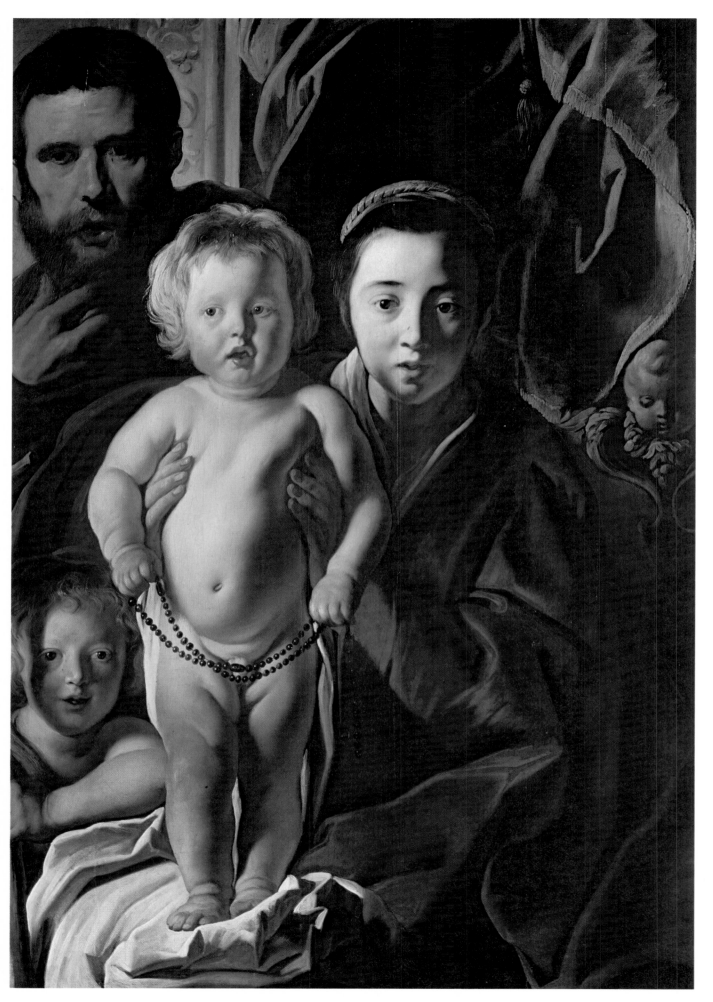

German School: *The Boy Christ Bearing the Emblems of the Passion* (detail). Dulwich College Picture Gallery, England.

Albrecht Dürer: *Christ among the Doctors*. Thyssen Collection, Lugano.

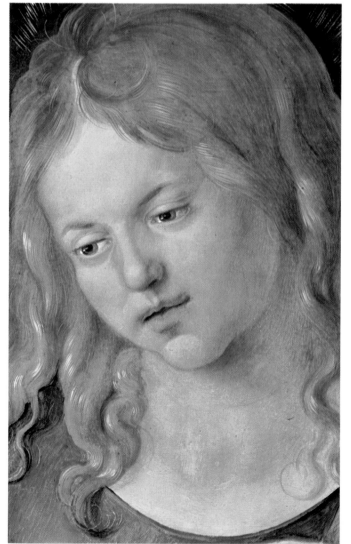

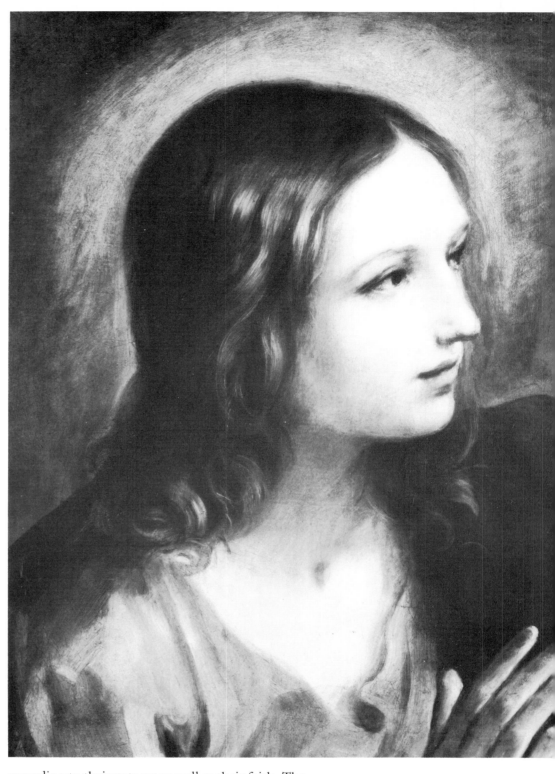

according to their natures as well as their faith. The
chubby, knowing child who looks steadily out of a
painting by Carlo Crivelli, for instance, will grow up into
a different-looking adult from the Christ of, say,
Giovanni Bellini. A marble relief by Duccio in the
Victoria and Albert Museum, London, suggests a subtle
likeness between the features of the child and the mother,
whose fingers the infant holds for support. The chubby
figure, attended by baby angels, conveys a feeling of
spontaneous vitality. Masaccio's noble *Madonna and Child*,
in the National Gallery, London, shows the child
reacting to the sharp taste of the grape which he has just
taken from Mary's hand. Carlo Crivelli, again, paints him

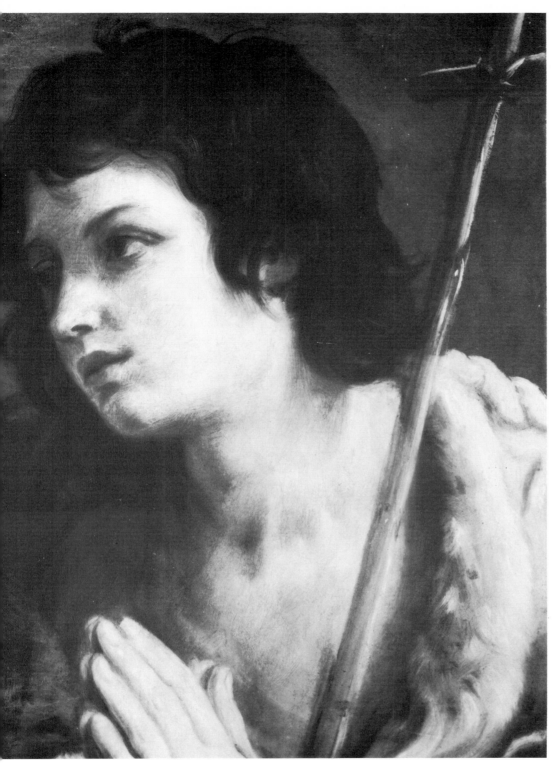

turning his head from the breast where he is feeding, as if interrupted by the spectator. In a *Virgin Adoring the Child* by Pietro Alemanno, in the Pinacoteca, Montefortino, he reclines on his mother's lap, naked, head resting on one elbow, a finger in his mouth, gazing thoughtfully out of the picture. Piero della Francesca, in his *Madonna of Senigallia* at Urbino, gives the child an almost patrician gravity. Neither he nor the Madonna wears a halo.

This diversity of attitude and expressions reflects a lack of any strict convention in depicting Jesus as a baby. Given the formless character of infants' faces, moreover, and the difficulty of using them as live models, some disparity between naturalistic representation and the

Andrea del Verrocchio and
Leonardo da Vinci: *The
Baptism of Christ* (detail).
c. 1470. Uffizi, Florence.

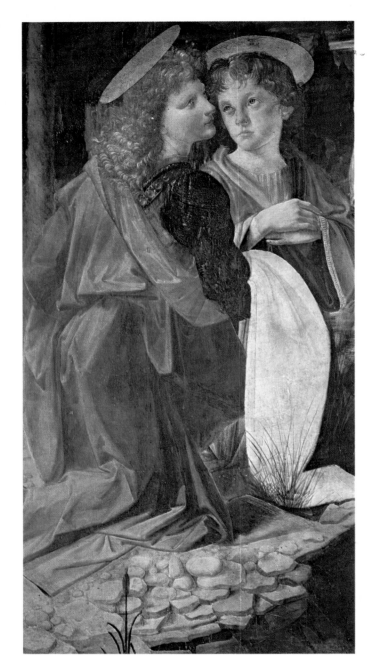

canonical requirement of the subject is to be expected.
The Christ Child is an elusive subject even for the
greatest master: the weight of Church history, and the
accumulated worship of generations, must be a heavy
charge. However, artists' exploration of the mother and
child relationship has been of lasting benefit to Western
culture. The theme has been with us from the Middle
Ages into the era of Picasso and Henry Moore.

The Mother and Child convention serves a different
purpose, and a different human need, from that of the
sacrificial Christ. There is a world of emotional difference
between the image of an infant in the embrace of its
mother, and the spectacle of that same child, come to
manhood, suffering and abandoned on the Cross. In an
increasingly cruel world, in which sickness, punishment
and injustice could fall on simple and innocent people as
if from some vengeful fate, the consolation of Christ's
victory on the Cross, the central event in the Christian
faith, was not always adequate. In northern Europe, as in
parts of the south, the hanging figure became imbued

William Blake: *Christ in the Carpenter's Shop* (detail). Watercolour. *c.* 1800. Walsall Museum and Art Gallery, England.

with a terrible intensity, the body outraged, the face twisted into a mask of pain. Grünewald's *Isenheim Altarpiece* is perhaps the most familiar, as it is also the most horrifying and corporeal, of such versions. Not only the distortion but also the sheer nakedness of the body cries out aloud. Nakedness, for so long proscribed by Christian scruple, assumes an expressionist intensity. There is a limit to the language of the human face, and a point at which the body takes over. The *Pietà of Villeneuve-les-Avignon*, in the Louvre, by an unknown painter of 15th-century Provence, shows the stiffening corpse in a dramatically simple arc. The dead face is stamped with pain. But the bony ribs, seemingly ripped from their cage, are most eloquent still.

John Rogers Herbert: *The Youth of Our Lord* (detail). 1856. Guildhall Art Gallery, London.

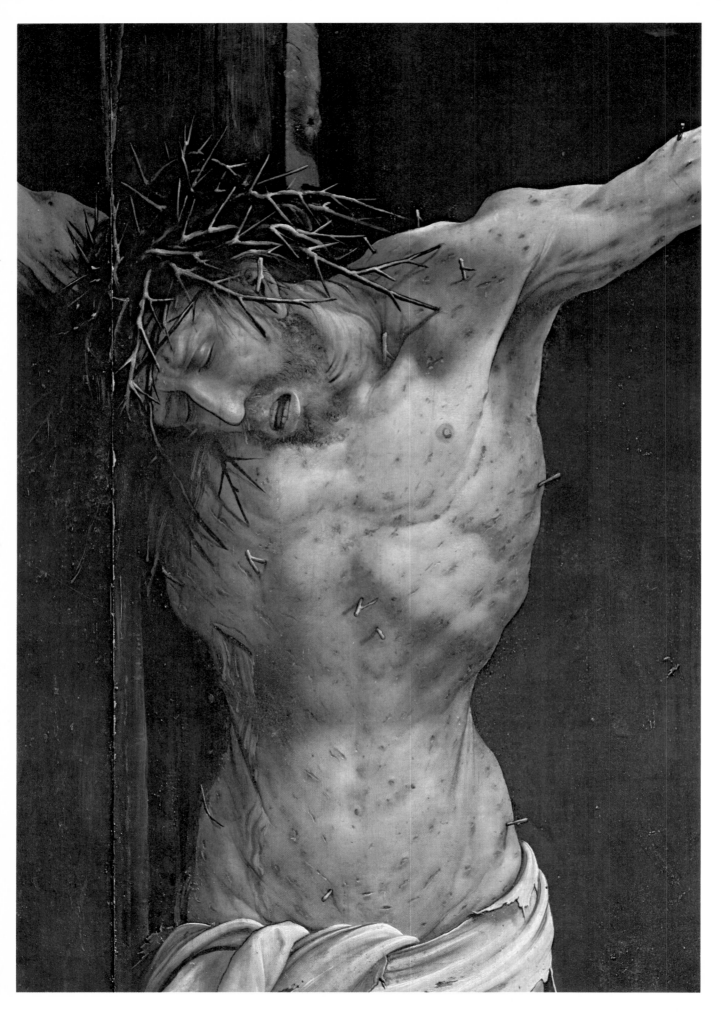

The martyred man

As an instrument of the emotions, whether vicarious or personal, the human body is familiar in art. The earliest Italian artists began to express this subjective idea in their representations of Christ on the Cross, in recognition both of the classical tradition of the heroic nude and also, as it seems, of those stirrings of physical sensibility which accompany our awareness of anthropomorphic beginnings. The crucified Christ, a subject which had earlier stood for a divinely effortless triumph over death, began to assume the weight and presence of living flesh.

In his *Crucifixion* at Arezzo, near Florence, the mysterious Cimabue, whose work stands as a precedent for later and more explicable work by other hands, gives Christ a body which is tense with pain. The straining chest and abdomen are patterned with sinews under stress; the body's sinuous curve contrasts with the rectangular severity of the Cross. The eyes are closed in a private ordeal which the spectator dreads to share.

The impact of Cimabue's image is still more powerful in a similar, and much bigger, version made for the Franciscan church of Santa Croce, in Florence, which is now available to us only in reproductions, having been ruined in the devastating floods of 1966. The crucified body is described with a heightened naturalism; the body, taut with feeling, swings in an arc against the patterned blocks that make up the grimly ornate cross, a gigantic monument in flesh.

In his classic study *The Nude*, Kenneth Clark likens these painted crosses to an ideograph, a powerful symbol to awaken the consciousness of a soul, which turned men

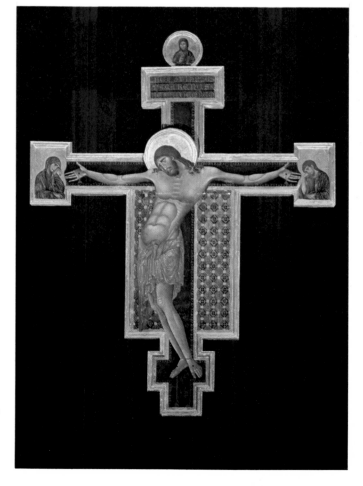

Cimabue: *Crucifixion*. 13th century. S. Domenico, Arezzo.

Opposite
Grünewald: *Christ on the Cross* (detail). Centre panel, *The Isenheim Altarpiece.* 1512–15. Unterlinden Museum, Colmar.

away from mere body worshipping paganism. In versions
of the Crucifixion where Christ is shown hanging
between the two thieves, the grace of his body, even in
the throes of death, contrasts with the distasteful
writhings of the baser victims painted with a less
controlled realism on either side. Like the earliest nudes
of Greece, Christ's body conforms to a canon, as Clark
puts it, and satisfies an inner ideal. A parallel extension of
the artist's vision, not always confined to religious
themes, brings a particular quality to the later medieval
paintings known as 'courtly Gothic'. The Uffizi's
Adoration of the Magi by Gentile, born in the Umbrian
town of Fabriano, is rich in landscape passages, both in
the dominant scene and in the surrounding panels. The
hilly countryside of the Marches, the sloping fields and
gently winding roads, convey a spirit of commonality
with the holy event and the familiar, if idealised, world.
The Nativity, indeed, seems in some danger of being
overwhelmed with such luxuriant detail. Christ, in head
and shoulders, presides over the bursting scene. In
contrast, a near-contemporary of Gentile, Antonio da
Fabriano, treated his *Christ on the Cross*, in the Museo
Piersanti, in an opposite style. Christ is given a strikingly
natural face, the eyes all but closed, the lips just parted.
The work is also distinguished by its accurate anatomy
and by a flourish of decoration on the cloth that is
slipping from the dying man's hips. The decorated loin
cloth is a conspicuous feature of the earlier *The Pisan
Cross*, otherwise known as the *Croce dell' Accademia*, by an
unknown artist working in the late twelfth century. This
monumental piece, of a kind that hung in many a

Tuscan School: *The Pisan
Cross*. Late 12th century.
Uffizi, Florence.

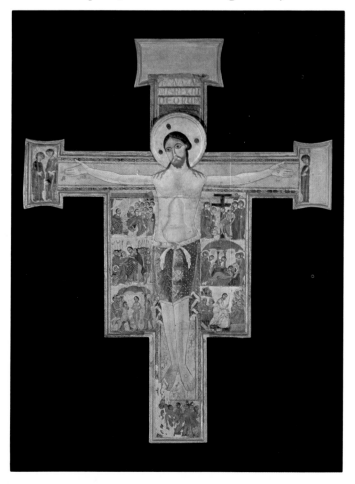

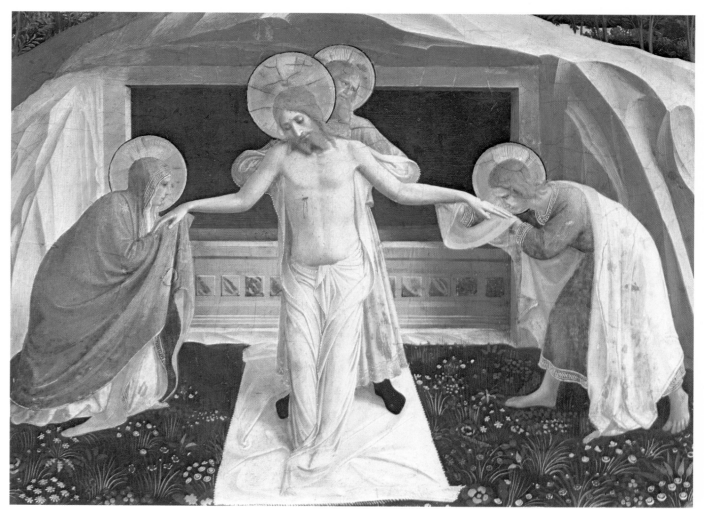

Fra Angelico: *The Lamentation over the Dead Christ* (detail). Early 15th century. Alte Pinakothek, Munich.

Romanesque church (it is now in the Uffizi), is a reminder of the iconic view of Christ which medieval art largely replaced. Antonio da Fabriano, like other painters of his time, turns the holy image into a fellow man.

The courtly style is most marked in the medieval *Books of Hours*, those brightly illustrated manuals, later known (inaccurately) as missals, which people of means commissioned or bought as part of the daily ritual of devotion. A *Book of Hours* would contain a calendar of holy days; sequences from the gospels; prayers; whole sections on Hours of the Virgin, Hours of the Cross, and Hours of the Holy Spirit; penitential psalms; a litany; an office of the dead; and suffrages of the saints, roughly in that order. They were on vellum, the text written by a professional scribe, the illustrations and borders added by skilled artists. As they were not produced under any religious discipline they tend to take an easy-going, almost lyrical view of canonical events. Delightful gardens make an appearance, sometimes populated with wildlife; or there may be hunting scenes, with ducks, boars or stags, not always relevant to the accompanying text, but creating an atmosphere of pleasurable piety. So precious were these ornate little books that they were normally carried and handled in a *chemisette* of silk.

The images, however, are not necessarily all sweet and comfortable. Martyrdoms tend to be shown in lurid detail, and the Passion is no mere fairy-tale. A Crowning With Thorns in a *Book of Hours* from Cologne (Hours of Reynalt von Homoet) shows Christ helplessly bound in

93

his purple robe while three torturers set about their business with oafish grins. A grotesquely twisted jester sits at Christ's feet, making insulting gestures. The face bears an expression of vivid pain. In the borders of the page are painted scenes from the animal world of the strong prevailing over the weak. Pilate looks on, unmoved; his wife has a close-up view from a nearby window. A *Last Judgement* in a French *Book of Hours* (the *Grandes Heures de Roban*) shows Christ, still with the stigmata and crown of thorns, in the role of all-powerful magistrate, a long sword in his right hand, the orb in his left – by no means a reassuring figure. Above, a quartet of angels blow the Last Trumpet with visible relish. Below, pitiful humans clamber out of their graves.

The artist and the man become as one in the person of Fra Angelico, of whom it has been said that in every religious picture he painted he seems to be present as an unseen participant. This gives an immediacy to his work which sets it apart, disarming incredulity by the single-minded purity of his vision: the vision of a Dominican brother who was 'the glory, the mirror, the ornament of painters', as the epitaph inscribed on his tomb described him, 'and a true servant of God'. Angelico's *Lamentation over the Dead Christ*, in the Museo di San Marco, Florence, painted to commemorate a donor who had been visited by visions of Christ's torments, gives the head a noble serenity in death, the face still youthful, with a last tinge of colour on the cheek. A fresco by Angelico at San Marco, *The Virgin and Child Enthroned*, makes the small figure of Jesus dominate a large composition (it includes eight attendant saints) by having him look straight out of the picture. At close quarters, he is seen to be blessed with truly angelic looks, flaxen and expressive, radiating love. It is the same face as that of the crucified man whom Angelico painted in *The Deposition*, also at San Marco, being tenderly lifted from the Cross – perhaps the most beautiful version ever conceived. Some scholars have doubted if Fra Angelico painted the whole picture. No one doubts that only he could have painted the face.

Of the *quattrocento* artists, perhaps only Giovanni Bellini, the Venetian master, strikes such a tremulous chord. His *Pietà*, of which there are versions at the Pinacoteca di Brera, Milan, and in London's National Gallery, shows a Christ whose ordeal is described by the exhausted face rather than by any expressionist treatment of the body. The physique remains unravaged, the more poignant for its muscular grace. The grieving women are victims of a second Passion, known to Catholics as the Passion of Our Lady, an echo of the great climax at Calvary. In some versions the dead man is cradled as if he were a child again. Mary's face, impassive in scenes of the Nativity and in the attitudes of Madonna and Child, at last succumbs. We are told, 'She considers the thorns which have sunk into his head, the spittle and blood which dishonour his face; and she cannot look her fill at this spectacle.'

In the north of Europe, Bellini's contemporary Rogier van der Weyden, whom the Italians admired as an equal, reached new heights of painterly brilliance. His *Crucifixion*, in the Escorial, is a God's-eye view of the symbolic drama, set in a cathedral of universal space. His

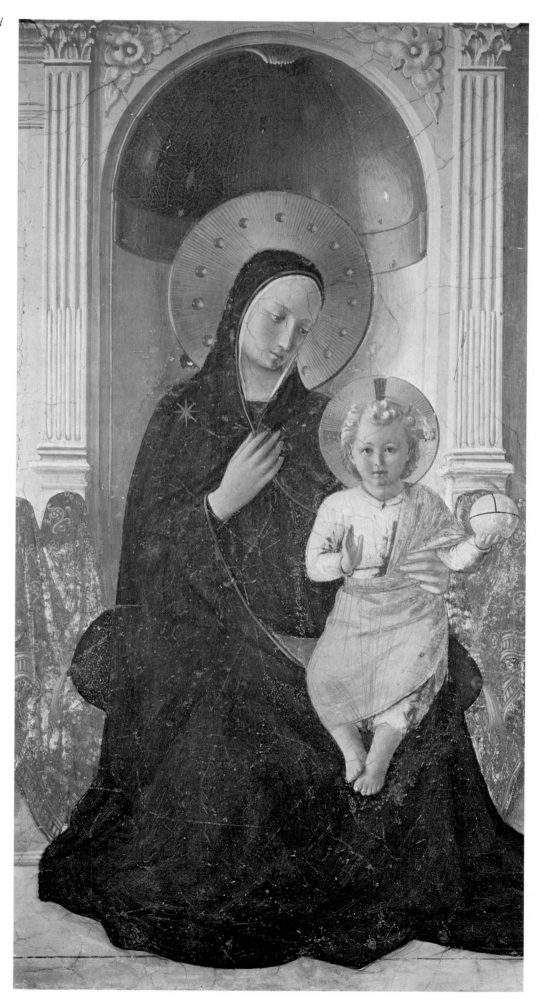

Fra Angelico: *The Virgin and Child Enthroned with Saints* (detail). 1418–29. S. Marco, Florence.

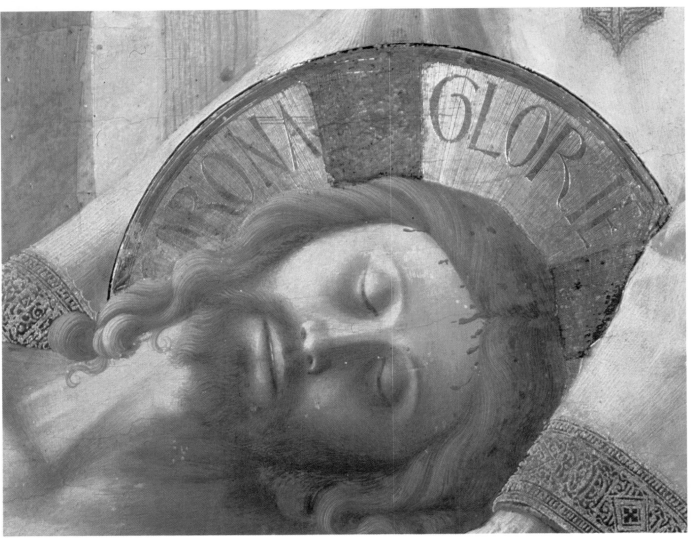

still more celebrated *The Deposition*, in the Prado, brings the event into the world of ordinary men and women. His painting shows Christ's dead body, suspended by loving hands, in an attitude almost identical to that of the Madonna, who is swooning with grief. The two forms seem to float to earth in sympathy, united in a shared ordeal. The composition is bathed in an atmosphere of tender resignation.

Art as a vehicle of such intense emotion is art whose springs lie in the realisation of humanity. The 'humanising' of the Christian belief is therefore the great achievement of medieval religious art. But as the medieval age darkened, stricken by plague and by cruelties perpetrated in the name of God, so the image of Christ began to change. Those serene pictures of the Testament story, familiar to thirteenth century churchgoers, in which horror and tragedy are endured with sublime stoicism, give way to scenes which are the essence of misery. The Lamb of God becomes The Man of Sorrows. The kingliness remains in a handful of masterpieces, such as Piero della Francesca's mysterious *Flagellation* at Urbino; but the divine face at last shows the agony of being mortal.

This figure, especially common in late medieval France, marks the extreme point reached by Western religious art in its progress from its Hellenic origins. In Greek art the debasement of a man in such an image would be rare enough; the debasement of a god would be

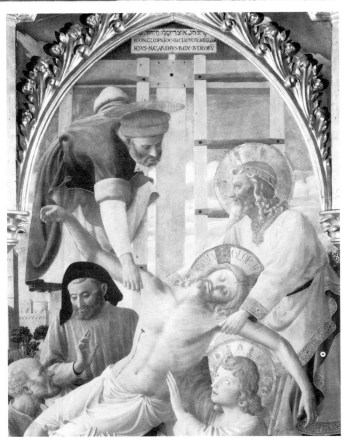

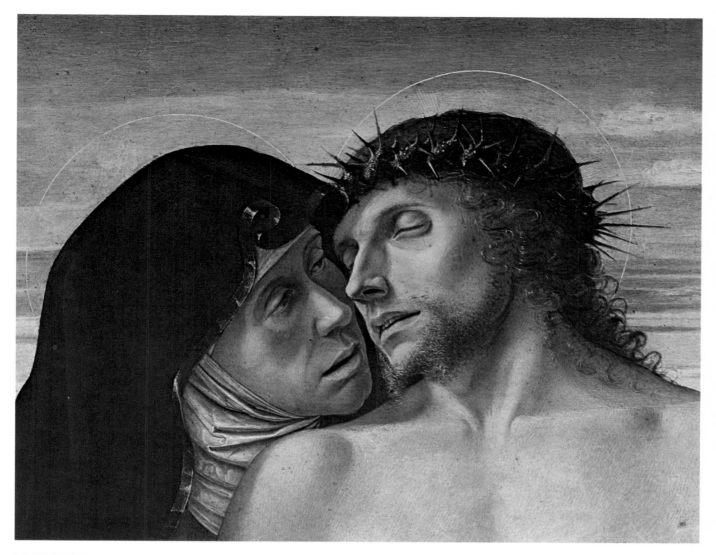

Opposite
Fra Angelico: *The Deposition*.
1424. S. Marco, Florence.

Above.
Giovanni Bellini: *Pietà*
c. 1470. Brera, Milan.

unthinkable. To the Greeks, who held that physical ugliness was ignoble, godlike qualities could only exist in godlike forms, where body and spirit were held in perfect balance. As a concept this belief had made its way into Christian art, enabling artists to express abstract truths in bodily forms. However, the personal sense of sin, for which atonement was necessary, also had to find expression in Christian art. Consequently, the Christ who in earlier times had been shown as the victor over death was made to assume a rather different role. St. Anselm, the Italian-born churchman and philosopher who succeeded Lanfranc as archbishop of Canterbury, preached that forgiveness for mortal sins was Christ's true mission. As in feudal times, sins committed against persons of high rank were more painfully punished than sins against the lowly; so the atonement suffered by Christ, in all its cruelty, represented expiation on an infinite scale. It followed that man's guilt must therefore be infinite. The Passion became the focus of the Christian sacrament, and a dominant theme in the paintings, carvings and church windows which blazed the message to the faithful. Each of the Stations of the Cross demanded its conscience-stricken prayer; the *via dolorosa* became a road for earthly penitents. In heaven, God might remain the beneficent Father. On earth, the sinner looked on the face and wounds of the tortured Christ, and shivered.

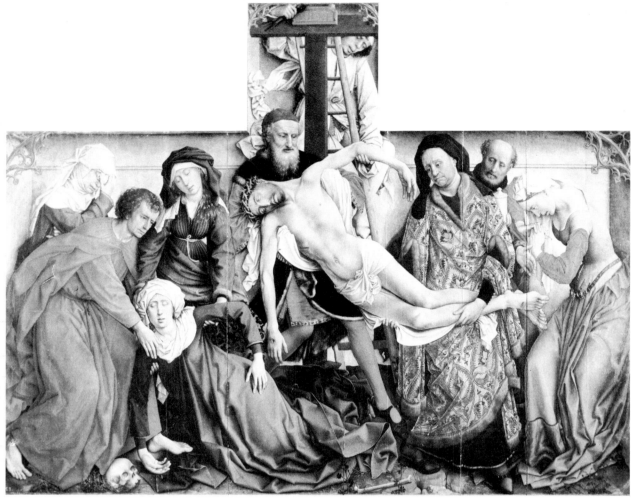

Rogier van der Weyden: *The Deposition. c.* 1432. Prado, Madrid.

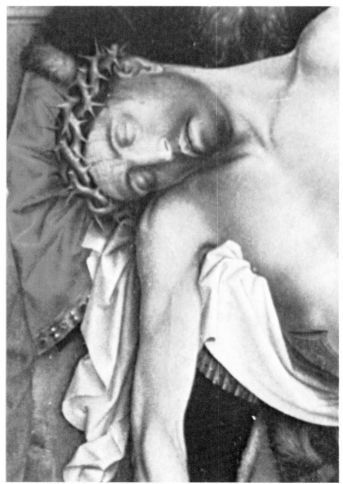

A light in the East

Christianity's progress in the East culminated in the conversion of Russia at about the time that Europe was emerging from the Dark Ages. There is a legend that Prince Vladimir of Kiev, setting out to discover which was the best of all religions, found that Islam was too austere (it prohibited the drinking of wine) and the Jewish faith too isolated (its adherents were all in exile). Reports brought back by Vladimir's emissaries from Byzantium, however, spoke of such beautiful churches and services that 'we knew not whether we were in heaven or earth'. Vladimir married the sister of the Byzantine Emperor Basil II, and Christianity promptly became the religion of his people. Kiev developed into a new centre of Christian art in the Byzantine tradition, with effects that can be seen throughout Russia even to this day.

In their relative isolation, cut off from regular and peaceful contact with the West, the Russians were to become strongly orthodox in the practice of the faith, and in their religious art. The scriptures, translated into appropriately ornate Russian, were taken literally as sources of learning. In art, their own national heroes, such as Alexander Nevsky, are shown in a stiff, stylised convention derived from Byzantine painting, sanctified

The Eastern church imbued the figure of Christ with an austere spirituality, which found its highest expression in the icon. Icons became themselves objects of worship, in apparent contradiction of Christian law. But a man-made image of the Son who had appeared in material form was regarded, by extension, as a permissible image of God himself. Within the iconic convention, the face of Christ was to become fixed for a thousand years.

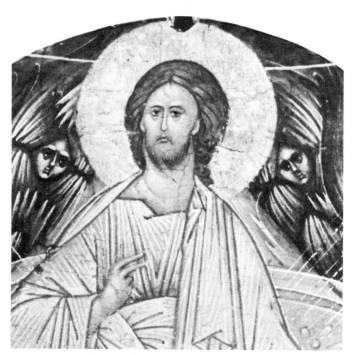

Andrei Rublev: *The Saviour in Glory* (detail). Miniature icon. 10th century. Tret'iakov Gallery, Moscow.

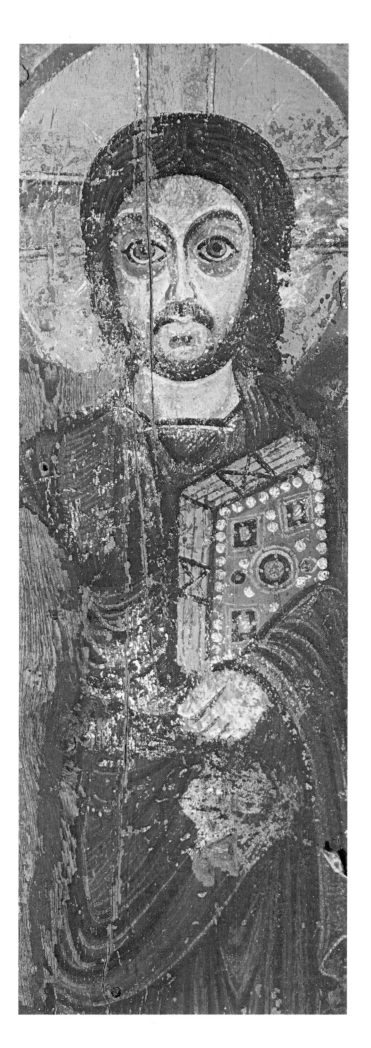

ChristN and St. Menas (detail).
Coptic icon. 6th century.
Louvre, Paris.

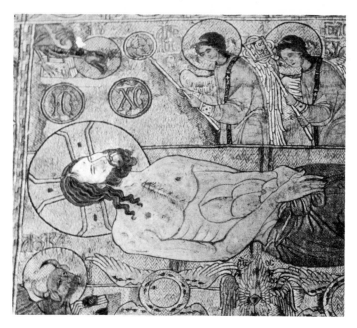

with halos. More even than in medieval Europe, the
Russian Orthodox Church preached the virtues of
suffering in imitation of Christ's example, along with the
ideal of Christian fellowship as the basis of nationhood.
Moscow, vowed the church leaders, would not go the
same way as Rome and Byzantium: by keeping to the
letter of the Word, Moscow would become the 'third
Rome'.

That Byzantine art should have been so readily
adopted by a Slav people, different in culture from those
who originated it, is due both to the Orthodox Church
and to the position occupied in the Middle Ages by
Constantinople, its capital city. Even after its conquest by
the Turks, the old Byzantium continued to exert a
powerful cultural influence which extended beyond the
borders of the former Roman Empire. Its reach and
continuity were both remarkable. *The Virgin of
Vladimir*, an icon painted in Constantinople at the
beginning of the twelfth century and taken to Russia,
became the accepted model for Russian icons for three
hundred years, its origins in all probability forgotten. In
the same way, the typical Byzantine Christ passed,
unmodified, into Russian art as the accepted
iconographic portrait. Commenting on the persistence of
Byzantine styles in the Slavonic context, Jean Lassus, in
his account of early Christian and Byzantine art, remarks
that the angels run with the same movement, their cloaks
falling in the same folds over their tunics, and that facial
expressions remain the same, whether of ascetic old men
with curly beards, Fathers of the Church with high-
domed foreheads, or fine-featured angels with inclined
heads and tight curls: 'It is the same humanity animated
by the same spirituality.'

The continuity of the imaginary portrait of Christ is
equally striking. However many icons one might look at,
the features of Christ seem not to vary. Their cumulative
force is all the more powerful for this uncanny
consistency, to say nothing of the luxuriant nature of the
painting and embellishment. One commonly accepted
image of Christ was enough for generation after
generation of Orthodox worshippers. As Jean Lassus

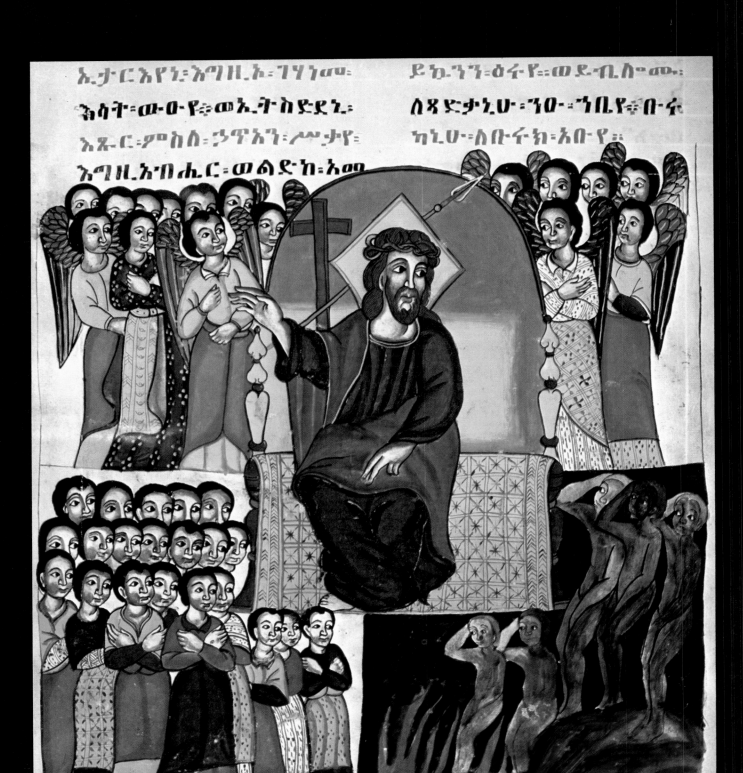

ኢታርእየነ፡እግዚኢ፡ገሃነመ። ይኩን፡ዕሩየ፡ወደብስመ።
ሕስት፡ውዐየ፡ወኢትስድደኒ። ለጻድቃኒሁ፡ነዐ፡ነቢየ፡ቡሩ
እጹር፡ምስለ፡ኃፕእን፡ሠታየ። ክኒሁ፡ለቡራክ፡አቡየ።
እግዚኢብሔር፡ወልድክ፡አመ

*Christ Sitting between Heaven,
the World and Hell.* Ethiopian
Manuscript. 10th century.
British Library, London.

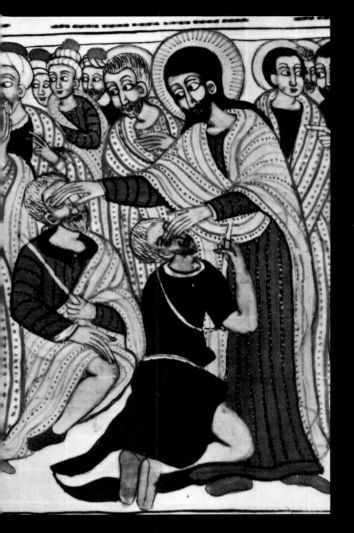

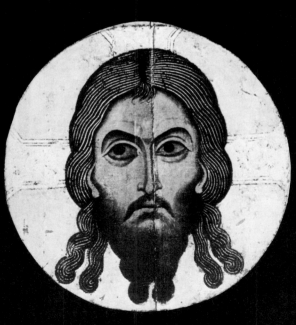

remarks, the perception of Giotto, the grace of Fra Angelico and the dread of Grünewald may have accustomed many in the West to artistic styles that move us more. 'But we will not escape the Byzantine expression without being affected by it. The depth of these eyes, the modesty of these lips, the flight of wings and the brilliance of these celestial lights surely have a spiritual meaning for us. For Byzantine art is a religious art.'

The painted screen known as the *iconostasis* was a feature of Russian Orthodox places of worship, serving the same purpose as the altar rail in the West or the curtain in the Orient, dividing the sanctum from the faithful. However, the *iconostasis* also served as a gloriously painted visual aid to the meaning of the liturgy. With its multitude of figures, scenes and tableaux it informed the congregation of the articles of the Orthodox faith. Painting such a hallowed object was itself an act of devotion, carried out by monks in a state of grace. Working on prepared panels of birch, pine, lime-wood or cypress, mixing their colours with yolk of egg, they followed a procedure as strictly regulated as any other form of Orthodox worship. The powers which, to the faithful, were contained in such awe-inspiring objects, were sometimes put to the test. When Novgorod was besieged in 1198, citizens carried a large icon of the Virgin round the bombarded walls for protection. When the icon was hit by enemy arrows, the Madonna was seen to weep; which provided another subject for the icon painters when the siege was over.

The earliest icons were produced for use in churches and for religious processions; but a demand for more easily portable ones led to the production of smaller versions for use by individuals and in family chapels. The owner might commission a frame studded with precious stones for the icon to stand in, or a hinged metal casing which concealed all but a few key details of the painting, as if its full glory were too much to be borne. Such was Vladimir's haste in building churches fit for the faith, that Russian craftsmen, unskilled in the production of such objects, were put to work under experts imported from Bulgaria. A national school gradually emerged, notably at Novgorod, the style of portraiture notably less austere than in Greek Orthodox art, the faces a more natural oval. A calm serenity imbues the early Russian icon with particular grace. Later, under the influence of more rigorous observances in monasteries and religious houses, the style was to take on a more ascetic quality. The names of two icon painters in medieval Russia stand out as worthy counterparts to the artists of Siena and the Marches: Theophanes, who was originally from Byzantium, and Andrei Rublev, born in Russia in 1370, whose output over a period of some forty years – he ran a workshop, in the Western manner – is one of the achievements of Russian art, honoured even in the atheistic age of the Soviets.

'*The Picture Not Made by Hands*', as it is historically known, derived from the legend of Veronica and makes frequent appearances, sometimes as '*Our Saviour of the Wet Beard*', so called because of the markedly pointed shape given to the beard in these versions. Generally, however, the most popular subject in Russian

103

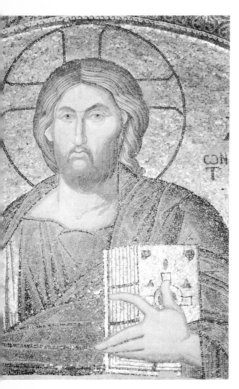

Christ Emmanuel. Mosaic. *c.* 1300. Kahrie Cami, Istanbul.

iconography is the Virgin. Not far behind is St. George, who sometimes assumes a Christ-like appearance. One might conjecture that such a legendary Christian soldier would be an attractive alternative to Christ as the subject of an icon, less constricting to the artist and at the same time endowed with the knightly virtues of the Christian faith. He is no less familiar a figure in the art of the Christian orient, notably Ethiopic. In Russian art his shield sometimes shows the face of the sun, suggesting a pagan reference half-remembered from pre-Christian times. Western versions show him in more traditionally saintly contexts, receiving accolades from heaven. Above all, the symbol of St. George and the dragon is so close to that of Christ as the enemy of the evil spirit – described in The Book of Revelations as 'that great dragon' – that some analogous substitution seems inevitable.

While the Russian Orthodox Church was absorbing much of the old Eastern culture, Byzantine art was enjoying a last revival, notably in the Peloponnese. A cycle of mosaics at the small church of Kahrie Cami, dating from the fourteenth century, shows the life of Christ, and of the Virgin, accompanied by allusions to newly introduced hymns. The interpretation is given a new homeliness – midwives preparing a bath for the new-born Jesus, the Virgin taking her first steps as a toddler, beggars and cripples turning up for one of Jesus's miracles. A representation of the Last Judgement, overhead, shows Christ in his kingly role, surrounded by a heavenly host, designed with a freedom and vitality unprecedented in Byzantine art. In the Peloponnesian citadel of Misra a number of small churches from the thirteenth and fourteenth centuries contain mosaics of equal quality, executed with an almost theatrical eye to effect, the brightly costumed figures striking lively postures on the bustling stage. In one such scene, as described by Jean Lassus, Christ is shown walking through a rocky gorge to the tomb of Lazarus. The Pharisees, hidden up to the knees, look on. Some men have just removed the marble door opening into the cliff face, to show Lazarus rising in his bandages preceded by a friend, who is holding his nose in his scarf.

It is tempting to compare such a scene, painted with a naturalism which we do not associate with Byzantine art, with its contemporary equivalent in Italy: the mosaicist of Misra with the painter Giotto. In both centres of Christian belief, art was showing signs of liberation from old forms. But the true value of the Byzantine culture remains its self-renewing continuity. John Ruskin, in a lecture given over a hundred years ago, paid it a tribute which still stands, venturesome though it must have seemed at the time. It was a school, he said, 'that brought to the art scholars of the thirteenth century laws which had been serviceable to Phidias and symbols which had been beautiful to Homer, and methods and habits of pictorial scholarship which gave a refinement of manner to the work of the simplest craftsman. It became an education to the higher artists which no discipline of literature can now bestow.' At the close of the fourteenth century the Byzantine culture still had much to endure. In the West, the medieval age was already passing into the Renaissance.

The humanist idea

'The evil example of the court of Rome has destroyed all piety and religion in Italy,' wrote Niccolo Machiavelli at the height of the Italian Renaissance. It was a pardonable exaggeration: the papacy by then was one of the most corrupt institutions in Christendom. Successive Holy Fathers embarked on careers no less committed to politics and luxury than to maintaining the outward shows of the faith. Pope Sixtus IV instigated the vendetta that led to the murder of Giuliano de Medici. Alexander VI ordered a portrait of his official mistress to be painted over the door of his bedchamber, clad in the robes of the Virgin Mary. (It was he who sired the dreadful Cesare Borgia, whom the admiring Machiavelli used as the model for the arch despot in *The Prince*.) Julius II liked to don armour and lead his own forces into battle, on one occasion scaling the walls of Bologna. Leo X spent most of his time hunting and gambling, in accordance with his maxim, 'The papacy is ours; let us enjoy it'.

But there are sometimes two sides to the exercise of unbridled wealth and power. It was Sixtus who built the Sistine Chapel. Alexander employed both Raphael and Michelangelo, as did his successor Julius. Pope Leo, a Medici, achieved a reputation as a bibliophile and man of letters, and it was to him that Raphael submitted his famous report on the antiquities of Rome.

Worldliness and self-seeking, in short, were no bar to intellectual and cultural adventures. Even Machiavellian politics, though directly opposed to the precepts of Christianity, could be accommodated within the ambiguous disciplines of the Church, which now found itself drawn into the workings of an infant capitalist system, wheeling and dealing in the markets. Christian beliefs and teachings co-existed, in the changed situation, with a new and aggressive intellectualism. These beliefs still rested on the assurances of the Trinity and of life after death – propositions based on revelation rather than on reasoning, and therefore beyond the reach of sceptically-minded philosophers to disprove. Among the population at large, the faith of the Middle Ages remained inviolate. The Renaissance, as well as being the era of curiosity and creative adventure, was also the age of zealous purism, epitomised by Savonarola. The glittering playthings of the new society, denounced as 'vanities', were burned in piles. In Florence, the people proclaimed Jesus the ruler of their city. In the north, whole populations turned to the fierce austerity of Martin Luther, the miner's son, who denied the pope's right to forgive people their sins.

Amid this excitement and upheaval, Europe was busily re-discovering antiquity. Digging up the past became something of a craze, every statue and relic seeming to reveal forgotten achievements by men of a godless age, yet marvellous – even chastening – to contemplate. They were seen as heroic images of a kind unknown in the modern world. These, and the re-discovery of classical poetry and philosophy, had a profound and disturbing effect. Even the ancients' ideas of morality could be seen as honourable and humane. How could so much have been achieved by people who had not been visited by Christ?

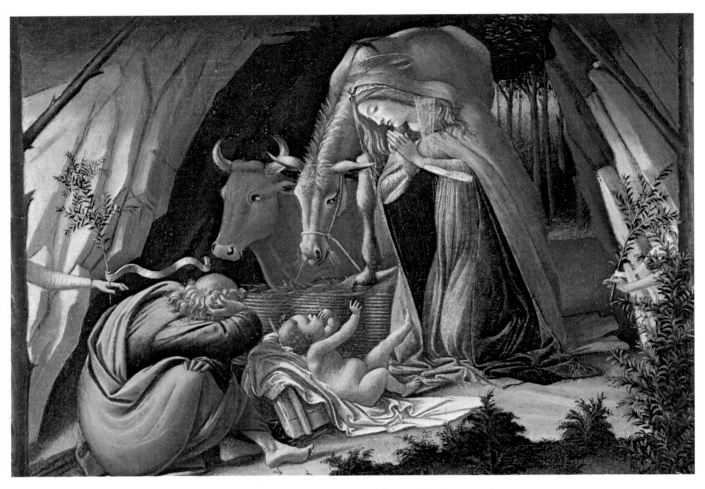

Sandro Botticelli: *Mystic Nativity* (detail). *c.* 1560. National Gallery, London.

God, once again, was conceived as in the image of man. Alongside pictures of the kind which graced the churches, abbeys and cathedrals of Italy there emerged a sort of licensed paganism, a harking back to old myths by means of which painters and sculptors reasserted the function of art as a vehicle of the human spirit. Botticelli is perhaps the most familiar example. The patron who commissioned *The Birth of Venus* released him from painting a picture on a Christian theme. Instead, Botticelli produced one of the most elevating images in Western art, one which combines bodily and spiritual beauty in a context owing nothing to Christian iconography, but a great deal to the pagan past. He made no visible distinction between his Graces, with their air of self-conscious feminity, and the Virgin of his religious paintings. In his *Adoration of the Magi*, in the Uffizi, he includes himself as a disinterested onlooker cloaked from chin to toe, turning his head from the Virgin and Child to confront the spectator with a sceptical stare. Scholars continue to unravel the meanings of his interlocking references and themes; but what puts Botticelli among the immortals is his fusion of the mystical and the realistic, which he achieves by ignoring the rules of his craft when it suits him, setting his instantly acceptable figures in spaces and proportions which exist only in the visionary imagination.

Where, in all this, is the face of Christ? Botticelli, a devotee of Savonarola and all that he stood for, might have asked the same question. He may have intended the great *Nativity*, in the National Gallery, London, as his own comment on the forces that brought Savonarola to

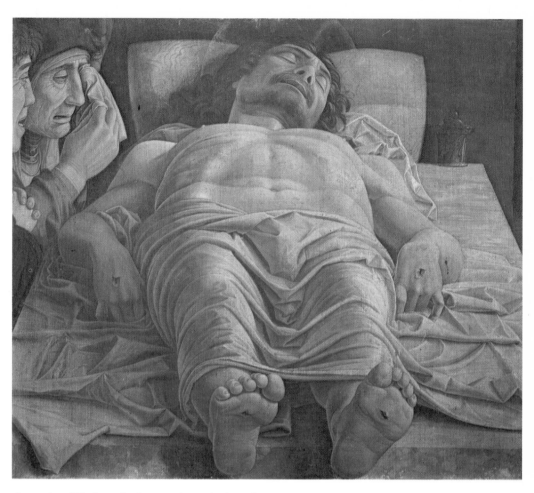

the stake. His inscription to the painting dates it 1500, 'during the fulfilment of the Eleventh Chapter of St. John, in the second woe of the Apocalypse, in the loosing of the devil for three years and a half'. It is a painting vibrant with religious ardour. For the face of Christ you have to look into the lower centre, at the naked baby looking imploringly up at the Madonna, her eyes closed in prayer.

Painters could by now make reputations not simply as interpreters of Christian subjects but as innovators in their own right. No one at the time regarded Mantegna as a 'religious' painter, though he has left a number of works which are charged with the fervour of a believing Christian. Instead, he was noted as the unequalled practitioner of the Antique, the man who, according to Leonardo in 1502, could 'in the twinkling of an eye draw the figures of men and animals of every age and variety, as well as the manners, dress and gestures of all sorts of people, in a way so lifelike that they almost seem to move'. It was Mantegna's skills, allied to his passion for antique art, that made him famous in his lifetime. Documentary attention to detail, and above all a mastery of the third dimension, can give some of his work the novelty of a conjuring trick.

The Dead Christ, in the Brera, Milan, brings the spectator to the very foot of the slab on which the body is laid. The height and weight are conveyed within the foreshortened space which the painter has chosen, and which in reality would correspond to the spectator's immediate field of view. The ingenious use of perspective makes the face of Christ follow the onlooker, whatever

position he may move to. It is a sight such as few could
imagine themselves confronting; it draws the eyes with
its novelty and power.

In scriptural terms, Mantegna's highly individual
tendency to represent biblical themes in a Romanised
manner does tend to detract from their validity. Bernhard
Berenson, the doyen of Renaissance art scholars,
complained that Mantegna forgot that Romans were
creatures of flesh and blood, painting them as if they had
never been anything but marble, processional in gait and
godlike in look and gesture. Mantegna, he admits, is not
to be blamed for romanising Christian art, any more than
Raphael is to blame for hellenising Hebraism: both did
their work so well that the majority of Europeans to this
day still visualise their Bible stories in forms derived from
these two Renaissance masters.

Raphael inclined to the Greek, as well as to the
Roman, ideal to become the 'master artist of the
humanists'. It is the Greek heritage in Western art that
has survived, to remind and reinforce the imaginations of
painters and sculptors into our own age. Raphael,
therefore, marks a high point in art history from which
descend so many of the images, religious and secular,
which later generations seem to have been aware of all
their lives. At the same time his name marks the dividing
line which Millais, Rossetti, Holman Hunt and their
circle saw as the point from which art had relapsed into
rhetoric and gesture, naming their counter-movement
the Pre-Raphaelite Brotherhood.

It seems unfair to blame the pious and blessed Raphael (who might easily have been made a cardinal) for the Grand Manner of his successors, as the Brothers did. Their own offerings appeared, after a time, ineffectual and even a little ridiculous. Holman Hunt, taking literally the edict to 'go to Nature in all singleness of heart', dragged home to his studio a twelve-foot palm tree to help create an Eastern background for his *Christ and the Two Marys*. The Brotherhood's own attempts to create a Christian art closer to the innocence of medieval frescoes than to the passionate grace of a Raphael brought them to a dead end, from which there was no way back.

Nevertheless, it is by no means heretical to look at Raphael with a candid eye, especially at those paintings which make a specifically religious declaration. Refinement and sophistication can come close to nullifying the metaphorical impact of those forms and faces, however ingeniously composed or immaculately laid down. At the end of his short life (he was 37 when he died) Raphael painted *The Transfiguration*, one of the treasures of the Vatican, in which the figure of Christ, falling short of the sublime, depends for its climax on little more than bravura.

A lesser artist, Sebastiano del Piombo, a pupil of Giorgione, was inspired by this same work to paint *The Raising of Lazarus* on a similar grandiose scale. Its fame has not lasted. We admire it for its parts, notably the head of Christ and the figure of the risen corpse; otherwise it strikes us as mere picture-making.

The difficulty lay less, perhaps, in the lack of such qualities in the artist as sincerity or orthodoxy than in

The Renaissance mind rediscovered God in the image of man. Christ assumed the physical qualities of the classical heroes of Parnassus. A release of admiration for pre-Christian achievements lent energy as well as nobility to the art of the time. Though still profoundly Christian, painters and sculptors of Renaissance Italy, France, Holland, Germany, and Spain invested Christ with a new presence: that of a humanly inspired immortal.

trying to bring the excitement inspired by natural beauty, the splendours and graces of the world about us, into the images of the Christian faith. This appears to have proved even more difficult, as an artistic feat, than combining the human and divine in a representation of Jesus. The Renaissance mind, delighted to find Man and Nature infused with their own life-force, rich in organic mysteries, was eager to identify these wonders with the Christian experience; but this was a task beyond the reach of all but the very great. Michelangelo, the range of whose mind and hand seems to us today, as it did in his lifetime, to border on the supernatural, created an image of transcendent beauty in his *Creation of Adam*, on the ceiling of the Sistine Chapel. The Creator and the first

Correggio: *Christ in Glory*. The Devonshire Collection. 16th century. Chatsworth, England.

man are painted in the same scale and in the same image. The mystery of God is suggested in the cloak that flows about him, and Man's vulnerable clay by the nakedness of Adam, who reaches towards the Father with a gesture of almost languid grace. There is no contact, for God is unknowable, but the mind imagines the divine spark that leaps between their outstretched fingers, and is moved by the universal kinship that exists between a father and a son. The painting balances the orthodox Catholic belief in the Creation with the new humanist idea of the essential self-sufficiency of Man. It is an image that gives hope of a lasting relationship between creator and created, between the body and the spirit. Its power, enabling it to move minds, has not diminished in the modern world.

Renaissance art is rich in works which bring nature and the human spirit into a close, harmonious relation, sometimes with an intensity which falls only just short of religious expression. The famous *Tempestà* of Giorgione, in the Accademia, Venice, includes a mother and baby who in other circumstances might stand as a Madonna and Child, except that the mother is virtually naked, her body expressive not of virginal purity but of mortal motherhood. Her face, as she stares from the picture in a private reverie, could well be that of the Virgin in Giorgione's altarpiece at Castelfranco, San Liberale, where she sits serenely enthroned in a landscape, guarded by two saints. In the *Tempestà*, it is the womanliness of the naked mother that haunts the imagination, mysteriously vulnerable amid the atmosphere of menace which pervades the painting.

Giorgione's versions of the female nude are an indication of a new attitude to the human body: in our day the word for it would be 'permissive'. In humanist terms, nakedness denoted innocence; the beauty of the body represented the superiority of the mind, which was close to the pre-Christian beliefs of the Greeks. Renaissance artists applied the same principle to subjects destined for places of worship, or commissioned as acts of piety by wealthy patrons. To the sixteenth-century thinker or artist, there was no conflict between the spirit and the body. Even sexual appetites could be condoned as natural rather than ungodly, releasing that voluptuous pleasure in the flesh, male as well as female, which helps to separate Renaissance art from anything produced in the Middle Ages.

Restored to its classical status, the human form could once again be used for thoughts and declarations on a Promethean scale. Michelangelo's gigantic *David*, in the Accademia, Florence, is in these terms a religious work. Conceived in emulation of the master sculptors of antiquity, it is charged with an almost superhuman energy. The figure's blatant nudity, magnified by its great size (it is seventeen feet high), is awesome: a perfect body at a perfect age, as a modern scholar has described it, stripped for admiration as much as for action, 'the athlete of God and himself godlike'. The subject, a biblical hero, completes the link with the immortals of classical antiquity and the Christian present. Michelangelo's use of the male nude is equally vivid in the *Dying Slave* in the Louvre. It evokes earlier images of the dying Christ,

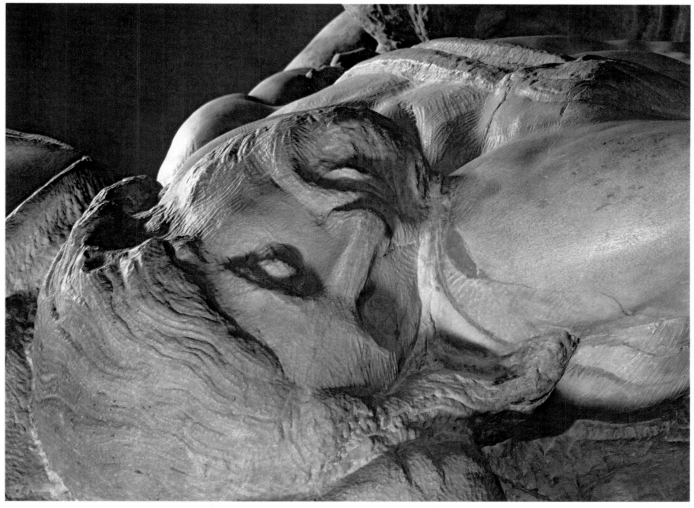

Top
Michelangelo: *Pietà* (detail).
c. 1556. Florence Cathedral.

Above
Michelangelo: *Pietà*.
St. Peter's, Rome.

though none with so languorously beautiful a face. There are other examples of this translation of classicism into Christian art. In the *Holy Family* (Uffizi, Florence), Michelangelo gives the Child a hero's head, the curls springing from the brow as if to receive an athlete's crown. The head of the recumbent Christ who lies in the Virgin's lap in St. Peter's, Rome – the *Pietà* – is irresistibly Greek; so is the elegant, unravaged body. The whole work rises above its agonised Gothic predecessors to a level of pure nobility.

Again, in *The Entombment* at the National Gallery, London, a relatively immature work, the body of Christ, naked except for a supporting band under the armpits, is supported by figures of Homeric vigour, gorgeously clad, including the beloved apostle St. John – an unusual translation for a visionary dreamer. Mary Magdalene, traditionally shown in a grief-stricken huddle at the victim's feet, becomes under Michelangelo's brush a veritable goddess in presence and stature, a dominant figure in the composition. Though Christ's head lolls in death, the face bears a look of repose, almost of satisfaction. Seldom can the sombre subject have been given such blazingly heroic treatment.

Michelangelo's faith – he was a sincere Catholic from his boyhood – enabled him to achieve a synthesis between the demands of orthodox religion and the values revealed from the pre-Christian past. His faith sustained the imaginative effort required of him on being commissioned to repaint the Sistine Chapel: at no point does that

masterpiece flag in its fervour and invention. As time passed, the Crucifixion assumed for him a deepening significance, both as a symbol of unjust retribution and as a terrible reminder of mankind's need for the saving love of God. As he grew older, his thoughts and imaginings turned towards his own salvation after death. His sonnets, written in the unchallenged supremacy of his later years, when in other men's eyes he was the living representation of an immortal spirit, are dark with foreboding. The Cross becomes the focus of an obsessive desire for grace:

> Oh flesh, Oh blood, Oh wood, Oh pain extreme!
> Let all my sins be purified through you
> From whom I came, as did my father too.
> So good you are, your pity is supreme;
> Only your help can save my evil fate:
> So close to death, so far from God my state.

He gave vent to these emotions in a series of drawings which now grace some of the world's greatest collections. One of these, in the British Museum, corresponds to a drawing described by his pupil Vasari, and also by Ascanio Condivi, his biographer, who had conversations with him in his old age. Condivi writes of a drawing of Christ on the Cross, 'not in the semblance of one dead, as is ordinarily the custom, but in a pose of life, his face lifted to the Father. He seems to be saying "Eli, Eli!" . . . The body is seen as if living through bitter suffering, arousing itself and writhing.' The artist's patron, Vittoria Colonna, declared that the drawing 'crucified in my memory any other pictures that I ever saw. One could see no better fashioned, more living or more finished image.' A leading modern authority, Professor Frederick Hartt, of the University of Virginia, states that the living Christ, still suffering on the Cross, had not been painted in Italy since the Italo-Byzantine style of the thirteenth century. 'Giotto's gently hanging Christ, already dead, had been universally followed in Italy . . . The torment of the damned in the Last Judgement, the ultimate pain of alienation from God, is here shown as experienced by Christ himself.'

In the Louvre there is a black chalk drawing, done in the artist's extreme old age, in which the same figure of Christ appears, suffering a shock of unbearable pain. The body is rigid, as if caught in that moment of see-saw torture when the feet momentarily brace the hanging body. The eyes are half-closed, the gaze is withdrawn. Michelangelo's attention to the details of the ordeal – what would actually happen to a man nailed upright to a cross – is to be seen in separate studies of neck and shoulders, groin and abdomen, undergoing the ordeal. Variants of the naked, hanging Christ, drawn at the very limits of remorse, bring Michelangelo closer and closer to the point where the face vanishes and becomes at one with the impassioned lines and hatching which describe the dead, forsaken body.

The appalling realism, bringing the spectator to the very scene of the event, is due largely to Michelangelo's introduction, from medieval Rhenish originals, of the Y-shaped cross. In this attitude there can be no heroics, no chance of prevailing over the tearing of muscles and the

deep, dragging wounds of the flesh. The body hangs as if in an abattoir. Yet the effect is overwhelming, the tragic metaphor elevated to the level of spiritual grace. Physical beauty, in the end, is sacrificed to the soul's departure. In the last of the *Pietàs*, the body has been divested of all its antique nobility. In Florence Cathedral we see it as a collapsed heap of flesh and bone. In the Castello, Milan, it is stripped to a core, barely emerging from the stone. This is Michelangelo's last work, finished six days before he died. The last lines of poetry he ever wrote have the same air of bleak submission, and the same deep pathos.

> Dear to me is sleep; still more being made of stone.
> While pain and guilt still linger here below,
> Blindness and numbness – these please me alone;
> Then do not wake me; keep your voices down.

Heroic dimensions

In Michelangelo the conflict between body and spirit, inhabiting the same earthly frame, became the dominating theme of his most mighty and disturbing works. With his contemporary Leonardo da Vinci, his equal in intellect if not in demonic energy, the Christian belief seems often to be held in abeyance while his inexhaustibly curious mind works out those subtleties of space, movement, composition and control which give his work such a hold on our senses. He did not share Michelangelo's admiration for the antique, nor did he regard the male nude as possessing any intrinsic aesthetic qualities beyond those of a bodily mechanism. On the other hand he was incapable of drawing a coarse or purely mechanical line. Leonardo's Madonnas have a notably un-pretty sweetness which lifts them into the highest company of religious art. He is known not to have regarded the female body as sensual or attractive, any more than did Michelangelo; but his consequent detachment seems to have helped him towards that psychological realisation of feminine beauty which distinguishes such works as the famous *Cartoon for The Madonna and St. Anne*, in London's National Gallery, and his two versions of *The Virgin of the Rocks*. In each of the latter, a chubby child squats at the bottom right-hand corner of the triangular group, acknowledging with a sign of the blessing the adoration of an infant St. John. But it is the women's faces that draw the eye, imbued with a serene intelligence that unites the group as gracefully as a chord of music.

Leonardo's few representations of the face of Christ are not as stylised as those of his holy men and attendant angels. In the workshop of Andrea Verrocchio, his first and only teacher, he was entrusted with the angel who kneels in the bottom left-hand corner of the master's *The Baptism of Christ*. The boyish face is flushed with the heavenly light descending on Christ's head and body from the hovering Dove. Verrocchio gives Christ an interesting 'lived-in' face, and a wiry physique which betrays no obvious classical origin. All his life Leonardo was to prefer the image of the Virgin. But a pastel study survives of the head of Christ as conceived for the *Last Supper*, undertaken for the fathers of the Monastery of Santa Maria delle Grazie, in Milan, which gives an indication of the quality of the original in that famous, but now sadly ruined, masterpiece. Vasari tells how Leonardo made it known that he had two heads still to do: that of Christ, 'which he would not seek for in the world, and which he could not hope that his imagination would be able to conceive of such beauty and celestial grace as was fit for the incarnate divine; and one of Judas.' He anticipated no trouble finding a model for the latter, 'a soul so evil that he was resolved to betray his Lord and the creator of the world.' Perhaps he did rely on his imagination for the likeness of Christ. It emerges as a young and sensitive face, with a melancholy Jewish beauty.

Leonardo's gift for portraiture, though not much exercised, cannot be denied; the *Mona Lisa*, and the *Cecilia Gallerani*, mistress of Lodovico Sforza, are among the most penetrating likenesses of women ever painted. They bear the imprint of a deeply thoughtful mind, that

Leonardo da Vinci: *Cartoon for The Virgin and Child with St. Anne and St. John the Baptist* (detail). National Gallery, London.

intellectual quality in Leonardo which, he said, overcame sensuality. It could be that the comparative lack of interest among painters of his time in the face of Christ was due to the licence to paint real people: with a wealth of human material to portray, a painter might feel less inclined than in earlier times to tackle the demanding – and for most artists disappointing – task of putting the divine face on canvas. It is difficult from the viewpoint of the modern age, when the outward appearance of our fellow men and women tends to fascinate us to the exclusion of their inner qualities, to realise that the appetite for portraiture is a relatively late development in art. Until the Renaissance, only the legendary, the divine and the very greatest of worldlings were considered as fit subjects for portraiture. The new humanism changed all that. Giorgione and his followers painted men and women whose very look, as Bernhard Berenson has expressed it, 'leads one to think of sympathetic friends, people whose features are pleasantly rounded, whose raiment seems soft to touch, and whose surroundings call up the memory of sweet landscapes and refreshing breezes.' From its beginnings in Venice, the art of portraiture spread throughout Italy, then into Europe north of the Alps. It became an alternative art form, as distinctive as the nude or, later, landscape painting.

The Renaissance painters carried in their minds the religious images that had come down to them through medieval times, of saints and martyrs, the Madonna and Child, of Christ the miracle worker and Christ the sacrificial victim. Antique art was able to help them towards a deeper realisation of Christ's person only through the concept of physical, as opposed to moral, excellence. In Michelangelo, bodily and facial beauty approach a classical synthesis in the Christ of his *Last Judgement*, in the Sistine Chapel; but the preconceptions inherited from early Christian art have proved too strong for even Michelangelo's image to replace. Titian comes close to a reanimated Byzantine likeness in his *Christ and the Tribute Money*, at Dresden. The kingly refinement of the face, contrasted with that of his base questioner, is closer to traditional forms: the hair and beard, the fine

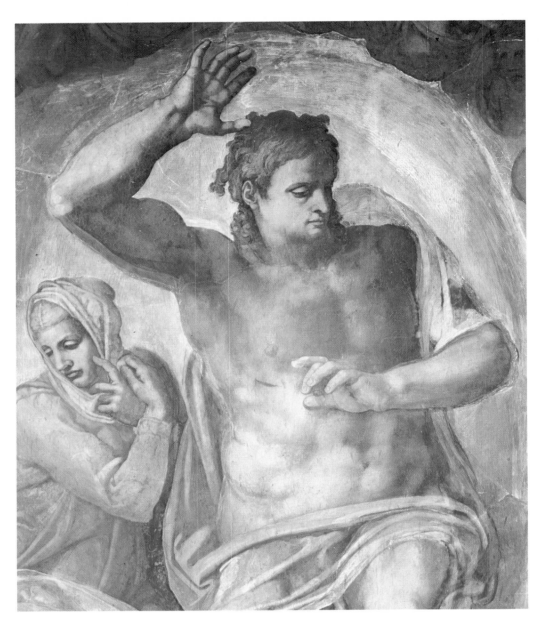

brow, the level gaze, belong to the familiar likeness found in the early mosaics. Understandably, artists have achieved their most convincing likenesses in subjects which show Christ going about his work in the rough glow of human company. Titian was no exception. With his firm grip on reality, and a mordant sense of the vanity of human wishes, he was in many ways the most complete expositor of his own times.

In *Christ Washing the Disciples' Feet*, in the National Gallery, London, by Tintoretto, the powerful colour sense of Titian is matched by a design that would not disgrace Michelangelo. The face, too, has an authority that rests on a long line of precedents. Here is a painter who inherited something of the *terribilità* of Michelangelo, along with the energy to sustain a hugely ambitious commission: the cycle of paintings in the Scuola di S. Rocco, which occupied him for twenty-three years. The climactic scene, *The Ascension*, shows a Christ in glory, conceived with the passion of unwavering faith. Before this apotheosis can be reached, however, there is the ordeal of the Crucifixion. Tintoretto treats it like a reporter, or a television camera roaming the scene with a dispassionate eye.

The painting has a wealth of documentary detail, of a kind not to be found elsewhere in Renaissance art. On the ground, one of the two thieves, taking up his position on the unraised cross, leans on his elbows as his feet are brought into place. His companion, already secured, is being heaved upright by a gang of straining workmen. At the cross on which Christ hangs, the ladder is still leaning. One extra-terrestrial touch illuminates the mundane scene: a crescent of light, shining from the Saviour's body, burns the upper parts of the Cross from view. The spectator finds his own way to this climactic point, isolating the face from the hubbub and the body from the pain. The action has just started; all is yet to come.

A panel in London by Andrea dal Castagno, who inherited much of Masaccio's controlled power, shows the Saviour in almost exactly the same attitude, flanked by the thieves. But the mood and the setting are worlds apart, separated by a hundred years. In Castagno's version the three crosses are alone in a silent landscape, with two standing mourners. It strikes a very different chord from Tintoretto's jam-packed scene of everyday horror. Three hundred years later Eugène Delacroix, at the height of the Romantic revolution, painted a *Christ Crucified between Thieves*, now in the Municipal Museum at Vannes, which seems to pick up the action only minutes after Tintoretto walked away. There are not many paintings that thrust the mind backward and forward from the same point in time. Tintoretto's *Crucifixion* is one of them.

In Germany, there were artists who came close to the spiritual grandeur of the great Italians. Breathing a less heady air than the aura pervading the Renaissance courts, they produced religious works in conventions of another kind. If, in the ferment of religious ideology that was about to rage across Europe, an alternative view of God and his works was to become established, that place was

Titian: *Christ and the Tribute Money*. 1568. Staatliche Kunstsammlungen, Dresden.

Jacopo Tintoretto: *The Ascension* (detail). 1670. S. Rocco, Venice.

Hans Baldung: *The Trinity and Mystic Pietà* (detail). 1512. National Gallery, London.

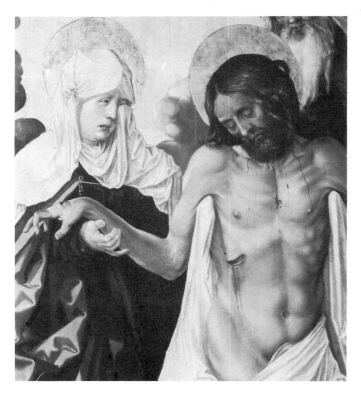

in the north. There the Christian imagination burned with a steadier glow, shielded from southern influences by geography and temperament. Hans Baldung could never have flourished in Venice, or Grünewald under the patronage of popes. Their closest peers are the Van Eycks, whose artistic and technical genius is one of the marvels of art history: it has been justly said of them that they possessed an absolute accuracy of vision which made them independent of teaching. Something of that quality emerges again in the German artists of the sixteenth century. Grünewald's famous interpretation of Christ as an anguished corpse has an almost hallucinatory sharpness. Baldung's *Dead Christ*, in London, combines physical reality with an oriental feeling of mysticism. The face, though it conforms to the conventional likeness, is that of an individual man, complete in his own character and person.

It is Dürer who forms the link between the Italian Renaissance and northern Europe. His first visit to Venice seems to have made little impact on him as an artist; but in 1505 and 1506 he was ready to absorb the Renaissance spirit and allow it to work both on his Gothic inheritance and on the linear art of his woodcuts. The religiosity of Rome was not, in the end, to his intellectual taste. He turned to the teachings of Martin Luther, with their emphasis on the gospels, rather than the Roman pope, as the source of Christian truth. This conversion, which prompted a severe mental crisis in his life, may have inhibited Dürer's treatment of religious subjects in later life. The *Little Passion* and the *Great Passion* stand as his own expressions of faith. The face of Christ, ablaze with heavenly light, bears the deep-grained intelligence of a thinking, as well as a suffering, man.

In the most striking of all Dürer's versions of Christ, an engraving of 1513 showing a Veronica cloth held by two angels, the face that looks out at us with such troubled intensity could be Dürer's own.

118

A fall of angels

One at least of the Italian artists seems to have been aware of a difference between their treatment of religious subjects and those of their counterparts in northern Europe, and of the way people looked at them. Michelangelo, referring to the 'pathetic' quality which distinguishes many such examples, ventured the thought that Flemish painting 'will generally satisfy any devout person, more than will the paintings of Italy, which will never cause him to drop a single tear.' This, he said, was due not to the 'vigour and goodness' of the paintings but to the piety of the beholder. Work of the kind he had in mind would please women, also 'friars and nuns and noble persons who have no ear for true harmony'.

We can forgive the great man this generalisation. He cannot have seen much painting by his contemporaries outside Italy: the traffic was nearly all the other way. But this remark draws attention to the difference in religiosity

Flemish religious painters were more likely to satisfy a devout person, stated Michelangelo, than Italian ones, 'who will never cause him to drop a single tear'. In the north of Europe, the suffering of Christ was to remain the dominant theme, producing images which, to this day, help to separate the northern imagination from that of the south. Rembrandt is the master who bestowed a plain, ordinary humanity on the face and person of Christ, as acceptable in our own times as it was unconventional in his.

Fra Angelico: *Christ Blessing.* 15th century. Reproduced by gracious permission of H.M. Queen Elizabeth II.

Giovanni Bellini: *The Blessing of Christ*. 1450–60. Louvre, Paris.

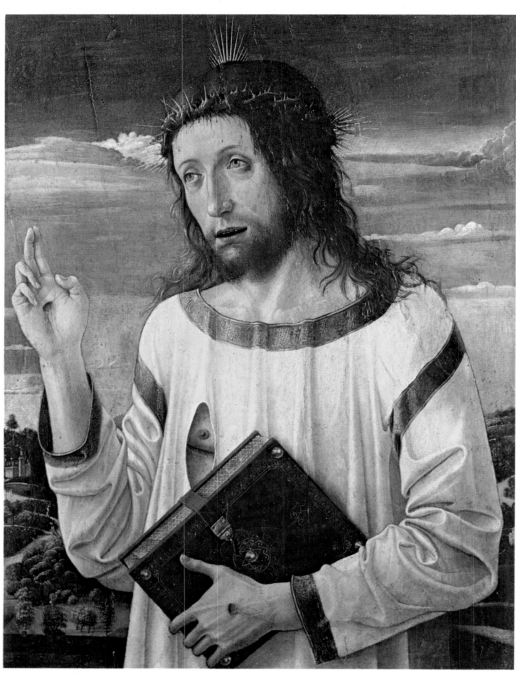

Sandro Botticelli: *Pietà* (detail). *c.* 1490. Alte Pinakothek, Munich.

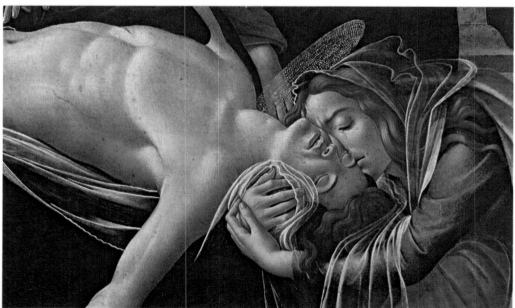

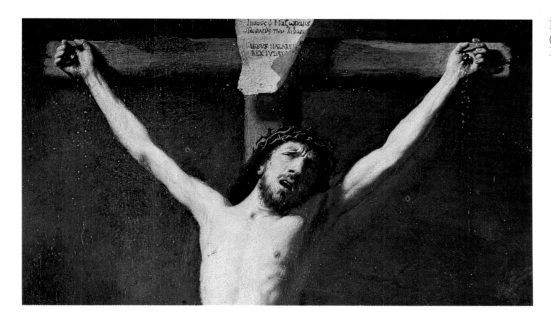

Rembrandt: *Christ on the Cross*
(detail). 1631. Church of Le
Mas d' Agenais, France.

Guido Reni (after): *Head of
Christ Crowned with Thorns.*
National Gallery, London.

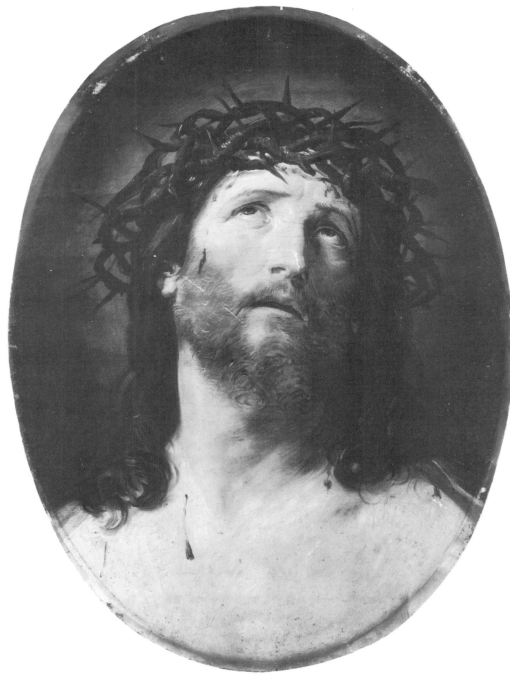

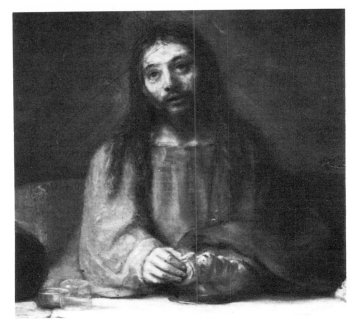

Rembrandt: *The Supper at Emmaus* (detail). *c.* 1629. Louvre, Paris.

Opposite
Hieronymus Bosch: *The Crowning with Thorns. c.* 1510. National Gallery, London.

Sodoma: *Head of Christ Crowned with Thorns.* 16th century. National Gallery, London.

between the Italians, whose artistic tastes had grown more sophisticated, and the northern Europeans, with their fundamentalist approach to Christian worship. Michelangelo's reference to people who 'have no ear for true harmony' is an indication of how far connoisseur ship had advanced in the High Renaissance. It implies a distinction which separates the achievements of the Italian artists from all others in Europe.

The suffering of Christ remained the dominant theme in the north. In the south, considerations of classical harmony, and aesthetic values nurtured by the liberation of the mind and imagination, brought with them a wider range of values. In the north, the extravagances of the papal courts were regarded with suspicion or disapproval. In the south, they were responsible for patronage on a princely scale, and for images which challenged the orthodox canons of devotional art.

The stated view of Vasari was typical of his time: perfection in painting, he said, could be defined as richness of invention, familiarity with anatomy, and skill that makes the difficult look easy. These, however, were not the kind of attributes to commend themselves to leaders of the Counter-Reformation, notably the Jesuits, who maintained that the function of art remained the same as ever – to illustrate the teachings of the gospels and bring people to the true faith. Under these pressures a form of censorship was set up, to bring art within the conventional disciplines of the church. A school was founded for the training of Catholic painters, called the Academy of St. Luke, complete with a rigid set of rules; and figleaves were applied to some of Michelangelo's figures in the Sistine Chapel.

The graduates of the Academy of St. Luke are now forgotten. But the mystical intensity of the Jesuit ideal found expression in El Greco, in paintings which dramatically re-animate the Byzantine tradition of his native Crete. El Greco combined zealous faith with a burning emotionalism which puts him among the most distinctive painters of his own or any other age. His representations of Christ, based on the Byzantine prototype, imbue him with a soulful nobility. He inhabits

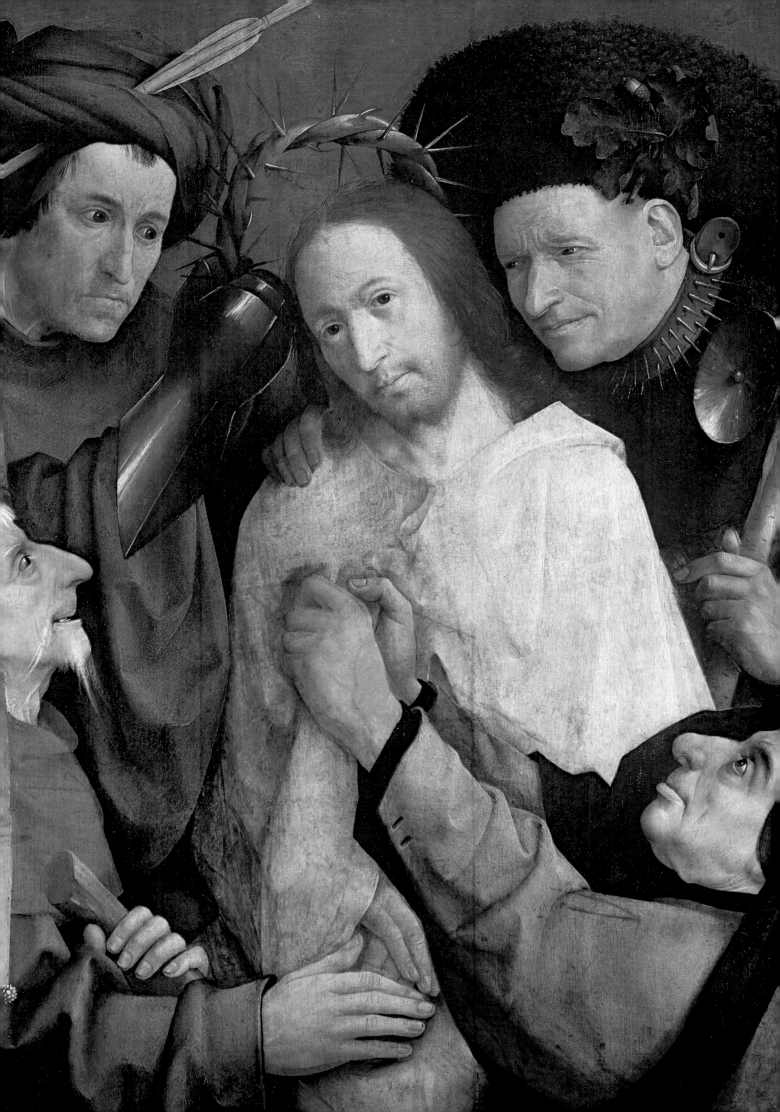

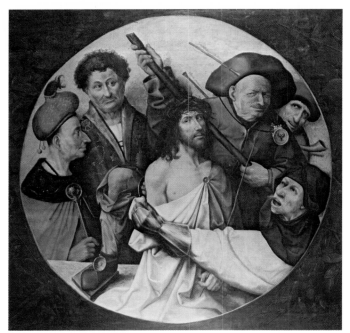

Hieronymous Bosch: *The Crowning with Thorns* (detail). Prado, Madrid.

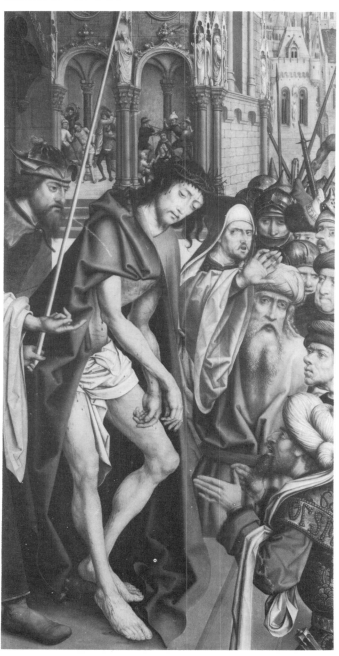

Master of the Bruges Passion Scenes: *Christ Presented to the People*. Left wing of an altarpiece. Early 16th century. National Gallery, London.

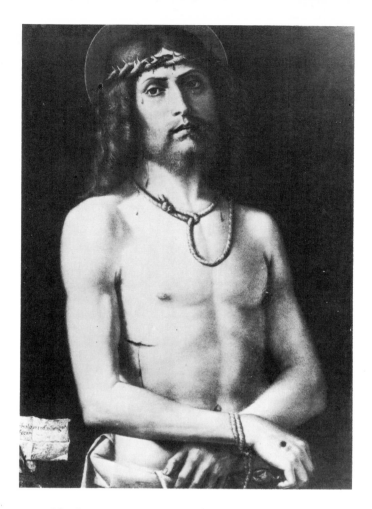

Bartolomeo Montagna: *Ecce Homo*. Early 16th century. Louvre, Paris.

a world of writing, flame-like forms, a drifting wraith beyond the touch of mortal man. After the divine muscularity of the Renaissance Christ, El Greco's is a vision or a dream, an inward incarnation. It is the more believable because of the familiar image of Christ the sufferer, the elongated face with its liquid eyes, the rhythmic gestures harking back to the Romanesque.

El Greco's achievement in creating a new language to describe the religious experience was not followed by other painters. It may, however, have indicated an extreme beyond which there was no further to go, just as there was no way forward from the art of Michelangelo except to imitation and parody. Grünewald, in the north, left no successors: his, too, was the last definitive statement of its kind. The Reformation split Europe in two. Whatever its benefits in terms of political progress, it came close to damaging the culture of Europe beyond repair. Art continued to play its part in places of worship, whether Catholic or Protestant. A few original spirits, such as Caravaggio, contributed personal images to the accumulated likenesses of Christ; but the heroic convention had by then relapsed into mannerism, with its self-conscious pleasure in virtuosity. Out of that style grew the Baroque, which graces and enlivens many of the most admired churches in Europe, and which by the end of the 17th century was to establish Rubens, the master colourist, above Raphael in the estimation of artists of the time.

In Spain the 'aesthetic of individual salvation', as it has been called, was inherited by Velazquez, the master of Spanish baroque naturalism. As a court painter,

Grünewald: *The Mocking of Christ* (detail). Early 16th century. Alte Pinakothek, Munich.

Pieter Bruegel: *The Procession to Calvary* (detail). 1564. Kunsthistoriches Museum, Vienna.

Jan van Scorel: *Christ Appearing to Mary Magdalene* (detail). *c.* 1550. City Museums and Art Gallery, Birmingham.

Titian: '*Noli Me Tangere*' (detail). National Gallery, London.

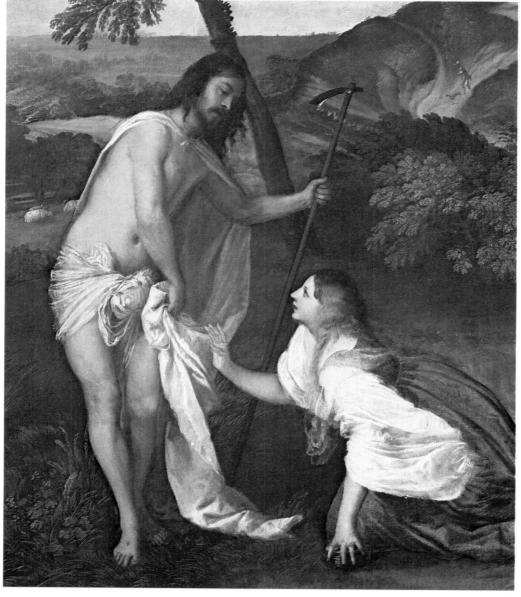

Velazquez was under no particular obligation to paint
religious subjects, and the few for which he is known are
by no means his most significant. In a painting by him we
look for the dynamic realisation of a true personality,
painted without flattery or deceit. The *Christ after the
Flagellation* in the National Gallery, London, for all its
Italianate pathos, has such an impact. It shows the beaten
body, noble even in humiliation, watched over by a
guardian angel and by a child representing the Christian
soul.

Velasquez' status in Spain corresponded with that of
Rubens in Holland: both were courtiers as well as
painters and enjoyed privileged treatment. In Rubens, as
with other masters whose work is on a three-dimensional
scale, the dominating element is not character but form.
His *Deposition*, part of the altarpiece in Antwerp
Cathedral, shows the body as a piece of organic design.
The pull of gravity is described in descending lines and

angles, of which those in the centre belong to the victim's bulk with its own dead weight. Rubens uses the same construction in his *Descent from the Cross*, in the Courtauld Collection, London. It comes close to Vasari's criteria, but with an integral imagery which would surely satisfy the demands of religious academicians. In such works the sources of Ruben's inspiration may be apparent, but seldom at first glance, so completely are they embodied in his brushwork and energetic colour. Facial expression plays a subsidiary part in Rubens's scheme. His concern is with the organization and impact of the whole.

The seventeenth century is generally regarded as the age of authority, both in political and religious establishments. It was the age of the divine right of kings, and of a renewed assumption by the church of authority over secular as well as religious affairs.

Juan de Flandes: *The Temptation of Christ in the Wilderness* (detail). Early 16th century. Private collection.

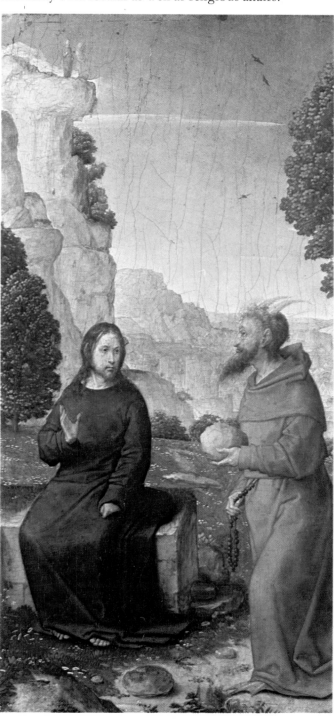

Opposite
Rembrandt: *Head of Christ*.
Metropolitan Museum of Art,
New York.

Right
Hans Holbein the Younger:
Noli Me Tangere (detail).
c. 1520. Reproduced by
gracious permission of H.M.
Queen Elizabeth II.

Below
Sebastiano del Piombo: *The
Raising of Lazarus* (detail).
Early 16th century. National
Gallery, London.

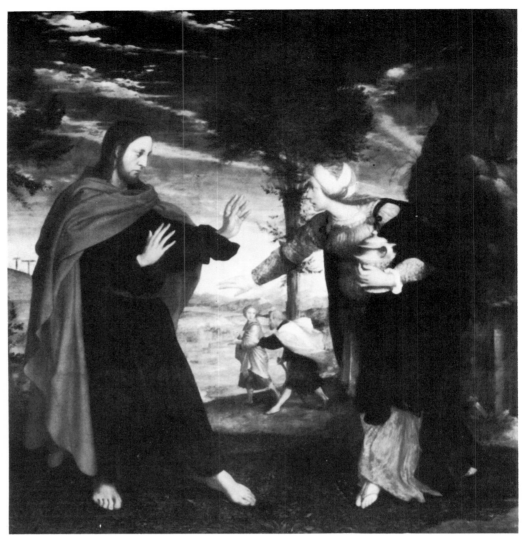

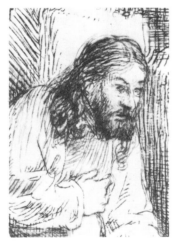

Above
Rembrandt: *Christ and the
Woman of Samaria* (detail).
Etching. British Museum,
London.

Right
Sir Anthony Van Dyck:
Christ Healing the Paralytic
(detail). Reproduced by
gracious permission of H.M.
Queen Elizabeth II.

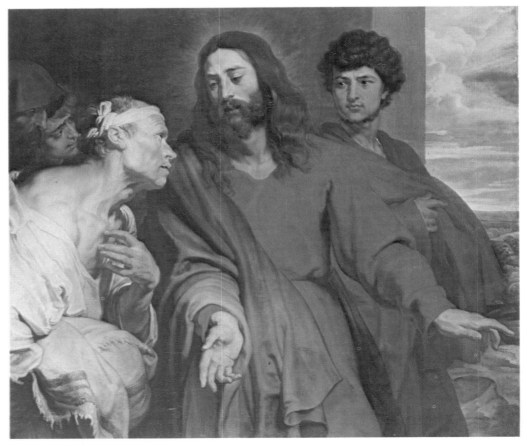

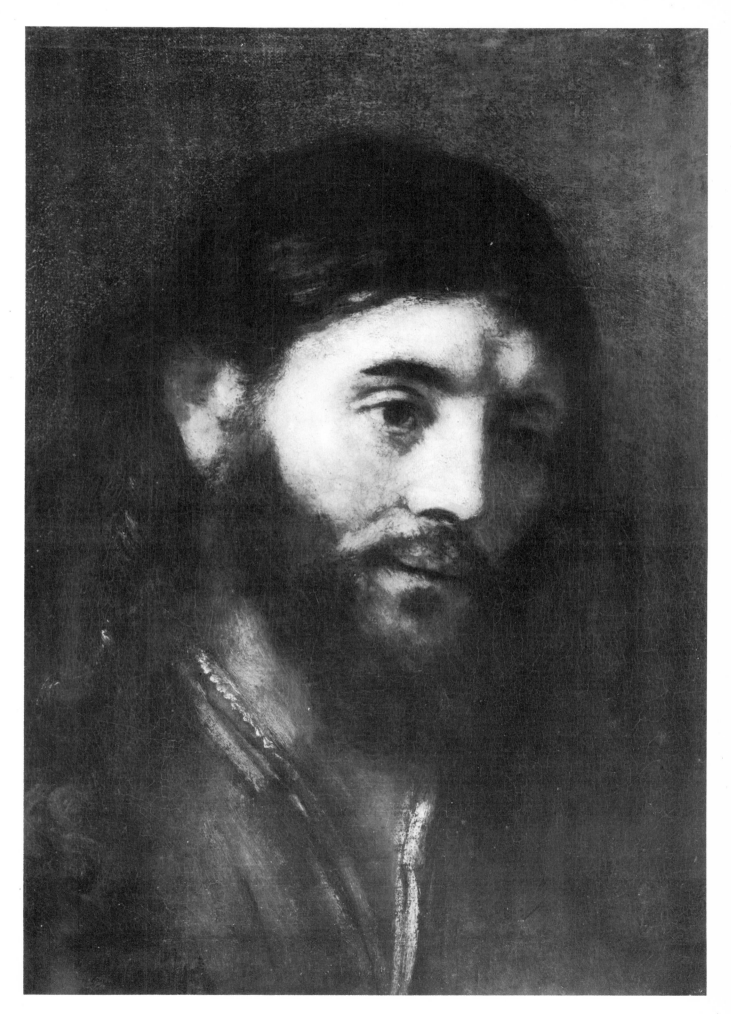

In the seventeenth century, generally regarded as the age of authority, art became a means of capturing men's minds through their emotions. The martyrdom of saints, and the great themes of the Passion, were depicted with an emotional intensity calculated to penetrate the soul. In a transitional age, the faces of Christ reflect both the triumphant Christian idea and the beginnings of more individual belief.

Guercino: *The Flagellation.* 17th century. Ashmolean Museum, Oxford.

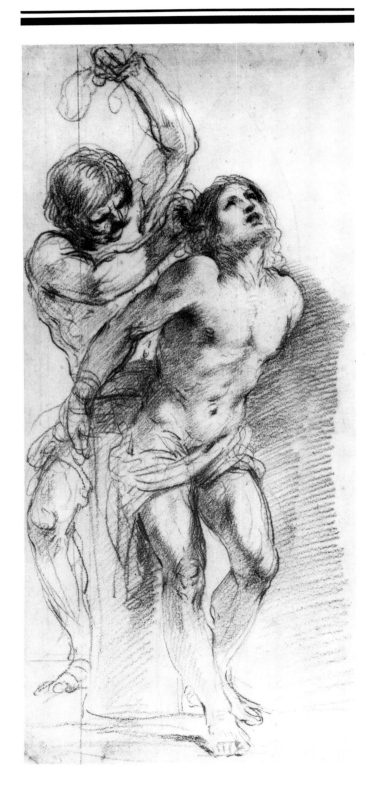

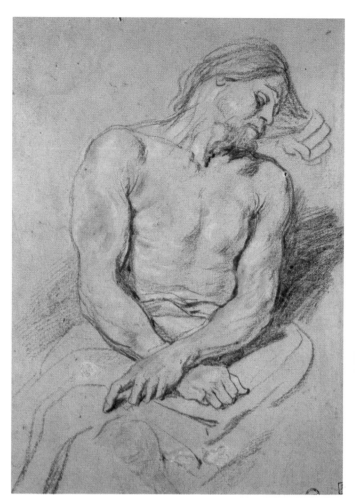

Sir Anthony Van Dyck:
Christ Mocked. Ashmolean
Museum, Oxford.

Juan Montinez Montanez:
The Merciful Christ (detail).
Polychromed wood carving.
1603. Seville Cathedral,
Spain.

El Greco: *The Trinity* (detail).
c. 1577. Prado, Madrid.

Grandees of the church became the most influential men of their time, serving monarchs who held sway with unquestioned might. In these conditions it was inevitable that art should be drawn into the mechanism of power. The effects of the Council of Trent, which laid down rules for religious images and prohibited heretical or indecent subjects, worked their way through the system. Religious art became an instrument for capturing men's minds through the emotions; the martyrdom of saints and the great themes of the Passion were depicted with an emotional intensity calculated to penetrate the 'psychology of the soul'.

Propaganda or not, much of this art produced religious images of remarkable grace. There is a purifying seriousness in the treatment of Christ by Guercino, the Bolognese master, whose paintings and drawings of religious themes are now once again unreservedly admired. His hugely successful contemporary, Guido Reni, reveals a classical intelligence which has not always been apparent amid the almost painfully expressive treatment of the devotional subjects which made his name. In sculpture, Bernini brought the art of the Baroque to its summit before turning to architecture and the all-embracing achievement of his church of S. Andrea al Quirinale, in Rome. Not since the great age of the Gothic cathedrals had so much richness, colour and invention been lavished on places of Christian worship.

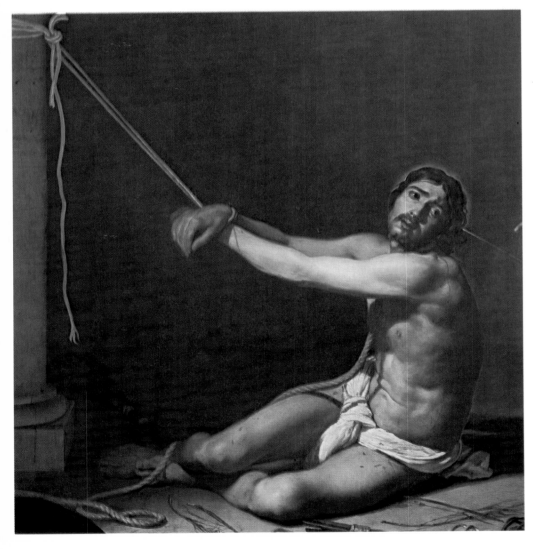

Diego Velazquez: *Christ after the Flagellation*. 17th century. National Gallery, London.

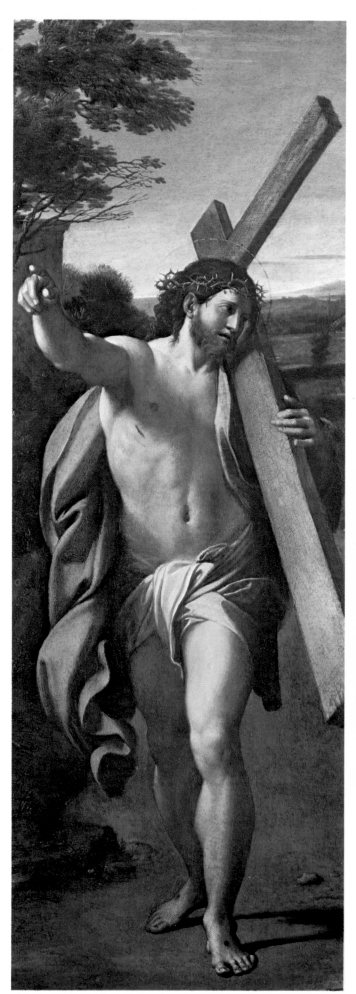

Annibale Carraci: *Christ Appearing to St. Peter* (detail). Late 16th century. National Gallery, London.

El Greco: *Christ Driving the Traders from the Temple* (detail). *c.* 1575. Institute of Art, Minneapolis.

135

The energising force behind these works was the didactic idealism of the Catholic faith. Elsewhere in Europe that faith was counterbalanced by more undemonstrative religious values, notably in the Netherlands. Rembrandt, brought up on the Bible, was able to detach himself from the doctrinal tensions of the age and follow his own road, from the stories of Jesus as a worker of miracles – his earliest role in Christian art – to his own realisation of a Christ who is a fellow man. In Rembrandt's versions of the Passion there is neither rhetoric nor theatrical grandeur; simply, the artist brings us to the scene as shaken observers. As documents of the imagination, only the late drawings of Michelangelo compare with Rembrandt's unwavering realism. Needing no word from priests or confessors, he identifies human life with the divine tragedy, raising it to the level of an experience in which all have shared.

As the age of authority waned, so religious observance waned with it. The atrocities which Christians perpetrated against one another in the name of the same God, deplenished the reserves of piety stored up from pre-Reformation times. With the eighteenth century came a gradual trivialisation of religious art. Design turned to mere decoration, sentiment to sugar. A few painters, commissioned to emulate the great religious paintings of the past, rose to the occasion with brilliance rather than conviction. Tiepolo, the dazzling Venetian, achieved the outward forms of devotional art with none of the inward beliefs which make it valid. A few large altarpieces, including a *last Supper*, now in the Louvre, demonstrate his virtuosity in a serious cause. Goya, with a stronger claim to live with the immortals, had more success with *The Taking of Christ*, in Toledo Cathedral, in which the coarse faces of the gang who have stolen up on

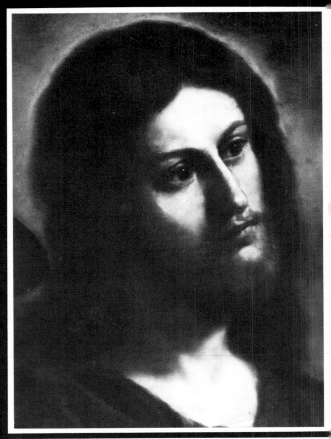

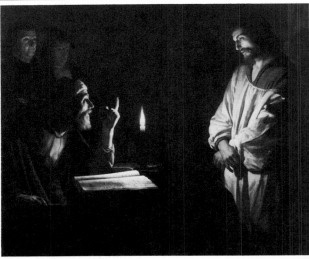

Top Left
Peter Paul Rubens: *Christ in the House of Martha and Mary* (detail). National Gallery of Ireland, Dublin.

Top
Guercino: *The Woman Taken in Adultery* (detail). Dulwich College Picture Gallery, England.

Above
Gerrit van Honthorst: *Christ before the High Priest* (detail). c. 1617. National Gallery, London.

Right
Nicolaes Maes: *Christ Blessing Children* (detail). 17th century. National Gallery, London.

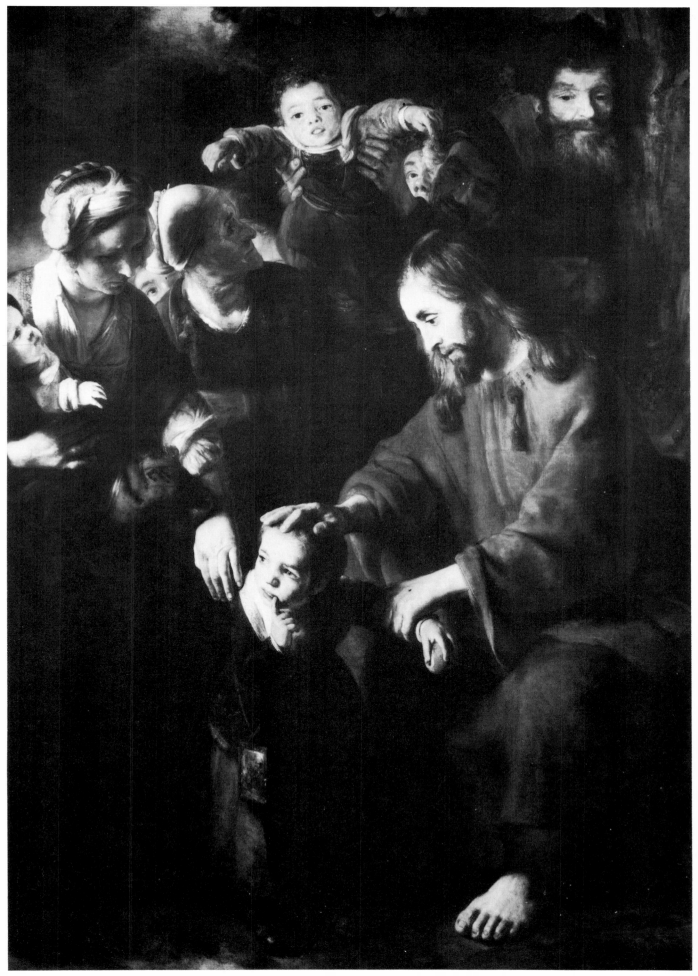

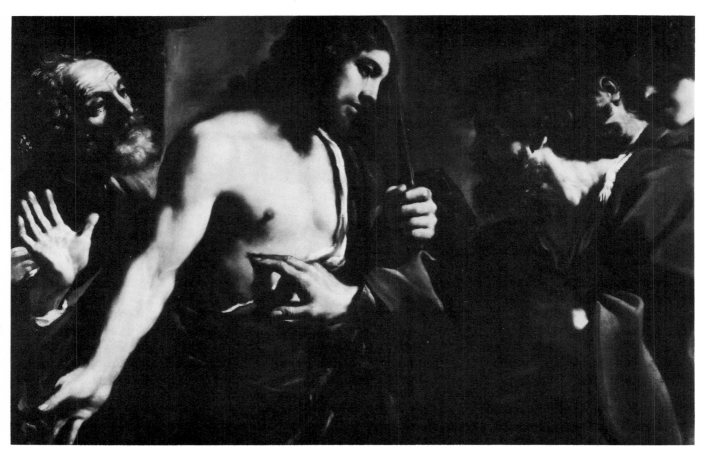

Above
Guercino: *The Incredulity of
St. Thomas* (detail). 1621.
National Gallery, London.

Right
Michelangelo da Caravaggio:
The Supper at Emmaus (detail).
c. 1600. National Gallery,
London.

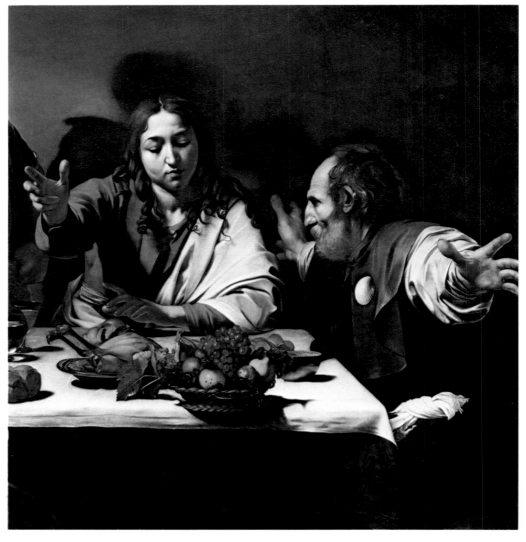

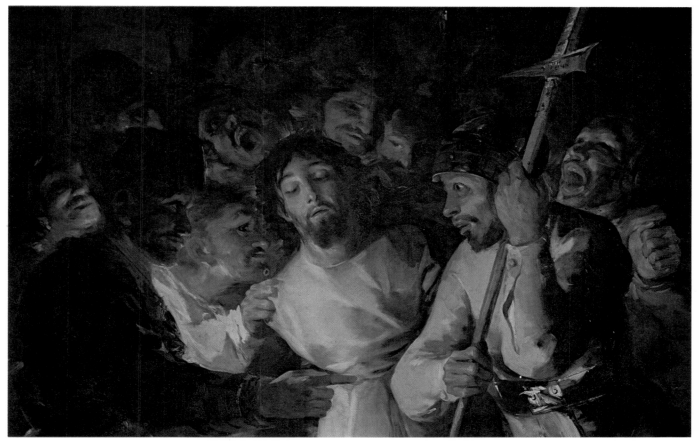

Top
Francisco Goya: *The Taking
of Christ* (detail). 1798.
Toledo Cathedral, Spain.

Above
William Blake: *Christ Blessing*.
c. 1810. Fogg Art Museum,
Cambridge, Massachusetts.

Christ by night contrast with the submissive dignity of
the arrested man. His most intense religious painting is a
small *Christ on the Mount of Olives*, his gift to the fathers of
the Escuelas Pías de San Antón, in which a white-robed
Christ kneels with outstretched arms, like the hostage
who waits to be shot in the terrible *Third of May*.

In England, religious faith took a poetical and
intellectual turn in the person of William Blake, whose
visionary art continues to grip the English imagination.
Blake was a nonconformist, with beliefs derived from
wider sources than the gospels alone. His highly
personal interpretations of religious texts are metaphors,
often of poetic intensity, which relate to his own
mythology. In eternity, according to Blake, 'we are all co-
existent with God – members of the Divine Body – all
partakers of the divine nature'. Christ, to him, was the
only God; 'and so am I and so are you'. The face of
Christ, as envisaged by Blake, is typically ethereal and
youthful, except when shown in a biblical context such as
the Crucifixion, when he usually adheres to the
conventional likeness. A *Christ Blessing*, in the Fogg Art
Museum, Cambridge, Massachusetts, shows him with a
round, Levantine face and a youthful forked beard, the
dark eyes fixed in a magnetic yet somehow charitable
gaze. One can grow particularly fond of Blake's Christ,
whom he much preferred to the Almighty. 'Thinking as I
do,' he wrote in his Vision of the Last Judgement, 'that
the Creator of this World is a very Cruel Being, and being
a Worshipper of Christ, I cannot help saying: "the Son,
O how unlike the Father!" First God Almighty comes
with a Thump on the Head, then Jesus Christ comes with
a balm to heal it.'

The rationalist spirit was not confined to those who,

*To the question, 'Who was he?' which we ask about
Christ, must be added the contemporary one, 'Who
am I?' It has its effect on the ways in which
believers think about Christ, and the ways in which
artists have continued to paint him; for it brings
into the reckoning a realisation that all our images
of him are pictures of ourselves. We have no other
model for a being whose form encompasses both
creator and created. Modern painters have made
few additions to the number created over the past
eighteen hundred years. Responding to a half-buried
memory, they have called on the forms of earlier
ages, and of a more resilient faith. What they have
made of the face of Christ is an image of how they,
and we, see ourselves, in another life and another
time.*

Francisco de Goya: *The
Agony in the Garden* (detail).
Church of St. Anton, Madrid.

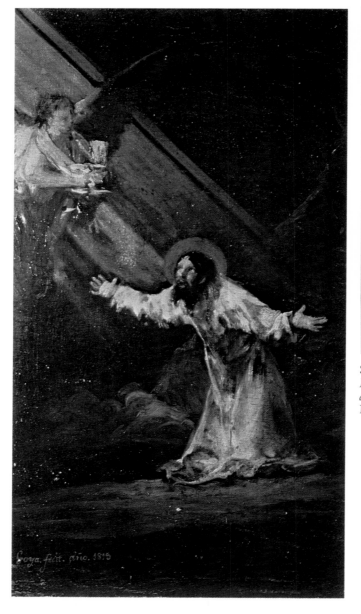

Sir Charles Eastlake: *Christ
Blessing Little Children* (detail).
c. 1839. City Art Gallery,
Manchester.

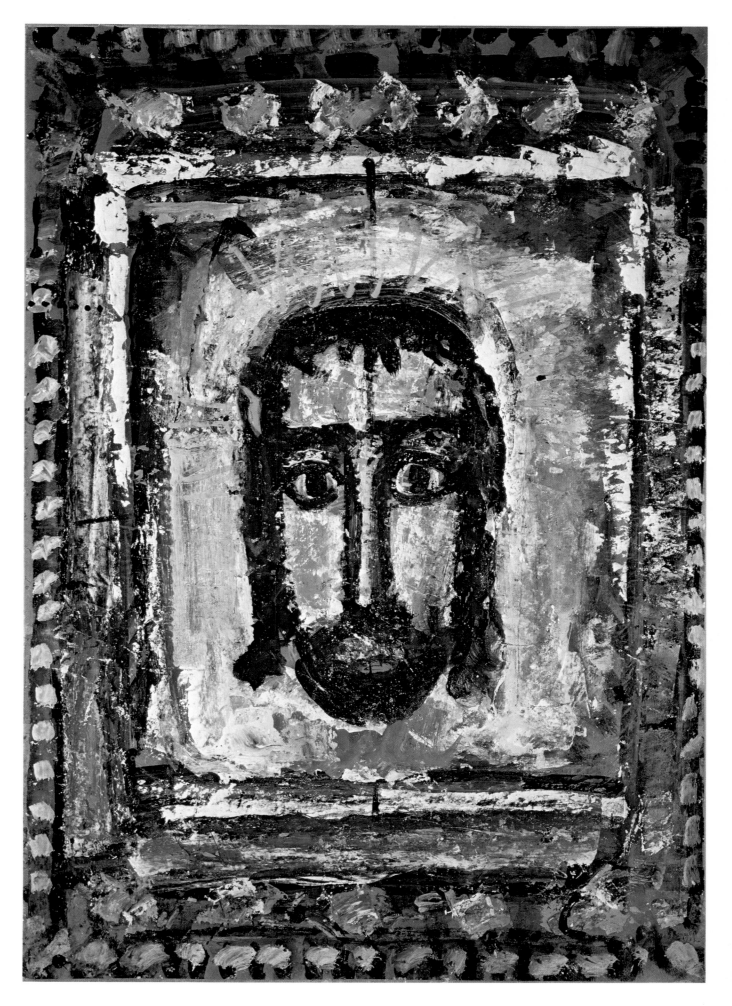

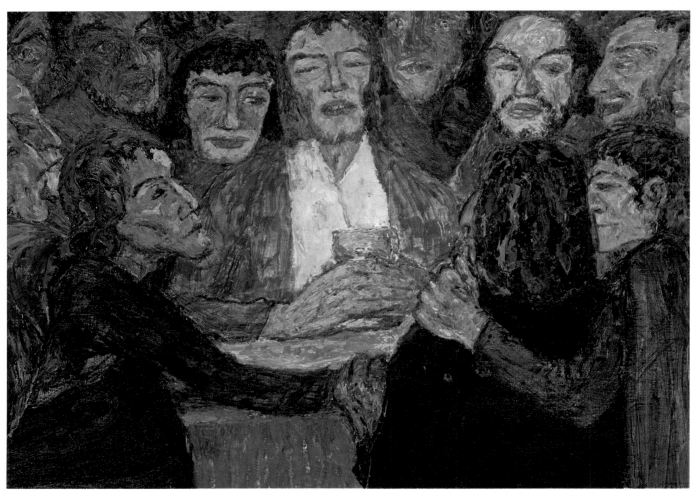

Above
Emil Nolde: *The Last Supper*.
1909. The Ada and Emil
Nolde Collection,
Neukirchen.

Right
Vincent Van Gogh: *Pietà*
(detail). After Delacroix. Van
Gogh Foundation,
Amsterdam.

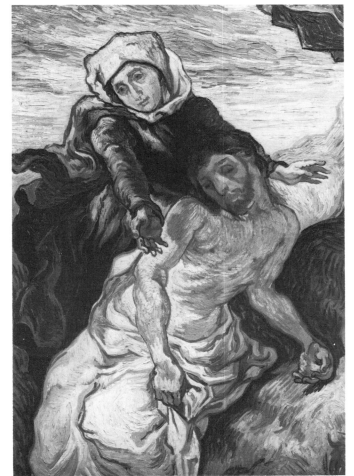

Charles Filiger: *Head of Christ*
(detail). *c.* 1892. Arthur G.
Altschul Collection, New
York.

Honoré Daumier: *We want
Barabbus. c.* 1850–70. Museum
Folkwang, Essen.

like Blake, had come to a personal arrangement with the orthodox Christian idea. It also spread to France, where Voltaire waged his scathing campaign against 'an absurd and sanguinary creed' – his description of Christianity – 'supported by executions and surrounded by fiery faggots'. The combined assault of satire and philosophy alarmed leaders of both church and state, many of whom also looked with misgiving on the counter-attacks being launched by low-churchmen like the brothers John and Charles Wesley, whose hymns and oratory drew enthusiastic crowds. In art, it was easier to turn away from these disturbing events than to join in arguments which questioned the very roots of Christendom. The leading French painters of the time, such as Fragonard, Boucher and Watteau, took refuge among the sofas and tumbled bedclothes of the well-to-do. An interest in the world of nature, God's handiwork without the awkward presence of God, stimulated the beginnings of landscape

Stanley Spencer: *Christ in the Wilderness: Scorpions.* 1939. Private Collection, London.

Emile Bernard: *Pietà* (detail).
1890. Clement Altarriba
Collection, Paris.

Paul Gauguin: *Christ in the
Garden of Olives* (detail). 1889.
Simon Norton Gallery, Palm
Beach, Florida.

Oskar Kokoschka: *Pietà*
Lithograph. 1908. Albertina,
Vienna.

as a subject for a serious painter. There is a sublimated
religiosity in Caspar David Friedrich, whose melancholy
landscapes epitomise the German romantic spirit.

A school of expatriate German artists, known as the
Nazarenes, emerged in Rome, professing the creed of
pre-Reformation Catholicism. Some of them regarded
Fra Angelico and Dürer as the last of the truly great
masters; others believed that painting had come to an end
with Giotto. They practised strict self-denial as a means
of achieving what they regarded as the loftiest aims of
art, adopting the life-style of a medieval sect. On his
return to Germany under royal patronage, Peter
Cornelius, the best-known of the Nazarenes, re-
introduced fresco painting with some success; but the
movement's achievement did not extend far beyond its
pious and retrograde gestures. It can hardly be said to
have added to the images of Christ. It was left to the
English painters who called themselves the Pre-
Raphaelite Brotherhood, to carry the Nazarenes' pious
experiment into the main stream of European art.

William Dyce, a Victorian painter who sympathised
with the Nazarenes' ideas, gives his Christ in *The Woman
of Samaria* (Birmingham Art Gallery) an ascetic gravity
which recalls the Byzantine model. His contemporary,
Charles Eastlake, in *Christ Blessing Little Children*, at
Manchester, shows him as pater familias, his classical
profile combining dignity and complacency.

The Romantic revolution did not so much banish Christ as disperse his presence among the organic forms of the living world. The invention of the Picturesque helped people to recognise in an untouched landscape a God-given balance which satisfied both the mind and the spirit. The advance of landscape painting coincided with a neglect of religious art, as if in a way it served the same purpose. Christ does make an occasional appearance in Romantic art, notably the late efforts by Delacroix to reach the heights achieved by Rubens a hundred years before; but the spirit of the age was against him.

Later in the nineteenth century, populist religion and Victorian piety combined to give Christian belief a new relevance amid Dickensian scenes of the kind which appalled Gustave Doré, the French illustrator, on his visits to London. The homeliness of the gospel stories made a direct appeal to people leading homely lives: *Christ in the House of his Parents*, by Millais, satisfied the typical Victorian demand for a picture that tells a story. Its critical reception, however, was hostile; in particular, it drew forth a violent attack from Dickens, who objected to its journalistic realism. When the Pre-Raphaelites drew up a pyramid of 'immortals', their most revered figures from the past, they put Christ at the head, with Shakespeare and the author of The Book of Job immediately below him. Holman Hunt was to paint the most famous painting of Christ in British art, *The Light of the World*, in 1853 (Keble College, Oxford). It shows the Son of God knocking at a barred wooden door, so firmly shut against intruders that it is covered with weeds and vines. The door, as John Ruskin explained, is the door to the human soul. The disconsolate face under the crown

William Dyce: *The Woman of Samaria* (detail). *c.* 1850. City Museums and Art Gallery, Birmingham.

and thorns offers no hope that the door will be opened. In the hushed night one hears a fall of angels.

The mid-nineteenth century was not a time for artists in search of religious themes to venture outside the scriptures. Both high church and low church attitudes were fixed in their different spheres, co-existing in mutual distrust. In such an atmosphere it was possible for a painter to produce a 'shocking' picture almost without knowing it. Dante Gabriel Rossetti managed to offend both factions with his *Girlhood of the Virgin Mary* (Tate Gallery), in which the Holy Family are seen going about their daily business like ordinary mortals. Ford Madox Brown adopted a similar approach to his *Christ Washing St. Peter's Feet*, also in the Tate. Millais' *Carpenter's Shop*, showing the young Christ in the home of his parents, proved similarly unsettling to the majority who liked their religious images to conform to those of the old masters, whom they felt to be closer to the reality than a modern painter could possibly be. Although, to the modern eye, nineteenth-century images of Christ may look stylised to the point of artificiality, there is no denying the sincerity of the artists who made them. The Victorians may sometimes be accused of hypocrisy, but only rarely of cynicism.

There is no painting of Christ in nineteenth century British art to compare with Manet's *Dead Christ with Angels*, which he exhibited in the Paris Salon in 1864, now

Sir John Everett Millais: *Christ in the House of His Parents*. 1850. Tate Gallery, London.

148

in the Metropolitan Museum of Art, New York. It has the tragic presence that distinguishes Christian painting up to the Counter-Reformation, and the imaginative realism that belongs to the Romantic age. Christ is shown seated, supported by a pair of startlingly flesh-and-blood angels. His eyes stare sightlessly, his mouth is agape. The body has the weight and muscularity of the classical period, but is not arranged in the conventional attitude of noble desecration. Théophile Gautier complained of the un-ethereal angels with their working-class faces. Other critics pointed out that Manet had painted the wound in the left side instead of the right (an error which he subsequently corrected in a sketch, made after the painting, which he gave to Zola).

Flawed though it is, Manet's picture exerts an uneasiness and tension which set it apart from religious paintings of his time. The persistence of the conventional likeness is a striking aspect of these later examples. It is to be seen in the shadowy profile of Christ in Daumier's *We Want Barabbas!* at Essen, a vividly realised image of mob passions in which the tethered prisoner, though hardly more than a ghostly presence, bears the stamp of dignified pathos. The features, at such a moment, do not need to be drawn. A painter sure of his touch, and of the spectator's received image of Christ, may achieve his effect by more expressionist means; for example, by simplifying the features into a mask, as Gauguin does in his *The Yellow Christ*; or, like Graham Sutherland in his *The Crucifixion* at St. Matthew's, Northampton, a scratched grimace. A lithograph *Head of Christ* by Odilon Redon shows the pinched white face and enormous eyes of a suffering jew, the image of hopeless acquiescence which in our own time stands for the tragedy of the Holocaust.

Over the centuries, artists have identified the face of Christ with that of a mortal, but perfect man. In doing so they have responded to hopes and ideals which belong to the world of the spirit, the world which Christ called his

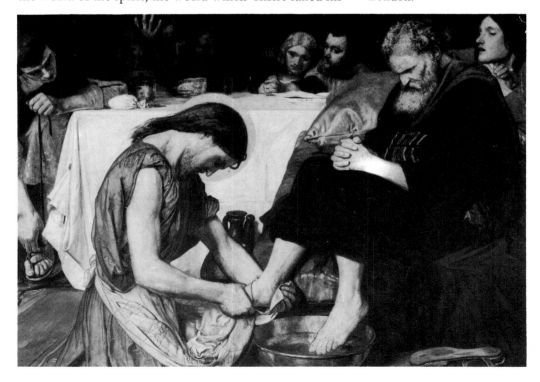

own, as well as to the world of the flesh. The progress from pagan imaginings to the power and beauty of the mind is a matter not so much of history as of progress towards what we recognise as civilised existence.

The use of art as propaganda has been understood from the beginning. In some causes, propaganda is a kind of truth, so fervently held that it defies disbelief. Perhaps the need for such faith is more important to life than the forms which it can take. The men who reached into their imaginations for the face and form of Christ, from the gloom of the catacombs to the ceiling of the Sistine Chapel, were responding to human needs. In looking on the face of Christ, the work of our own hands and minds, we are looking at ourselves, both as we are and as we would like to be.

José Clemente Orozco: *Christ and His Cross.* 20th century. Mexico. Baker Library, Dartmouth College, New Hampshire.

Bibliography

Of the numerous works consulted, the following have been particularly valuable in tracing references and sources.

Bainton, R. H. *The History of Christianity* (Nelson, 1964); Beckwith, John *Early Medieval Art* (Thames & Hudson, 1964); Berenson, Bernhard *The Italian Painters of the Renaissance* (Oxford, 1930); Clark, Kenneth *Civilisation* (B.B.C./Murray, 1969); Every, George *Christian Mythology* (Hamlyn, 1970); Gough, Michael *The Origins of Christian Art* (Thames & Hudson, 1973); Grabar, André *Byzantium* (Thames & Hudson, 1966); Hartt, Frederick *The Drawings of Michelangelo* (Thames & Hudson, 1971); Henderson, George *Early Medieval* (Penguin, 1972); Hetherington, P. B. *Mosaics* (Hamlyn, 1967); Hulme, Edward *Symbolism in Christian Art* (Blandford Press, 1976); Lassus, Jean *The Early Christian and Byzantine World* (Hamlyn, 1966); Levey, Michael *Early Renaissance* and *Late Renaissance* (Penguin, 1967 and 1973); Mâle, Emile *Religious Art from the Twelfth to the Eighteenth Century* (Routledge, 1949); van der Meer, F. *Early Christian Art* (Faber, 1967); Moore, A. C. *Iconography of Religions* (S.C.M. Press 1977); Newton, Eric and William Neil *The Christian Faith in Art* (Hodder & Stoughton, 1966); Nordenfalk, Carl *Celtic and Anglo-Saxon Painting* (Chatto & Windus, 1977); Rice, Tamara Talbot *Icons* (Batchworth Press, 1959); Toynbee, Arnold J. *Hellenism* (Oxford, 1959); Weitzmann, Karl *Late Antique and Early Christian Book Illumination* (Chatto & Windus, 1977); Wilson, Ian *The Turin Shroud* (Gollancz, 1978). The translation of Michelangelo's poems is by Elizabeth Jennings (Folio Society, 1961), and the passage from Richard Rolle is taken from H. E. Allen's *English Writings of Richard Rolle* (Oxford, 1931).

Index

Ordinary numbers refer to pages,
italic numbers to illustrations

Acknowledgements

The publishers would like to thank all those organisations and individuals who have provided illustrations for this volume.

Illustrations were obtained from the collections mentioned in each caption, except for those on the following pages which were obtained from:

p. 12: Foto Mas, Barcelona*. p. 13 *left*: Bildarchiv Foto Marburg*; p. 14: *top* Scala, Florence; p. 14 *bottom**; p. 16 *right*: The Lord Chamberlain, London; p. 17 *left*: Scala; p. 18 *top*: Cooper-Bridgeman Library, London; p. 18 *bottom left**; p. 19: Scala; p. 20*; p. 21*; p. 22 *top left*: Courtauld Institute Library, London; p. 22 *bottom left*: Cooper-Bridgeman Library; p. 22 *right*: Scala; p. 24: Scala; p. 25: Scala; p. 26*; p. 27: Mansell Collection, London; p. 30*; p. 31*; p. 32 *top**; p. 33: Caisses Nationales des Monuments, Paris; p. 34 *left*: Sonia Halliday, Weston Turvill; p. 35 *left and right*: Sonia Halliday; p. 37: Scala; p. 38 *top**; p. 38 *bottom*: Scala*, p. 39: *top* Scala*; p. 39 *bottom*: Scala*, p. 40 *top and bottom**; p. 42 *top*: Abril Press, London; p. 42 *bottom*: Foto Mas*; p. 48 *top**; p. 48 *bottom*: Reunion des Musées Nationaux, Paris*; p. 51 *middle*: Mansell Collection; p. 52 *right**; p. 53 *top*: Scala; p. 53 *bottom**; p. 54 *top and bottom**; p. 55**; p. 60: Foto Mas*; p. 61 *left*: Edwin Smith, Saffron Walden; p. 61 *right*: Caisses Nationales des Monuments; p. 62 *left and right*: Caisses Nationales des Monuments; p. 63*; p. 64 *right*: Caisse Nationales des Monuments; p. 65 *top**; p. 65 *bottom*: Scala; p. 66 *top and bottom*; Scala; p. 67 *top*: Scala; p. 68 *bottom*: Bayerische Staatsgemäldesammlungen, Munich; p. 69 *top**; p. 69 *bottom*:

Scala; p. 71*; p. 72 *top*: Dr. Schafke, Cologne; p. 73 *left**; p. 73 *right*: Scala; p. 75 *bottom left*: Scala; p. 76 *left**; p. 82: Scala; p. 84: Cooper-Bridgeman Library; p. 85 *bottom**; p. 88 Cooper-Bridgeman Library; p. 90: Cooper-Bridgeman Library; p. 91: Scala; p. 92: Scala; p. 93: Kunst Dias Blauel, Munich; p. 95: Scala; p. 96: Scala; p. 97: Scala; p. 98: Scala*; p. 99*; p. 100*; p. 101*; p. 102: Michael Holford, Laughton; p. 103 *bottom*: Bildarchiv Foto Marburg*; p. 104: Josephine Powell, Rome; p. 107: Scala; p. 109: Courtauld Institute Library; p. 111 *top*: Scala; p. 115*; p. 116: Vatican Museums, Rome; p. 117 *bottom*: Scala; p. 119: The Lord Chamberlain, London; p. 120 *top*: Reunion des Musées Nationaux; p. 120 *bottom*: Cooper-Bridgeman Library; p. 121 *top*: Reunion des Musées Nationaux; p. 122 *top*: Caisses Nationales des Monuments; p. 124 *top*: Cooper-Bridgeman Library; p. 125: Caisses Nationales des Monuments; p. 126 *top and bottom*: Cooper-Bridgeman Library; p. 129: Cooper-Bridgeman Library; p. 130 *top and bottom right*: The Lord Chamberlain, London; p. 133 *bottom left**; p. 133 *right*: Foto Mas; p. 139 *top*: Foto Mas; p. 140 *top**; p. 141: Reunion des Musées Nationaux; p. 144: Arbor Films, London; p. 145 *bottom*: Cooper-Bridgeman Library; p. 146: Cooper-Bridgeman Library; p. 151*; p. 152 *top*: Stephen Meakins, Northampton*; p. 153*.

* Photographs of these illustrations are held in the Hamlyn Group Picture Library, Feltham.

Special thanks to Angela Murphy for researching and collecting all of the illustrations.